First published in the UK in 2014 by Aurora Metro Books Ltd.
67 Grove Avenue, Twickenham, TW1 4HX
www.aurorametro.com info@aurorametro.com

We have made every effort to trace all copyright holders of photographs included in this publication. If you have any information relating to this, or to the text, please contact the publisher: provence@aurorametro.com
With many thanks to: Neil Gregory, Richard Turk, Alex Chambers, Molly Gibbons, Faye Allum, Suzanne Mooney, Simon Smith.

10 9 8 7 6 5 4 3 2 1

Printed in the UK by Cambrian Printers, Aberystwyth.
ISBN: 978-1-906582-33-3

PROVENCE

PEOPLE PLACES FOOD

A CULTURAL GUIDE

ED. CHERYL ROBSON

AURORA METRO BOOKS

CONTENTS

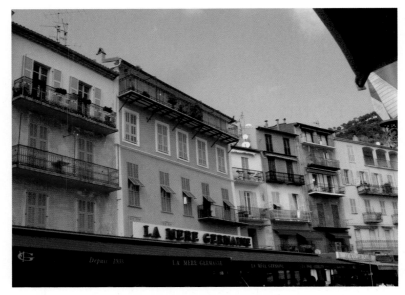

ABOVE: COLOURFUL BUILDINGS, CAFES AND RESTAURANTS IN THE PORT OF VILLEFRANCHE-SUR-MER, ON THE RIVIERA.

BELOW: THE PALAIS DES PAPES AND THE PIAZZA IN AVIGNON, IN THE DEPARTMENT OF BOUCHES-DU-RHONE.

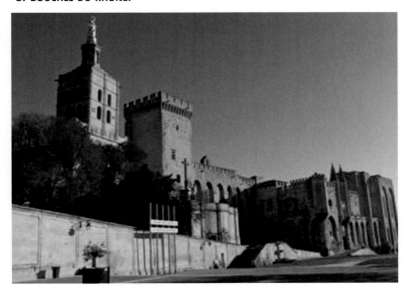

INTRODUCTION

Many books will tell you the history of Provence and give you a list of interesting places to visit. Some will help you to appreciate the lifestyle and understand the culture.

Where this book differs, is that it gives you an insight into the lives of those remarkable people who've chosen to visit the region or have settled here.

The focus of the book is on those who've lived in the region during the past two hundred years, although on a few occasions, we've gone back further in time to include other noteworthy residents such as Nostradamus, the Popes of Avignon and the Knights Templar.

Many visitors rush from one landmark to the next, trying to 'do' the South of France in a day or two. But to really experience the Provençal way of life, you need to eat fresh food in the open air, enjoy some of the fine local wines and allow life to slow its pace enough to experience the here and now.

The French have mastered the art of relaxing, making light conversation with friends in a café, and playing at boules for the simple joy of playing.

If you want to enrich your stay by learning about those who've become part of the mythology of Provence over the centuries, then this book is a good place to start. It will give you the chance to follow in the footsteps of the many artists, writers, stars of film and sports, politicians and royals who have made Provence their home, contributing to the vibrant cultural life of the region.

Provence is made up of six different Departments, each with its own number (see map on page 16). The region stretches from the azure blue of the Mediterranean Sea in the south to the snow-capped alps in the north-east, with the wide valleys and limestone hills of the Luberon at its heart.

Some people prefer the laid-back pastoral idyll of the hinterlands, others like to explore the ancient history of the perched villages, while most of the summer tourists opt for the liveliness of the coast. The tourist influx and the traffic congestion in August can lead to long delays and over-priced hotels, which

it's best to avoid.

Provence's coastal jewels are the major cities of Marseille and Nice, and lying in between them, is the deep and strategic port of Toulon. Through these harbours which face towards Africa, trade and prosperity have flown into Provence from the wider world for thousands of years bringing people, goods, spices, innovation – and occasionally – invasion, destruction and war.

The walled city of Avignon at the western edge of the region, became one of the largest cities in Europe in the 14th century, the home to Popes, bringing wealth, viticulture and artistic creation in its wake. The population swelled to 40,000 people until the last Pope, Gregory XI, finally left for Rome in 1377.

While the high Alps have acted as a natural barrier, their glaciers also feed the river Rhone which runs down to Arles where it splits to form the Camargue delta before running into the Mediterranean Sea. This fast-flowing river also provided important trade and transportation, connecting Provence with Lyons, Switzerland and beyond.

The limestone hills and caves of the Luberon offer a distinct contrast to much of the coastal landscape of the Riviera. This is where you'll find old stone farmhouses, lavender fields, vineyards

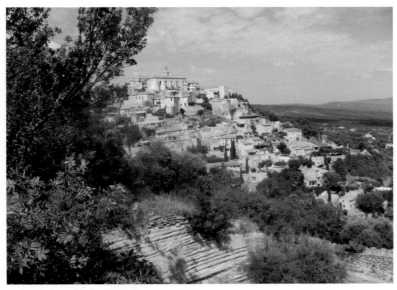

HILLTOP VILLAGE OF GORDES

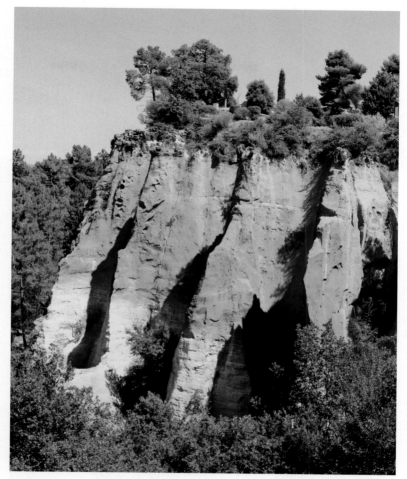

OCHRE CLIFFS, ROUSSILLON

and stone-built villages perched on top of hills. Discover the small town of Roussillon and marvel at its red, orange and yellow ochre cliffs contrasting magnificently against the green of the trees and the bright blue sky. This is where ochre was mined for use in paints and dyes.

The love of art and artists is a characteristic of French culture. When visiting many of the towns and cities in Provence you will see the names of writers, artists and poets honoured as well as those of politicians and national heroes, emblazoned on street signs and plaques.

OPERA HOUSE, NICE

Nice is by far the richest city and the largest resort on the Côte D'Azur. Due to its port and strategic location near to Italy, people have fought over Nice throughout the centuries. It has belonged to Romans, Saracens, Ottomans and the Counts of Savoy and Sardinia. Napoleon III made a deal to restore the city to France in 1860. This mixed heritage has led to a unique blend of cultures, architecture and cuisine.

From the mid-18th century onwards English aristocrats visited Nice as part of their Grand Tour of Europe. Queen Victoria liked to spend the winter there and her presence attracted other European royalty and high society. With the advent of modern transportation the city became popular with the English upper classes. During the Belle Epoque, tourism grew rapidly and became the mainstay of the economy.

In the last fifty years, with the coming of mass tourism, around four million people visit the French Riviera annually. It has helped Nice to develop into the fashionable and cosmopolitan place we know today.

However, it could have been a very different story because it was Hyères-Les-Palmiers in the Var which first attracted the attention of the wealthy English aristocrats, including the Prince of Wales, who visited in 1788 and 1789, looking to escape the cold and misery of the English winter.

A small community of British *hivernants* began to visit the seaside haven regularly, as it was the easiest resort to reach from Marseille. Tolstoy, Robert Louis Stevenson and Joseph Conrad were later residents. The American novelist, Edith Wharton, lived in the Castel Sainte-Claire, a former convent which is high up in

VIEW OF HYERES FROM RAMPARTS

the old town where it provides wonderful views from its gardens. Also in the old town, the wealthy Noailles family later built an ultra-modern summer house where they entertained Cocteau, Brancusi and Giacometti among many others.

It was the railway line from Paris via Lyons to Nice, completed in 1867, that gave Nice an economic advantage and led to its rapid expansion. Previously, there had only been a local train-line connecting Nice to Cannes and it was by this route that Tsar Alexander II of Russia visited Nice in 1864 and found the climate to his liking. Other Russian visitors followed and a community formed that continues to this day.

Once the right to paid holidays was granted in the 1930s, tourists descended *en masse* from the frequent trains, eventually spreading westwards to Cannes and eastwards towards Monaco and Menton in what has now become known as the French Riviera.

There's a festive atmosphere from May to September and we list some of the many festivals that are organised throughout the region. The Carnival in Nice, the Jazz Festival in Juan-les-Pins and the Film Festival in Cannes are some of the most popular.

The older generation of French people will often tell you that France is a country that has everything so there's no need to travel anywhere else. But there is a growing rift between those who want to cling on to the traditional ways and maintain the *status quo* and those who want to modernise the country – such as the entrepreneurs and employees of the hi-tech companies sited at Sophia Antipolis, which is about half an hour's drive along the autoroute going west from Nice.

Visitors sometimes comment on a certain arrogance and unworldliness among the French who appear to believe they can carry on with their way of life, irrespective of what goes on in the rest of Europe or the world in general. But the recent Islamist attacks and the euro crisis have dented this belief.

Globalisation is affecting the farmer working laboriously on his *terrain* in the traditional way, as well as the cabinet-maker now employed to assemble flat-packs from *Ikea,* and the wine merchant competing with the new world wines in a global marketplace. *'Le monde bouge...'* Just as the railway came to Nice bringing the English in their hundreds to stroll along the *Promenade des*

VIEW OF MENTON FROM THE PORT

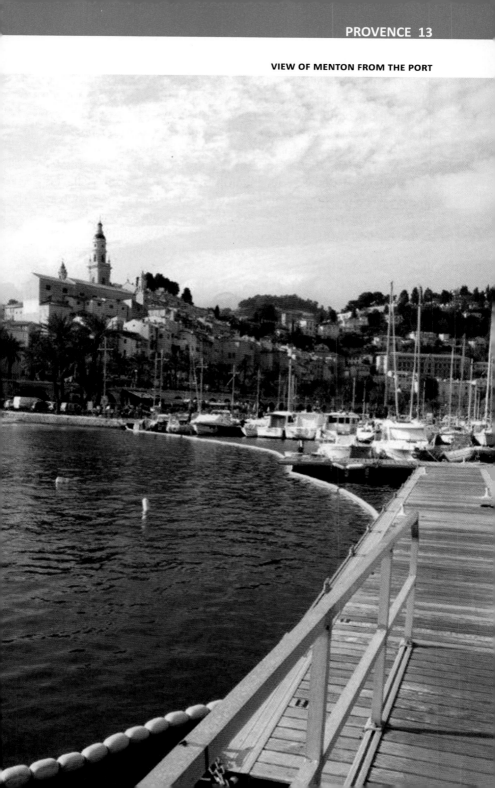

Anglais during the winter months, now the cruise ships docking in Nice, Marseille and Monaco disgorge thousands of Asian tourists to buy local crafts and eat Provençal specialities. Provence has absorbed each wave of newcomers and adapted to accomodate them. This unique cultural blend is part of its enduring appeal.

While the landscape and the quality of light in the region provided inspiration for artists such as Matisse, Picasso and Chagall in the early part of the twentieth century, American writers such as F. Scott Fitzgerald and Ernest Hemingway, both heavy drinkers, came to the Riviera to party and escape the Prohibition. Others fled to the south to avoid the worst of the German Occupation during World War II.

Movie star Grace Kelly brought glamour to the principality of Monaco in the late 1950s when she married Prince Rainier III. Monaco is less than 1 square mile (2km) in size and is surrounded by France on three sides. It has expanded from the fortified old town which sits on 'The Rock' between Port Hercules in La Condamine and Fontvieille. You can visit the palace that has been occupied by the Grimaldi family since the thirteenth century and is now home to Prince Albert II and his South African wife, Princess Charlene Wittstock.

MONACO'S PORT HERCULES

STEAMED MUSSELS

Since the end of World War II, entrepreneurs and stars from sport and the world of entertainment have made Monaco their base to enjoy the Mediterranean lifestyle and escape increasing taxation in their home countries. But it is probably the glorious climate (almost 300 days of sunshine each year) and relaxed way of life which continue to exert the strongest pull on its wealthy citizens.

We hope you enjoy reading about the many extraordinary people who've either lived in Provence or frequented the region – far too many to include all of them in this book. We've also had to be selective in choosing which places to include – leaving out many of the remarkable towns and villages in Provence for lack of space. Please use this book as a stepping-off point to adventure further, to join in one of the dozens of local festivals, or go in search of some ancient history. You may simply want to imagine the glamour and romance of living in a place like Juan-les-Pins at the height of the jazz age.

And you can always try some of the authentic recipes we've included to bring back the wonderful tastes and flavours of Provence, long after your visit has ended.

Cheryl Robson

FLAG OF PROVENCE

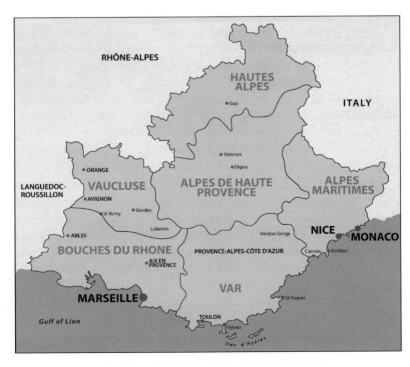

MAP OF PROVENCE SHOWING THE DEPARTMENTS

PEOPLE AND PLACES

STREET IN AIX-EN-PROVENCE

AIX-EN-PROVENCE (BOUCHES-DU-RHONE)

Founded by the Romans, it was one of the oldest towns in ancient Gaul, and the spa which was created still continues.

In 1189, the Counts of Provence were based there but the population dropped dramatically in the 14th century due to war and the spread of plague. Good King René, whose statue stands at the heart of the town in the Cours Mirabeau, retired to Aix in the 15th century where he encouraged the arts and set up a university. He was also responsible for annexing Provence to France in 1481.

Aix-en-Provence is a place that combines elegant architecture with a youthful energy. Considered the most 'Italian' French town, it has fashionable shops and restaurants as well as wide boulevards for walking and simply enjoying the ambience.

PLACES

Museum of Old Aix.
Natural History Museum.
Tapestry Museum.
Paul Arbaud Museum (Pottery).
Granet Museum includes works by Cézanne Degas, Gauguin, Monet, Picasso Renoir, Van Gogh.
Vendôme Pavillion (Arts) a 17th century house.
The Vasarely Foundation houses the works of the Hungarian-born artist Victor Vasarely. (see page 88)
L'Atelier Cézanne, the studio of artist Paul Cézanne.
Jas de Bouffan, the house and grounds of Cézanne's father.
Les Deux Garcons (2Gs) restaurant, on the Cours Mirabeau where Cézanne used to meet Zola.
St. Sauveur Cathedral, near the Place de l'Universite. See the triptych by Nicolas Froment, commissioned by King René in 1476, recently restored.
Saint-Jean-de-Malte Church, on the corner of Rue d'Italie and Rue

Cardinale. See *The Crucifixion* (1820) by Eugène Delacroix and the rose window created in honour of Cézanne.

VISIT

Chateau de Vauvenargues, originally occupied by the Counts of Provence then King René, followed by the Archbishops of Aix and then the Marquis de Vauvenargues. In 1958, Pablo Picasso and his wife Jacqueline bought it, living there from 1959 until 1962. They were buried in its grounds. Open from June to September.

Mont Saint-Victoire (1011m), a landmark east of Aix. Paul Cézanne painted it obsessively throughout his lifetime.

Sisteron, about an hour north of Aix, enjoy spectacular scenery, Sisteron citadel and the 12th century cathedral, now the Church of Notre-Dame-des Pommiers.

Les Penitents des Mées, narrow rocks 100 m high near Digne.

FESTIVALS

International Art and Music Festival, July. Features mainly opera and chamber music.

Festival of Dance, July-August.

www.en.aixenprovencetourism.com

PEOPLE

PAUL CÉZANNE (1839 – 1906)

"I go into the countryside every day. The shapes are beautiful and I prefer to spend my days there rather than anywhere else."

A French painter whose style challenged the classical conventions of the day through his unique treatment of shape, colour and form. He inspired many modern artists to develop abstract painting.

Born in Aix on 19th January, 1839, he went to a local primary school in the Rue des Epinaux until, aged 10, he was sent to the Saint Joseph boarding school.

In 1852, Cézanne studied at the Bourbon College (now Mignet College), where he met and became friends with Emile Zola and Baptistin Baille. In 1858, when Zola left for Paris, the two friends wrote to each other frequently. Forced by his father to study law, Cézanne continued to take art classes to enrol at the Ecole des Beaux Arts in Paris in 1861, but he failed the entrance exam.

His father, a banker, eventually provided him with an allowance so he could paint. Cézanne met other artists including Pissarro, Monet and Renoir while in Paris and it was Pissarro who encouraged him to work outdoors. Although he submitted his work to the Paris Salon, they rejected it several times. Following a small exhibition, his reputation as an artist began to grow.

Cézanne married his long-term companion Hortense Fiquet in 1886 and they had a son, Paul. He loved the local countryside and particularly the Mont Sainte-Victoire which he painted repeatedly.

He rented a small house in Bibémus and tried to purchase the Château Noir, both subjects of his painting. When his parents' home, the Jas de Bouffan was sold in 1899, he moved to the Rue Boulegon in Aix and set up a studio later in the Chemin des Lauves.

On October 15th, 1906, he was painting in the countryside when a thunderstorm struck. He caught a cold and died on 23rd October, at the age of 67.

MONT STE-VICTOIRE BY PAUL CEZANNE
COURTAULD INSTITUTE

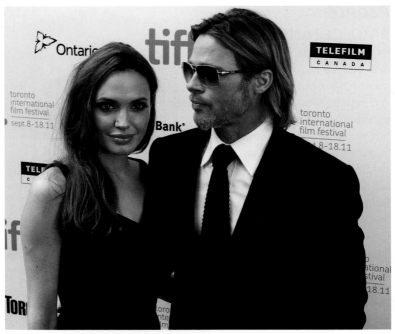

ANGELINA JOLIE (1975 –)

An American actress, director and UN High Commissioner for Refugees. She made her screen debut aged 7 with her father Jon Voight in *Lookin' to Get Out* then as a teenager she appeared in *Cyborg 2* (1993) and *Hackers* (1995) before winnning an Academy Award for Best Supporting Actress for *Girl, Interrupted* (1999).

In 2001, she starred in *Lara Croft: Tomb Raider* (2001), and its sequel *Lara Croft Tomb Raider: The Cradle of Life* (2003). She was also nominated for an Academy Award for Best Actress for *The Changeling* (2008).

Previously married to actors Jonny Lee Miller and Billy Bob Thornton, in 2005, she met Brad Pitt on the set of *Mr. & Mrs. Smith* and this led to a long-term relationship and motherhood. She has adopted three children from third world countries and has given birth to three children fathered by Brad Pitt.

In 2008, they bought the historic Chateau Miraval in Brignoles near Aix for $35 million. Recently, Jolie has undergone a double mastectomy to avoid the onset of breast cancer.

COUNT MIRABEAU
(1749 – 1791)

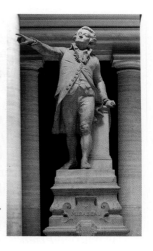

Honoré-Gabriel Riqueti, Comte de Mirabeau, played an important political role in the French Revolution.

Mirabeau was born on March 9th, 1749 in Le Bignon, south of Paris into an impoverished aristocratic family. As a young man he led a decadent life, and racked up serious gambling debts. He edited a newspaper called *Le Courrier de Provence* and wrote essays critical of the Ancien Regime which landed him in prison.

In 1789, Mirabeau became the leader of the Third Estate, acting on behalf of ordinary people, and due to his ability as an orator, established his reputation as a statesman. He contributed to the writing of the Declaration of the Rights of Man with Abbé Sieyes and helped set up the National Assembly.

When the King, Louis XVI, tried to have the Assembly dissolved, on June 23rd, 1789, Mirabeau said: *"Tell those who sent you here that we stand here by the will of the people and we will leave only by the force of bayonets."*

Mirabeau was a moderate, in favour of a constitutional monarchy, and was opposed to the idea of a Republic which soon brought him into conflict with the revolutionaries. In 1790, he became one of the King's special advisers, but on April 2nd, 1791, he died in mysterious circumstances. Initially, his remains were interred in the Pantheon, but when the public learnt of his close relationship with the King, they removed his remains and put those of Marat in their place.

BRAD PITT (1963 –)

An American actor, producer and designer. William Bradley Pitt was born on December 18th, 1963, in Springfield, Missouri. Following small TV roles, it was as the cowboy/thief in *Thelma and Louise* (1991) that he first came to public attention. This led

to major roles in *A River Runs Through It* (1992), *Interview with a Vampire* (1994) and *Legends of the Fall* (1994), which earned him his first Golden Globe nomination.

He won a Golden Globe Award and an Academy Award nomination for *12 Monkeys* (1995). In 1999, *Fight Club* was a cult hit followed by *Ocean's Eleven* (2001) and its sequels. Then came *Troy* (2004) and *Mr. & Mrs. Smith* (2005), a box office success.

The Assassination of Jesse James (2007) was a critical success while his starring role in *The Curious Case of Benjamin Button* (2008) garnered another Academy Award nomination.

As a producer, his film *The Departed* won an Academy Award for Best Picture (2007) with sports drama *Moneyball* (2011) being nominated for several awards.

He married *Friends'* star Jennifer Aniston in a $1m ceremony in Malibu in 2000 but split from her in 2005 following a relationship with Angelina Jolie with whom he worked on the movie *Mr. & Mrs. Smith.*

He has adopted three children with Jolie: Maddox, Pax and Zahara, while Shiloh, Knox and Vivienne are their biologcal children.

In 2006, Pitt founded the Make It Right Foundation and donated $5m along with Steve Bing to build sustainable homes after Hurricane Katrina in New Orleans. He also jointly set up the Jolie-Pitt Foundation with Jolie, giving large donations of $1m to Global Action for Children, Doctors Without Borders, an agency to help refugees in Pakistan and following the Haiti earthquake, a further $1m to Doctors Without Borders for urgent medical aid.

KING RENE (1409 – 1480)

René of Anjou, also known as René I of Naples and Good King René, was born in the castle of Angers and became the Duke of Anjou, Count of Provence at the age of 25.

He was the second son of Louis II of Anjou, King of Sicily and his mother was Yolande of Aragon. His sister, Marie,

became Queen of France on her marriage to Charles VII. His younger daughter Margaret of Anjou, married King Henry VI of England. This helped to cement the peace negotiated at Tours, but in 1471 she was defeated in the Wars of the Roses then imprisoned and held for ransom.

At age 10, a marriage treaty was made for René with Isabella, the daughter of Charles II, the Duke of Lorraine, but this led to a dispute over the title of Duke of Lorraine with Antoine de Vaudemont who defeated René in battle and was given support in his claim by the Holy Roman Emperor Sigismund at Basel in 1434.

When his elder brother died, René succeeded to the throne of the Kingdom of Naples and also inherited a fortune from Joanna II, Queen of Naples.

After his second marriage with Jeanne de Laval, René retired to Provence and spent time writing and developing the arts, including the performance of mystery plays. He developed the university in Aix and his charity work earned him the reputation for being 'Good'.

He wrote two books: *The Mortification of Vain Pleasure*, (1455), and a romantic quest, *The Book of the Lovelorn Heart*, (1457). Both works contain illuminations by the painter, Barthélémy d'Eyck.

EMILE ZOLA (1840 – 1902)

A French novelist, journalist and social campaigner.

Born on April 2nd, 1840, Zola was the son of an engineer who died while contructing a canal. He was 7 when his mother became a poor widow in Aix. She then began a legal battle over her husband's estate, which may have contributed to Zola's keen sense of social justice.

Zola went to boarding school aged 12, where he won several prizes. He met Paul Cézanne when they were both studying at the Bourbon College (now Mignet College) in Aix and they became close friends. Cézanne said of him: *"Zola was always day-dreaming... wild and stubborn... the type children hate... he was always alone... I didn't care... I couldn't help talking to him anyway."*

The family moved to Paris in 1858. Zola took on poorly paid clerical jobs, slowly making a reputation as a writer. He wrote for various newspapers, often criticising Napoleon III. His open letter to the President published on the front page of the newspaper *L'Aurore,* titled "J'Accuse", accused the French Military of anti-semitism for convicting Alfred Dreyfus of treason and sentencing him to life imprisonment on Devil's Island. The case divided liberal and traditional parts of French society. Zola was convicted for libel in 1898. Facing prison, he fled to England.

Between 1871 and 1893, he wrote a series of twenty novels known as Les Rougon-Macquart subtitled *Histoire naturelle et sociale d'une famille sous le Second Empire.* The novels dealt with social injustice. Other notable examples of his work are: *Therese Raquin, La Bête Humaine, Nana, L'Assomoir, Germinal* and *Les Mystères de Marseilles.*

In 1886, he wrote a novel called *L'Oeuvre* about an artist, which was a thinly-veiled portrait of Paul Cézanne. It upset Cézanne and they fell out as friends, never speaking again to each other.

Zola returned to France in 1899 and had his honours restored.

Zola died in 1902, due to inhalation of fumes from a blocked chimney. Some claimed that the chimney had been blocked deliberately as retribution for his involvement in the Dreyfus Affair.

LES DEUX GARCONS RESTAURANT

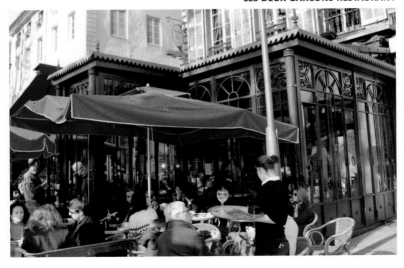

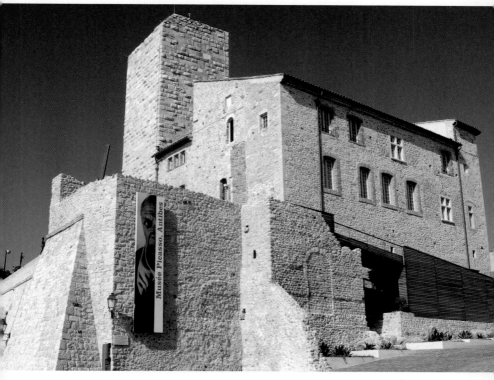

Musée Picasso, Antibes

PICASSO MUSEUM

ANTIBES/JUAN-LES-PINS (ALPES-MARITIMES)

Originally called Anti-polis over 2000 years ago by the Greeks due to its position on the bay opposite Nice, it was a trading port for the Phocaeans in the 5th century BC. Later, as part of the Roman Empire, it was renamed Antiboul.

The old town was fortified to withstand the attacks of the Barbarians and Saracens in the Middle Ages and it became the staging post for the start of the first Crusade in the 11th century.

In 1385, the Grimaldi family took ownership of the small castle built into the ramparts of the old town (see above). In 1946 it became Picasso's workshop by the sea and is now a museum.

In the 20th century, Juan-les-Pins and Cap d'Antibes became fashionable due to the wealthy society attracted by resident Americans such as Frank Jay Gould and Gerald and Sara Murphy who encouraged sunbathing and swimming in the sea.

PLACES

Picasso Atelier Museum, on the ramparts.
Museum of Archaeology.
Museum Peynet, works by Raymond Peynet and other cartoonists.
Fort Carré, 16th century fort on the Saint Roch peninsula, with a panoramic view.
Hotel du Cap-Eden-Roc a luxury hotel where artists, writers, movie stars, royalty and heads of state have stayed (see Gerald Murphy below).
Villa Eilenroc Gardens A Belle Epoque villa surrounded by a verdant park of 27 acres at Cap D'Antibes now open to the public.

PHOTO: HOTEL DU CAP-EDEN-ROC

FESTIVALS

International Jazz Festival, July.
Established in 1960, it takes place in a pine grove where Ray Charles and Miles Davis made their European debuts.

www.antibes-juanlespins.co.uk

PEOPLE

SIMONE DE BEAUVOIR (1908 – 1986)

"One is not born a woman, but is made one."
She was a French existentialist philosopher, writer and social theorist, and long-term partner of Jean-Paul Sartre.

Born on January 9th, 1908 into a Catholic household, she attended a girls' Catholic school until she took her Baccalaureate. She formed a close friendship with Elizabeth Mabille (Zaza), until her untimely death in 1929. She met Jean-Paul Sartre while studying at the Ecole Normale Superieur and the two developed a close relationship until his death in 1980. The two never married but had an open relationship, allowing for de Beauvoir's bisexuality.

Following the Occupation, de Beauvoir was dismissed from her teaching post in Rouen and wrote a novel *The Blood of Others*

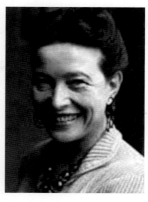

*(*1943) about the resistance followed by *The Mandarins* (1954) about moral ambiguity, which won the Prix Goncourt. She is best known for her exploration of women's oppression in *The Second Sex* (1949), which established her as a leading light of the feminist movement in France.

From 1930, she often visited the French Riviera, mainly Antibes, frequently with Sartre or her adopted daughter, Sylvie Le Bon.

An atheist, she died of pneumonia, aged 78, and is buried next to Sartre at the Cimetière du Montparnasse in Paris.

GUY DE MAUPASSANT (1850 – 1893)

"The past attracts me, the present frightens me, because the future is death."

He was a popular 19th century French writer, considered one of the greatest short story writers. Born in a chateau in Dieppe on August 5th, 1850, he studied law in Paris initially, before signing up for the army, aged 20.

Many of his stories are set during the 1870s Franco-Prussian War and explore the futility of war.

A protegé of Flaubert, he published what is considered his masterpiece, *Boule de Suif* (1880) which was an instant hit.

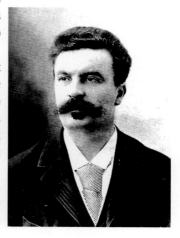

In 1881, he published his first volume of short stories *La Maison Tellier* which was reprinted twelve times in two years. In 1883, his first novel, *Une Vie* was published followed by *Bel-Ami*, (1885); both were great successes.

He wrote over 300 short stories and six novels including: *Le Horla* (1887) and *Pierre et Jean* (1888). He

travelled widely to England, Italy, Algeria, with each trip inspiring a new story. He liked to cruise the Mediterranean on his yacht *Bel-Ami*, and lived in both Antibes and Cannes.

He suffered from syphilis which led to a slow mental decline, an obsession with self-preservation and a terrible fear of death.

On January 2nd, 1892, Maupassant tried to commit suicide by cutting his throat. He was committed to an asylum in Paris, where he died over a year later, on July 6th, 1893.

NICOLAS DE STAEL (1914 – 1955)

"I am not a photographer, writer or painter. I am an impaler of things that life offers to me as it passes by."

A Russian-born painter whose work was influential in the post-war period. Born on January 5th, 1914, in Saint Petersburg into the nobility, he was the son of Lieutenant General Baron Vladimir Stael von Holstein.

Due to the Bolshevik revolution, the family fled to Poland in 1919 where his parents died, and in 1922, de Stael and his sister Marina, were fostered by a Russian family in Brussels.

He studied at the Académie Royale des Beaux-Arts (1932–4) then travelled to Paris, Spain, Italy, Morocco and Algeria, returning to France from 1938 where he studied briefly under Lèger.

He joined the Foreign Legion in 1939 and met his partner Jeanine in Morocco. In 1940, in Nice, he met Jean Arp, Sonia and Robert Delauney and began to experiment with abstract painting – his 'Compositions'. In 1943, he met Braque in Paris but De Stael and his wife were poor, hungry and cold; Jeanine fell ill and died.

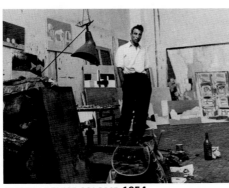

In 1944, during the German Occupation, the Jean Bucher Gallery gave him his first exhibition which helped his reputation.

In 1953, he bought a chateau in Menerbes and the next year he moved into a studio in Antibes

PHOTO: DENISE COLOMB 1954

with a sea view and produced over 300 paintings moving away from pure abstracts to still lifes, landscapes and figures, creating blocks of intense colour in a fluid style, using a palette knife.

Trying to finish a large work called 'The Concert', he became mentally exhausted and committed suicide on March 16th, 1955.

EDWARD VIII, THE DUKE OF WINDSOR (1894 – 1972)

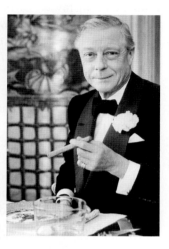

Edward VIII created a scandal by abdicating as king of the United Kingdom and Emperor of India to marry American divorcée, Wallis Simpson.

Born on June 23rd, 1894 in Richmond, Surrey, the eldest child of the Duke of York, he was called David by his family. He attended naval colleges at Osborne and Dartmouth and studied at Magdalen College, Oxford but was a poor student. In 1910, when his father became King George V, Edward became the Prince of Wales.

In World War I, he joined the Grenadier Guards but saw no active service. He trained as a pilot against his father's wishes and then he was sent off on foreign tours, on behalf of the king. His visits to slum areas in Britain in the 1930s, increased his popularity.

Attracted to married women, he had a number of affairs before falling under the spell of American socialite, Wallis Simpson. Although the foreign press reported their affair, the British press were forced to keep silent on the subject.

When King George V died in 1936, Edward became king but he was often late for meetings and failed to deal with his paperwork and keep up with his administrative duties.

Edward found security in Wallis Simpson's ability to deal with his foibles; they shared the same sense of humour, loved to gossip, play cards and were fond of dogs, shopping and kitsch. Wallis enjoyed entertaining and tried hard to lift Edward's sulks and depression. The two became inseperable. Despite the advice of

ministers, bishops and courtiers who believed that as head of the Church of England, Edward should not marry a divorced woman, Edward felt unable to give her up .

Wallis Simpson went to stay at Villa Lou Viei in Cannes owned by her friends Kitty and Herman Rogers where she waited for news of the abdication. On December 10th, 1936, Edward agreed to abdicate in favour of his younger brother Albert who became King George VI. The following day he made a poignant broadcast to the nation and the empire, explaining his inability to *"discharge the duties of king as I would wish to do without the help and support of the woman I love."*

On June 3rd, 1937, the couple were finally married in Paris, taking the titles of Duke and Duchess of Windsor. Wallis Simpson was not permitted to use the appellation, Her Royal Highness, which Edward felt was a terrible slight to his wife.

The Duke rented the Château de la Croë in Cap d'Antibes for ten years (now owned by Roman Abramovich) where the couple socialised before the war. Wallis was seen as a trendsetter in the world of fashion. Edward too had impeccable style. Diana Vreeland commented: *"The Duke of Windsor had style in every buckle on his kilt, every check of his country suits."*

Following a visit to Germany in 1937, where they had an ill-advised meeting with Adolf Hitler, they were accused of being nazi sympathisers. It was said that the Duchess passed sensitive information to the nazis during the war and that Hitler had plans

to install them as the puppet King and Queen of Great Britain, if Germany won the war.

Churchill was concerned about this and helped them to leave Europe in 1940 by offering Edward the job of Governor of the Bahamas. While his wife became involved in the Red Cross and charity work, Edward became embroiled in a nasty murder investigation on the island. They left as soon as the war was over, returning to Paris, where a number of European ex-royals resided due to favourable tax conditions.

After the war, they wrote their autobiographies. Edward had *A King's Story* published in 1951 while Wallis's book *The Heart has its Reasons*, appeared in 1956. Both were bestsellers.

Due to prolonged bad feeling with his relatives, Edward made only a few short visits to England to attend the funerals of family members.

PAUL GALLICO (1897 – 1976)

An American author and journalist who was born in New York to an Austrian mother and an Italian father. He went to Columbia University in 1916 but his service in the navy during World War I delayed completion of his science degree until 1921.

As a sports writer, he interviewed, sparred with and was knocked out by boxing champion Jack Dempsey. This led to his own newspaper column. He also founded an amateur boxing competition, The Golden Gloves. Apart from his sports articles he also wrote fiction and his book, *Lou Gehrig: Pride of the Yankees* (1942) was made into a movie. He wrote over forty novels and twelve film scripts.

During World War II, he worked for three years as a war correspondent but after the war, he became famous due to the success of his novel, *The Snow Goose,* (1941*),* the tale of a recluse who takes part in the Dunkirk evacuation. The novel was made into a movie as was his novel, *The Poseidon Adventure* (1969).

PHOTO: CARL VAN VECHTEN 1937

Both *The Zoo Gang* (1971) and *The Adventures of Hiram Holliday* (1939) were adapted for TV.

Married four times with numerous children, he lived with his wife Virginia in Monaco briefly before moving to Antibes where he spent his remaining years. He died there in 1976, aged 78.

FRANK JAY GOULD (1877 – 1956)

An American businessman and philanthropist, who financed the building of casinos and hotels on the French Riviera.

Born on December 4th, 1877, the son of financier and railroad developer Jay Gould, he inherited a large fortune.

At 23, he married Helen Kelly, with whom he had twin daughters. In 1908, they divorced and he founded the Virginia Rail and Power Company then married Edith Kelly but this marriage was not to last either, due to his problem with alcohol.

He was said to be fond of his pets – St Bernard dogs. He met

and married the San Franciscan opera singer, Florence LaCaze in 1923. They moved into the Villa Semiramis in Cannes where they collected art by Impressionist painters.

Gould enjoyed dancing and Florence enjoyed gambling and drinking champagne. She introduced water-skiing to the Riviera as well as the fashion for baccarat pyjamas, with wide pockets for her gambling chips. For over thirty years they entertained guests such as Charlie Chaplin, Elizabeth Taylor, Nelson Rockefeller, Paul Getty and Orson Welles. But they preferred to stay at Villa La Vigie in Juan-les-Pins.

Gould built the Art Deco Casino in Nice, the Palais de la Mediterranée, at a cost of $5 million. In 1926, he rebuilt the casino in Juan-les-Pins and added a cabaret. He then renovated the large Hotel Provençal which became

PHOTO: BAINS NEWS

a fashionable place to stay on the Riviera in the 20s and 30s. He also restored La Pinède where the jazz festival now takes place.

After World War II, Gould built a new house next to La Vigie and let the old one out. One of the tenants was Picasso who painted frescoes on the walls, but when he left, Gould had them painted over.

He died in 1956 in Juan-les-Pins and Florence remained in Cannes where she continued to entertain and set up a number of arts and literary prizes.

GRAHAM GREENE (1904 – 1991)

He was an English novelist and playwright who began his career in journalism.

Born October 2nd, 1904, he grew up in a school where his father was headmaster, before going to Oxford. He was related to the wealthy family who owned the Greene King Brewery.

He converted to Catholicism in 1926, despite his lack of faith, to marry Vivien Dayrell-Browning with whom he had two children. He became a heavy drinker and a serial adulterer and was said to suffer from bi-polar disorder. The couple separated in 1948 but never divorced. That year he won the James Tait Black Memorial prize for *The Heart of the Matter.*

His prodigious novel and short story output was combined with a job as a spy for MI6 where his superior was Kim Philby. He also wrote screenplays including: *The Third Man, The Fallen Idol.* Many of his novels were made into films too: *The Fugitive* (from *The Power and The Glory), Brighton Rock, The Quiet American, The Honorary Consul, Our Man in Havana, The Orient Express (from The Stamboul Train)* and *The End of the Affair.*

As a result of a financial scam, he had a problem with paying tax to the Inland Revenue but they were unwilling to prosecute him (due to secret payments from MI6), so in 1965 he moved to

Antibes, to be with his mistress Yvonne Cloetta, staying at the Residence des Fleurs. *Chagrin in Three Parts* and *May We Borrow Your Husband* are both set in Antibes.

In 1982, he published *J'Accuse – the Dark Side of Nice,* accusing the mayor Jacques Medecin and the police of corruption. He lost a libel case over the affair (the mayor was subsequently convicted of corruption in 1994). Despite numerous threats, Greene continued to live and write in Antibes for several years.

He was awarded the French Companion of Honour (1966) and the Order of Merit (1986). In 1990, he went to Vevey for treatment for leukemia, and died in hospital in Switzerland in 1991.

VICTOR HUGO (1802 – 1885)

A French writer of poetry, novels and plays, artist, statesman and a leading figure in the Romantic Movement in France.

Born in Besancon in 1802, the son of an army officer, who became a general, Hugo's family often moved due to his father's military postings. When his mother tired of this, the couple separated and she moved to Paris with her children.

From 1815, Hugo attended the Lycée Louis-le-Grand where he began writing poetry and winning awards.

He waited until his mother died before marrying Adèle Foucher in 1822, with whom he had five children.

In 1830, his play *Hernani* caused controversy but it was his novel *Notre Dame de Paris (The Hunchback of Notre Dame)*

which led to overnight success.

He met the actress Juliette Drouet while staging one of his plays and they developed a relationship that lasted over fifty years.

In 1841, he was finally elected to the Academie Française, and became more involved with social and political issues. Two years later, he was devastated to learn that his beloved daughter Léopoldine and her husband had been drowned in a boating accident at Villequier in Normandy.

Initially, he had supported Louis Bonaparte but he became disillusioned, remarking, *"We've had Napoleon the Great, now we have Napoleon the Small"*. After the coup d'état by Napoleon III in 1851, he fled to Brussels, then went into exile, finally settling in Guernsey and buying Hauteville House.

In 1870, he returned to Paris and was elected to the National Assembly. He was a frequent visitor for short holidays, both before and after his exile, to Antibes and the Arrières-Pays.

Regarded as one of the greatest French poets, *Les Contemplations* and *La Légende des Siècles* are still widely admired today. His best-known works are the novels *Les Misérables* and *Notre-Dame de Paris (The Hunchback of Notre Dame)* which have both been adapted for stage and film many times.

He died in Paris in 1885. His death led to a period of national mourning and despite his wish to have a small funeral ceremony, he was buried in the Pantheon.

NIKOS KAZANTZAKIS (1883 – 1957)

He was born in Heraklion in Crete (where the airport is named after him) and was a Greek writer and philosopher who only became well-known abroad when his novel *Zorba the Greek* was made into a film in 1964, after his death.

Born in 1883, he studied Law in Athens (1902) then philosophy in Paris (1907). He fought as a volunteer in the Greek Army during the Balkan Wars then travelled widely, publishing travelogues.

He tried to integrate the teachings of Buddhism, Christianity and Marxism in his philosophy, expounded in *Askitiki* (1927). In 1938, he published an epic poem *Odyssey: A modern sequel*, taking up Ulysses' story from the end of Homer's epic.

Other novels include: *The Last Temptation of Christ* (1955), later filmed by Martin Scorsese in 1988; *The Greek Passion* and *Freedom or Death*.

He served as a left-wing Minister in the Greek Government

in 1945 and also worked for UNESCO in Paris until 1948, when he bought a villa in Antibes and moved there.

He narrowly missed out on The Nobel Prize for Literature, losing by one vote to Albert Camus in 1957.

Suffering from leukemia, he fell ill on his return flight from China and Japan and was taken to Freiburg, Germany, where he died on October 26th, 1957. He is buried near the Chania Gate in Heraklion because the Orthodox Church prevented his burial in a cemetery. The epitaph on his tomb reads: *"I hope for nothing. I fear nothing. I am free"*.

There is now a Nikos Kazantzakis Museum in Crete.

GERALD MURPHY (1888 – 1964)

He was an American socialite who became the centre of a fashionable artistic and literary circle on the French Riviera.

Born in Boston into a wealthy Irish-American family which made luxury leather goods, as a young man he was more interested in the arts than his studies or business. In 1913, he met Cole Porter at Yale, which was the beginning of a lifetime friendship. Sara Wiborg was a friend from an early age in East Hampton, where

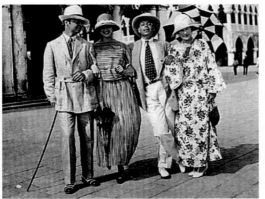

the wealthy Wiborg family had a large house and even a beach named after them. The pair married in 1915, despite the disapproval of both their families, and moved to New York where they had three children.

GERALD AND SARA MURPHY, COLE PORTER, GINNY PFEIFFER

In 1921, they sailed to Paris where artist friends inspired Gerald to take up painting. He began by painting scenery at the Ballets Russes, then his work took on a cubist style, influenced by French artists he met there, and prefiguring American pop art.

"The Murphys were among the first Americans I ever met and they gave me the most agreeable impression of the United States." Ivor Stravinsky said of them.

In 1923, the Murphys visited their friend Cole Porter in the South of France and persuaded the Hotel du Cap-Eden-Roc to stay open in the summer. They became the centre of a group of artists and writers who collected together there including Picasso, Cocteau, Hemingway, Fitzgerald, Cole Porter and Dorothy Parker. Picasso painted Sara several times.

They bought a house nearby which they named "Villa America" creating an atmosphere of *joie de vivre,* sunbathing and picnicking on the beach at La Garoupe. They were said to be the inspiration for Nicole and Dick Driver in Fitzgerald's *Tender is the Night* as well as for the couple in Hemingway's *The Garden of Eden.*

In 1929, their son Patrick was diagnosed with TB and Gerald took him to a Swiss clinic. He set aside his painting forever.

With the financial collapse on Wall Street, the family business selling luxury leather goods fell into crisis so in 1934 Gerald Murphy returned to the US. His son Baoth died suddenly from meningitis and then a year later his other son Patrick succumbed to TB, aged only 16.

In 1937, they returned to Sara's family home, a huge mansion

called *The Dunes* in East Hampton but it was too expensive to run and so they had it demolished. Gerald wrote to Fitzgerald, *"Only the invented part of our life – the unreal part – has had any scheme or beauty."*

He later refused to talk about his painting or the death of his sons. The couple drifted apart, with rumours of Gerald's bisexuality. He died on October 17th, 1964, in East Hampton.

Sara died in 1975 in Arlington, Virginia.

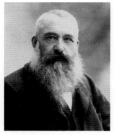

CLAUDE MONET (1840 – 1926)

A French painter who was a leader of the Impressionist movement. He was born Oscar-Claude Monet, on November 14th, 1840, in Paris. His father was a grocer and his mother was a singer. The family moved to Le Havre, in Normandy when he was 5 and Monet earned money by selling charcoal sketches.

At 16 he went to live with his aunt, when his mother died. At 21, he joined the army but contracted typhoid fever and his aunt paid for him to leave the service. He then went to art school and met Renoir, Sisley and Bazille who were also experimenting with colour and technique. In 1865, his first paintings were accepted by the Paris Salon for exhibition.

In 1870, he married his model Camille Doncieux, three years after the birth of their son, Jean. As the Franco-Prussian War unfolded, they moved to London, where Monet found an art dealer. In 1874, Monet's picture titled 'Impression, Sunrise' (1873), of Le Havre in the fog, caused a stir and led to the adoption of the name 'Impressionism' for work that sought to capture the essence of a scene and broke with classical tradition.

Camille died in 1978, after the birth of their second son Michel. From 1883 Monet lived in Giverny with Alice Hoschede, the wife of a friend, and their combined families. He bought a house and created a garden with lily ponds which he painted obsessively from 1889 onwards, creating his most well-known works.

In 1888, he spent the winter in Antibes, where he painted many landscapes, including the bay and the Chateau Grimaldi.

He died on December 5th, 1926, at his home in Giverny.

WALLIS SIMPSON (1896 – 1986)

"You have no idea how hard it is to live out a great romance."
Born Wallis Warfield on June 19th, 1896 in Maryland, Pennsylvania, she married Prince Edward, Duke of Windsor, formerly King Edward VIII of the United Kingdom.

Her father, a flour merchant, died when she was a child. Her mother had to seek financial aid from uncle Solomon Warfield, founder of the Continental Trust Company, and from aunt Bessie Merryman.

Wallis's first marriage to navy pilot Win Spencer ended in divorce due to his abuse and drinking problems. She then travelled to China for a year by herself. In 1934, married to Ernest Simpson, she moved to London and was introduced to Edward, Prince of Wales at a country house party. She became his mistress, going on frequent holidays with the Prince. By the time Edward became king, they were inseparable. The Prime Minister, Stanley Baldwin, was opposed to their marriage so Edward abdicated in 1936, saying that he was unable to live without her.

They finally married after the coronation of Edward's younger brother Albert, spending their honeymoon in Italy and Austria.

In 1937, they went to Germany and met Hitler, raising concerns of nazi affiliation. When World War II began, they helped in the war effort but when Paris was invaded they retreated to Antibes.

"Since I can't be pretty, I try to look sophisticated," Wallis told Vogue in 1943 but once Italy came into the war on the side of the Germans, the couple fled to Spain and then Portugal where they were asked to spy for Germany. There were reports of Wallis passing secrets to her friend Joachim von Ribbentrop (later hanged for war crimes).

Churchill arranged for them to go to the Bahamas in 1940, where Edward became governor until the war ended.

In the 1950s and 1960s, the couple were based in Paris, but travelled a good deal, living a kind of early retirement.

After the Duke's death in 1972, Wallis started suffering from dementia and she withdrew from public life.

She died on April 24th, 1986, aged 89, at her home in Paris. She was buried next to Edward in the royal burial ground at Frogmore. She left her estate to the Pasteur Institute. The sale of her jewels alone fetched $45 million.

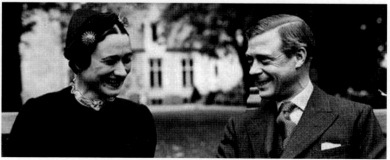

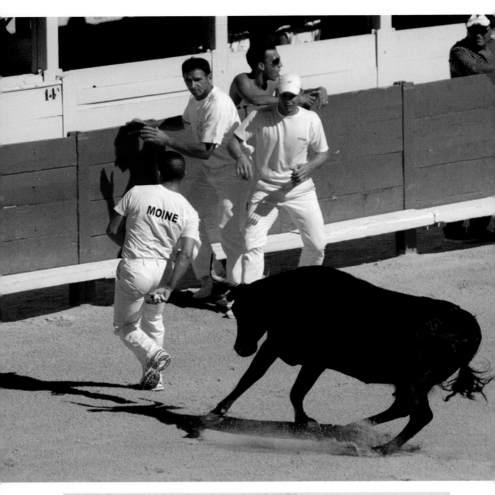

ARLES (BOUCHES-DU-RHONE)

Important since Roman times (and only second to Rome for the extent of its well-preserved Roman sites), Arles was given UNESCO World Heritage status in 1981 for its Roman amphitheatre (the arena opposite), the ancient theatre, the Cryptoporticus, Constantine's Roman Baths, the remains of the Roman circus, St Trophime Monastery, St Trophime gate and the Alyscamps, which marks the point of departure of the Via Tolosana, a Catholic pilgrimage route leading to Santiago de Compostela in Spain.

PLACES

The Museum of Ancient Arles from the Neolithic era to late antiquity.

The Réattu Museum, modern artists and photography.
The Arlaten Museum, exhibits objects, costumes, furniture of 19th century Provençal life.
The Langlois Bridge painted by Van Gogh.

VISIT

Les Baux de Provence (above), ancient village, castle and former quarry with multi-media shows
(see **www.carrieres-lumieres.com/fr**)
The Camargue – salt marshes, wildlife reserve in the river delta, pink flamingoes, bird watching, horse riding.
The Saint-Paul Asylum, where Van Gogh stayed at Saint-Remy.

FESTIVALS

Salon International des Santonniers, November - January.
Rencontres D'Arles, International Photography, July.
Les Suds a Arles, Music, concerts, July.
Feria Corridas, Easter to September, bull-fighting in the arena.
Saintes-Maries-de-la Mer Gypsy Festival, May.

www.arlestourisme.com

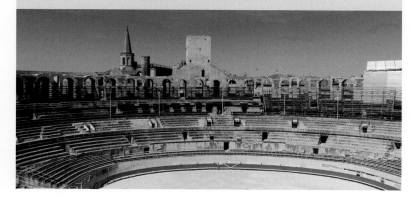

PEOPLE
PAUL GAUGIN (1848 – 1903)
"Art is either plagiarism or revolution."

A leading French post-Impressionist artist who inspired the movement for Primitivism in art, influencing Pablo Picasso and Henri Matisse. Born in Paris on June 7th, 1848, to journalist Clovis Gauguin and Alina Maria Chazal, the family moved to Peru a few years later but his father died on the journey.

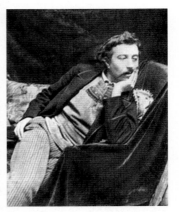

In 1855, his family returned to Orléans and a few years later he was sent away to a Catholic boarding school, which he disliked. He joined the merchant navy aged 17 then at 20, the French Navy, travelling widely for two years. In 1871, Gauguin returned to Paris where he became a successful stockbroker for a decade.

In 1873, he married a Danish woman, Mette-Sophie Gad, and began to paint in his spare time. He met Pissarro and Cezanne, and eventually exhibited his work with the Impressionists in 1881.

He fathered five children and the family moved briefly to Copenhagen, Denmark in 1884, but with language and money problems, the marriage foundered and Gauguin returned to Paris in 1885, alone.

Now free to paint full time he was influenced by the Cloisonnist style as well as African and Asian art and began to paint with bold colours, using symbolism. He visited Panama and Martinique in 1887, then in 1888 he spent nine weeks in Arles staying with Vincent van Gogh during which time van Gogh was hospitalised.

In 1891, Gauguin sailed to French Polynesia and settled in Tahiti where he had relationships with a number of young teenage girls, fathering more children. He moved to Punaauia in 1897, where he created one of his finest paintings: *Where Do We Come From,* then moved to the Marquesas Islands, where he sided with the natives against the French government in a dispute. This led to

a fine of five hundred francs and a short prison sentence.

Suffering from syphilis and lacking the funds to pay the fine, he took an overdose of morphine. He died on May 8th, 1903, aged 54. He was buried in the Cimetière Calvaire in Atuona, Marquesas Islands, where there is now a Cultural Centre dedicated to his work. His life has since inspired music, opera, films and novels.

VINCENT VAN GOGH (1853 – 1890)

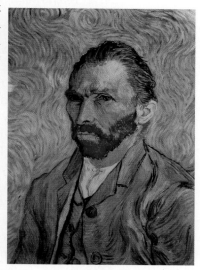

A Dutch post-Impressionist painter whose work had a significant influence on 20th century art. He was born in the south of Holland on March 30th, 1853 into a religious family. His father was a church minister.

He began drawing as a child, and aged 11 was sent to boarding school, but missed his family. His first job, aged 20, was as an art dealer and he travelled to London where he fell in love with Eugenie Loyer, the daughter of his landlady. When she rejected him, he turned to religion, and the study of theology in Amsterdam in 1877, where he failed the exam. He worked as a missionary in a mining town in Belgium and decided to become an artist.

He then returned home to Etten and proposed marriage to a cousin but she rejected him too so he left for The Hague. There he began painting with oils and set up home with a prostitute and her child, contracting gonorrhea. He left her in 1883, and almost married his cousin Margot Begemann in 1884, but was prevented by both his family and hers. She took an overdose of strychnine but Van Gogh managed to get her to hospital before she died.

He studied fine arts in 1886 in Antwerp then moved to Paris to live with his brother Theo, also an art dealer. Influenced by the Impressionists, he began to use vivid colours. He met Toulouse

Lautrec and Paul Gauguin and they organised an exhibition of their work in a restaurant in Montmartre.

Exhausted from smoking, drinking absinthe, eating little and painting over 200 works, Van Gogh moved to Arles in February 1888, with dreams of starting an artists' colony. Inspired by the light and the local landscape, he experimented with brighter colours. He painted many works in Arles, such as *Van Gogh's Chair, Bedroom in Arles, Starry Night Over the Rhone, Still Life: Vase with Twelve Sunflowers.* Eventually, he persuaded Paul Gauguin to join him there.

Gauguin arrived in October 1888, and the two worked together for two months with Gauguin painting Van Gogh's portrait. But they argued continually and the stress was unbearable for Van Gogh, who feared that Gauguin would soon desert him. With Christmas approaching, they had a terrible quarrel and Van Gogh ran off, taking refuge in a nearby brothel. There, he cut off part of his left ear, handing it to one of the prostitutes.

Gauguin left and contacted Theo who arranged for his brother to be hospitalised. The artist Paul Signac visited Van Gogh in hospital and Van Gogh was allowed home in his company but only a few months later in May 1889 he entered the Saint-Paul asylum in Saint-Rémy-de-Provence voluntarily.

Located in a monastery, surrounded by vineyards, cornfields and olive groves, Van Gogh responded to the routine, painting in the garden and the grounds in the swirling style which became his unique trademark. While there, he painted 'The Irises' which was

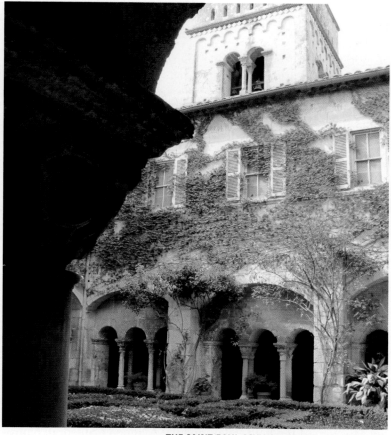

THE SAINT-PAUL ASYLUM, ABOVE AND OPPOSITE

exhibited with 'Starry Night over the Rhone' at the Paris Salon in September 1889, and in January, 1890 several of his paintings were exhibited in Brussels. By May, Van Gogh felt well enough to leave: *"I feel quite calm and I don't think that a mental upset could easily happen to me in my present state."*

He moved north to Auvers-sur-Oise outside Paris to be near to Dr. Paul Gachet, who treated many artists and was recommended by Camille Pissarro. But Van Gogh's depression became more severe. In some reports he shot himself, in others he was shot by local youths. He survived, despite his wounds, for two days and Theo arrived in time to be with him in his final hours.

He died on July 29th, 1890 and was buried in the local cemetery.

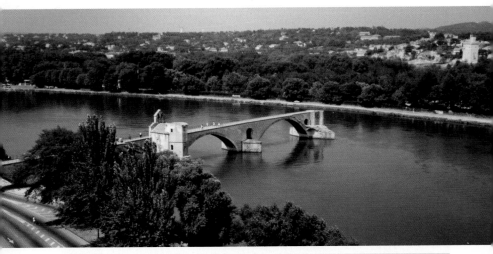

AVIGNON (VAUCLUSE)

In 1033, Avignon became part of the Holy Roman Empire and set itself up as a republic ruled by local Counts. Avignon was sold to the popes by the Queen of Sicily (Countess of Provence) for 80,000 florins in 1348. At this time the Black Death was prevalent, with over half the population of the city dying from the epidemic. Avignon became the capital of Christendom from 1309 until 1377 and belonged to the papacy until the French Revolution.

Avignon is listed by UNESCO World Heritage for its historical sites at the Palais des Papes and its square, the Pont d'Avignon, the Museum of the Petit Palais and the Avignon Cathedral, Notre-Dame des Doms, as well as the stretch of ramparts that run from the Garden of Les Doms to the bridge.

PLACES

Palais des Papes, biggest gothic palace in the world with twenty rooms accessible to the public including the Papal apartments. Cultural events are held throughout the year.

The Pont Saint Bénézet (above), built in the 12th century, it was ruined by floods and fell into disuse in the 17th century. Famous for its children's song. 'Sur le pont d'Avignon...'

Le Jardin des Doms, a park high above the city with great views, accessible via the ramparts from the Pont d'Avignon.

Museum of the Petit Palais, over 300 Italian paintings from the Campana Collection, acquired by Napoléon III. Also sculpture displays from the 12th to the 15th century.

The City Ramparts, built 14th century, over four km in length.

Fort St André, built 14th century across the river from the palace to house a garrison of soldiers; offers a view of Mont Ventoux.

Calvet Museum, houses paintings and library with 140,000 books.

Cathedral of Notre-Dame des Doms dates from 1037, houses the tomb of Pope John XXII and church treasures.

Saint-André Abbey, Benedictine abbey with views and gardens.

Visit

Mont Ventoux, the climb to its summit has been the scene of many battles in the Tour de France cycle race.

Festivals

Festival d'Avignon, the 'In' Festival, a huge multi-arts celebration of around forty shows, and the 'Off' Festival, a diverse fringe theatre festival with shows in every kind of venue imaginable.

www.festival-avignon.com

PEOPLE
JEAN ALESI (1964 –)

A French motor racing driver who won the 1995 Canadian Grand Prix on his 31st birthday. Born in Avignon to Sicilian parents, he began as a rally driver and came to prominence in 1985, driving his own Dallara-Alfa Romeo. He won the French F3 Championship in 1989 for Jordan.

He then joined the Tyrell team and when Michele Alboreto left shortly before the French Grand Prix, Alesi was given a chance. On his debut at the Paul Ricard track he finished fourth.

He took second place in Phoenix in 1990 to Senna (whom he overtook at one stage after losing the lead) and came second in the Monaco Grand Prix in 1991.

Intent on joining Williams' British team, he suddenly switched to Ferrari and partnered with Alain Prost. But he failed to gain the necessary points, perhaps due to technical problems with the cars, while Williams' team went on to victory throughout the 90s.

In 1994, he suffered a back injury in Brazil and Ferrari took the chance to replace him with Michael Schumacher who went on to success. Alesi spent two seasons with Benetton, where he was accused of dangerous driving in the Austrian Grand Prix. A brief spell with Sauber followed. In 2000 he signed a two year deal to race for his former partner, Alain Prost.

Then in 2001, Alesi swapped with Heinz-Harald Frentzen to drive for Jordan. He retired from F1 and moved to Mercedes-Benz driving in the German Touring Car Championship (DTM). In 2002, he did a test run for a new McLaren-Mercedes F1 car and notched up a number of victories racing in the DTM. He retired

in 2006, finishing in ninth place.

He is married to Japanese pop star Kumiko Goto and they have four children.

They own a vineyard near Avignon where they produce their own wine.

PIERRE BOULLE (1912 – 1994)

A French author, engineer and secret agent famous for his novels *The Bridge Over the River Kwai* and *Planet of the Apes.*

Born in Avignon on February 12th, 1912, he studied electrical engineering in Paris, then worked for two years before leaving France, aged 26, for a job in Malaysia, overseeing a rubber plantation near Kuala Lumpur.

During World War II, he signed up to the French army in Indochina but when France came under nazi rule, he switched sides, joining the Free French in Singapore where he passed himself off as an Englishman named Peter John Rule, and secretly helped organise resistance to the Japanese in China, Burma and Indochina.

In 1943, he tried to escape by floating down the Mekong River on a raft but was captured by the Vichy French and sentenced to hard labour in the death camps of Saigon. He kept a diary on scraps of paper.

When the war was almost over, Boulle did escape and returned to his plantation in Malaysia before going on to France. He drew on his experience to write books, notably *The Bridge Over the River Kwai* (1954), which was made into a film in 1957, directed by David Lean, starring Sir Alec Guinness. It won numerous Oscars including one for Best Adapted Screenplay which went to Boulle, despite the fact he hadn't written the screenplay.

His novel *Planet of the Apes* (1963), a science fiction story about apes rising to ascendancy over man was made into an Oscar-winning movie in 1968 starring Charlton Heston. Numerous films and TV series have since been produced from the idea.

His other works include: *Face of a Hero* (1956), *The Test* (1957), *A Noble Profession* (1960), *Ears of the Jungle* (1972) and *Just You and Me, Satan* (1992).

Boulle lived with his sister in Paris and was awarded the Croix de Guerre and the Medale de la Resistance as well as being made an officer of the French Legion of Honour. He died on January 30th, 1994, aged 81.

MIREILLE MATHIEU (1946 –)

A French singer who rose to fame during the 60s with her crooning renditions of songs by Edith Piaf.

She was born on July 22nd, 1946 into a poor family in Avignon. Her father was a stone mason who sang in church. She sang in public for the first time, aged 4, at midnight mass. She suffered at school due to her dyslexia and went to work in a factory at the age of 14 where she saved some of her wages for singing lessons, giving the rest to her mother to help feed her large family.

In the early 60s, she won a local talent contest and the mayor of Avignon paid to send her to participate in a TV talent contest in Paris. She was signed by Johnny Stark who also managed pop star Johnny Hallyday and singer/actor Yves Montand.

Stark suggested the famous urchin bob haircut and developed her career. Her performances at the Paris Olympia in 1965 led to a recording contract with Barclay Records. Popular singles included: *Mon Credo, C'est Ton Nom*, and *Qu'elle Est Belle,* promoting Mathieu's reputation at home and abroad.

But it was her cover of Englebert Humperdinck's *The Last Waltz* that proved an instant hit in the British charts, raising her profile internationally.

Mathieu has recorded 1200 songs in 9 languages and 39 albums over a four decade career. She has sold 122 million copies of her albums and sung duets with some of the world's most famous singers, including Elvis Presley, Tom Jones, Charles Aznavour.

She was voted France's favourite singer in 1967 and is particularly popular in Russia, Germany and Japan. A devout Catholic, in 1997, she sang in the Christmas concert from the Vatican. In 2011, she was made an officer of the French Legion of Honour in France.

She lives in Neuilly-sur-Seine, near Paris, and travelled with her sister and her mother on tour. She visits her family regularly who are still living near Avignon in a large house which she was able to purchase for them.

AVIGNON PAPACY (1305 – 1377)

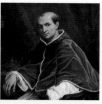

POPE CLEMENT V

When the papal conclave finally elected Clement V as Pope in 1305, he chose to stay in his native country, France, moving his entire court to Avignon. Six French Popes followed as the French court became gradually more and more influential, with key jobs given to royal supporters and a grand lifestyle common to one and all.

Following on from Clement V (1305–1314) came Pope John XXII (1316–1334), then Pope Benedict XII (1334–1342), then Pope Clement VI (1342–1352), then Pope Innocent VI (1352–1362), then Pope Urban V (1362–1370) and finally Pope Gregory XI (1370–1378) who abandoned Avignon, and returned the court to Rome. A group which disputed his popehood, chose to regard the bishop of Avignon as the head of the church.

A period of great division followed from 1378 to 1414, known as the 'Great Schism' and during this time two 'Anti-Popes' returned to Avignon to reside there. From 1414-1418, the Council of Constance discussed the Three-Popes Controversy and finally ruled to either depose or accept the resignation of the remaining Papal claimants and elect Pope Martin V.

PETRARCH (1304 – 1374)

Francesco Petrarco (Petrarch) was an Italian poet, scholar, diplomat and an early exponent of humanism.

He was born in Arezzo on July 20th, 1304 while his family were in exile from Florence. His father Pietro di Parenzo di Garzo was a lawyer and expected his son to follow him into the profession.

When Petrarch was 7, the family moved to Pisa to be near the new Emperor and then in 1312 to Avignon following the new Pope, Clement V, and settling in nearby Carpentras.

He was forced to study law in Montpellier and Bologna with his brother Gherardo, but he disliked the profession intensely and when his father died in 1326 he switched to study the arts and

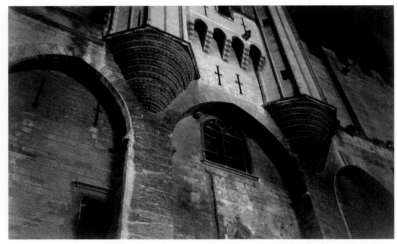

PALAIS DES PAPES AT NIGHT

classical literature. Without any means of financial support, both he and his brother, Gherardo, entered the service of the church.

While attending an Easter Mass on Good Friday, April 6th, 1327, Petrarch laid eyes on Laura de Noves, a married woman, with whom he fell madly in love. He wrote her hundreds of sonnets expressing his devotion which he collected into *Il Canzoniere (The Song Book)*. She died in 1348, having had eleven children with her husband. The sonnets were considered sublime, imitated throughout Europe and inspired many other writers, such as Shakespeare, to compose lyric poetry.

Having finished his Minor Church Orders, Petrarch entered the service of Cardinal Colonna in 1330 and in the ensuing years, undertook numerous diplomatic missions for the church.

In 1333 Petrarch crossed France and the Netherlands and visited Germany on church business.

Petrarch decided to climb to the summit of Mont Ventoux near Avignon on April 26th, 1336, with his brother and two servants. After admiring the view, he took out his copy of Saint Augustine's confessional writings and it fell open on the following words:

"And men go about in awe of the heights of the mountains, and the mighty waves of the sea, and the wide sweep of rivers, and the rolling of the ocean, and the revolution of the stars, but themselves they consider not."

This encouraged Petrarch to begin to reflect on the inner world of the soul and to think about the human condition.

The following year, he travelled to Flanders and Rome for the first time. In 1340, he was invited to become Poet Laureate by both Rome and Paris at the same time. He chose Rome and on Easter Sunday, 1341, he was crowned Poet Laureate.

In 1338, Petrarch fathered an illegitimate son, Giovanni, and in 1343 his daughter, Francesca, followed.

In 1345, while living in Verona, Petrarch discovered an ancient collection of letters by Cicero and he decided to copy Cicero and started a collection of his own letters, written to friends, popes, royalty and the ghosts of Cicero and Homer.

He moved to Venice in 1362 to avoid the plague but lost most of his family to it, including many friends.

On the morning of July 19th, 1374, a day before his 70th birthday, his daughter found him slumped over his desk. He had died the previous night while writing, pen in hand. He was buried in the local church but his remains were later transferred to a tomb in Arquà near Padua.

There is a museum which honours his work located in Fontaine-de-Vaucluse close to his former home in Provence.

MONT VENTOUX FROM AVIGNON PHOTO: TOGNOPOP

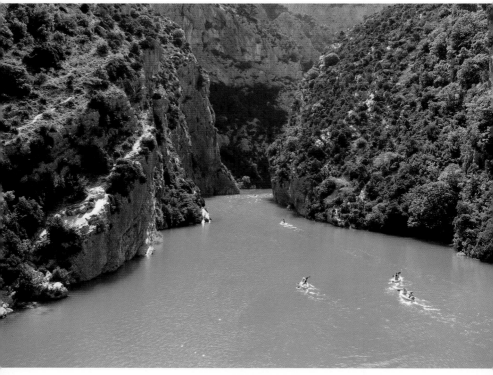

GORGES DU VERDON PHOTO: PAOLO BENEDETTI

"There is nothing more extraordinary than this combination of rocks and chasms, green waters and purple shadows, this sky redolent of a Homeric sea and this wind which speaks with the voices of dead gods." Jean Giono (see page 188).

BARGEMON (VAR)

'The pearl of the upper Var', Bargemon is an ancient village situated high up in the mountains at an altitude of 480m offering splendid views over the village of Claviers.

Dating back to the early 9th century, Bargemon was fortified in the Middle Ages and still retains vestiges of ancient watchtowers and city gates. On the Clock Tower Gate, the indentations for the original portcullis are still visible in the wall. The clock used to show the different phases of the moon as well as striking every hour. Its parts are now on display in the Camos Museum.

PLACES

Honoré Camos Museum, in the former Chapel of Saint-Etienne. **The Chapelle de Montaigu,** built in 1609 by the White Penitents. Its name was changed in 1635 after a statue of the Virgin, said to aid miracles, was brought from Montaigu, Belgium.

VISIT

Gorges du Verdon, one of the most beautiful river canyons in Europe. Formed by the emerald coloured Verdon River, which has eroded a deep ravine from 250 to 750 metres deep through the limestone mountains, it snakes for upto 25km before flowing into the Lake Sainte-Croix. Popular for canoeing, rock-climbing, hiking and sight-seeing.
Verdon Museum, Aups.
Grotto of Mary Magdalene, in the nearby village of Aups.
Mont Lachens 1,715 m highest point in the Var, near Mons.
Sillans-la-Cascade, a 42m waterfall and castle-gallery.
Prehistoric Museum at Quinson.
L'Occitane Factory at Greoux-les-Bains.
Grottes Troglodytes in Villecroze.

FESTIVALS

International Music Cordiale Festival, August.
Miniatures and Doll House Exhibition at the castle of nearby Sillans-la-Cascade, February.
Cheese Festival, in Banon, May.

www.ot-bargemon.fr/

PEOPLE

DAVID BECKHAM, OBE (1975 –)

An English footballer and model who recently retired from the game after a short stint with Paris Saint-Germain.

He was born on May 2nd, 1975, in Leytonstone, East London. His father fitted kitchens for a living and was an ardent Manchester United supporter. Beckham signed up for the youth team at Man U when he was 14.

PHOTO: PETR KRATOCHVIL

At 17, he played his first professional game for Manchester United which had a highly successful period while he was signed to them, winning the FA cup twice, the EUFA Champions' League in 1999 and the UK Premier League title several times.

At 21, Beckham played his first game for England and went on to captain the team four years later. Playing against France in 2008, he celebrated his hundredth cap and beat his idol Bobby Moore's record of 108 caps in 2009.

He married pop singer Victoria Adams known as 'Posh Spice' in 1999 in a lavish ceremony and the couple were then referred to as 'Posh and Becks' in the tabloids. They have four children, Brooklyn, Romeo, Cruz and Harper.

After Manchester United, Beckham played for Spain's Real Madrid, Los Angeles' Galaxy, (on loan) to Italy's Milan as well as Paris Saint-Germain.

Beckham is said to suffer from OCD. He is involved in numerous charities and is a UNICEF Goodwill Ambassador. He has modelled for a number of brands and launched his own fragrance 'Instinct'.

The couple bought the Domaine Saint Vincent near Bargemon in 2003 as a holiday home. The house is rumoured to be haunted by the ghost of its former owner.

VICTORIA BECKHAM (1974 –)

PHOTO : PETR KRATOCHVIL

Victoria Beckham is an English entrepreneur, fashion designer and former pop star.

Born on April 17th, 1974 in Hertfordshire, as Victoria Adams, she trained as a ballet dancer and went to Laine Arts Theatre College in Surrey at 17. She was hoping to become a dancer when she successfully applied to be part of a new pop group called The Spice Girls in 1993.

The group's 'girl power' message was popular and their first album *Spice* sold over 20 million copies worldwide. Their second album in 1997 was less successful; a film they made grossed £30 million at the box office. When the Spice Girls split, Victoria Beckham briefly went solo, and achieved four UK Top 10 singles; *Out of Your Mind* went to Number 2 in the charts.

Dubbed 'Posh Spice' by the British press, she has since become a style icon and is constantly in the media. She met footballer David Beckham in 1997; they had a son Brooklyn in 1998 and then married at a castle in Ireland. Since then they have had three more chidren.

She has built her own successful brand with clothing, sunglasses and perfume lines and authored a bestselling autobiography *Learning To Fly* (2001) and *That Extra Half an Inch: Hair, Heels and Everything in Between* (2006), a fashion guide.

She has appeared in numerous TV reality shows and documentaries as well as featuring at the opening ceremony of the British Olympics performing with The Spice Girls.

The Beckhams bought the 19th century Domaine Saint Vincent which is secluded within 250 acres of woodland and sited next to a military base. She is said to spend much time in Nice at Elton John's home, preferring to be closer to the action on the coast.

CANNES (ALPES-MARITIMES)

The area came under the protection of the monks at the Abbey Lerins in the 10th century and was fortified against invasion. In 1815, Napoleon disembarked there, returning from his exile in Elba. Cannes was still a small fishing village when Lord Brougham arrived in 1834 and then built a sumptuous villa which encouraged other aristocratic English and Russian 'hivernants' to stay for the winter. In the 1930s, wealthy Americans visited and established a summer season, swimming and sunbathing on the beaches. After World War II, the International Film Festival created an aura of

glamour around the town with the visit of numerous film stars each year.

La Croisette, the promenade along the beach, is lined with designer shops, cafés, and restaurants. The long sandy beach with its sunloungers for hire is packed during the summer. At night, you can visit the nightclubs and discos or you can try your luck at the casinos. There is a vibrant gay scene too.

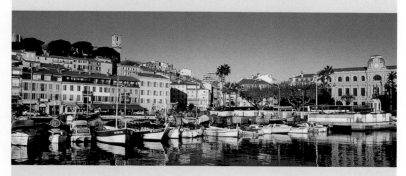

PLACES

La Croisette, promenade around the bay to Port Canto.

The Old Port, simple fishing boats and restaurants.

Ile de Lerins, take a boat ride across to the nearby islands.

Le Suquet, visit the old town, panoramic views across to the islands.

Castre Museum, art and artifacts inside former Cannes Castle.

Miramar Building, Gallery, exhibitions and film screenings.

The Palais des Festivals, convention centre for festivals and conferences.

The Villa Rothschild, now the main library.

The Villa Domergue designed by the artist Jean-Gabriel Domergue who founded the Film festival. Hosts a jazz festival in August.

Museum of the Sea, located in a fort on L'Ile Sainte-Marguerite, contains artefacts from shipwrecks and the mysterious case of the *Man in the Iron Mask* as chronicled by Alexandre Dumas.

Malmaison Museum, a 19th century mansion, art collections and beautiful gardens.

Fernand Léger Museum, in nearby Biot.

Bellini Chapel, originally built for Princess Kara-Georgevich of Serbia, later became the studio of painter Emmanuel Bellini.

FESTIVALS

International Games Festival, February.
Carnival on the Riviera an annual street parade, February.
Shopping Festival, March.
The Pan-African Film Festival, April.
The Cannes Film Festival, since 1946, May.
International Actors' Performance Festival, comedy and fringe theatre, May, June.
Le Festival d'Art Pyrotechnique, fireworks competition, July and August.
Jazz Festival, Villa Domergue, August.
Festival de la Plaisance, boat show, Old Port, September.

www.cannestouristinformation.co.uk

PEOPLE

ARNOLD BENNETT (1867 – 1931)

"Any change, even a change for the better, is always accompanied by drawbacks and discomforts."

He was an English novelist, playwright and journalist. Born in Hanley, Stoke-on-Trent in Staffordshire, the son of a lawyer, he moved to London in 1889 intending to study law. He won a writing competition and worked as a magazine editor but soon devoted himself entirely to his writing.

He was inspired by Zola's realism and his best known novels are: *The Man from the North, The Old Wives' Tale, Clayhanger, The Card* and *Anna of the Five Towns.*

In 1903, he moved to Paris where he married Marguerite Soulie, who worked in a fashion house.

His wife's family lived in the South of France and he was a regular visitor to the Riviera where he enjoyed sailing and kept a yacht named *The Amaryllis* in Cannes.

He wrote copiously and in 1911 when he visited America,

he was hailed as the greatest British writer since Dickens for his novel *The Old Wives' Tale*. He was awarded the James Tait Black Memorial Prize for his novel *Riceyman Steps* in 1923.

At the outbreak of World War I, Bennett joined the Ministry of Information and became heavily involved in writing propaganda.

He had an omelette named after him at the Savoy Hotel in London (a combination of eggs, smoked haddock and parmesan cheese) as he ordered it whenever he stayed there.

Bennett fell in love with the actress Dorothy Cheston and left his wife in 1921 to live with her. Their daughter, Virginia, was born in 1926.

It was after a visit to France in 1931, that Bennett contracted typhoid and died at his home in Baker Street, London, on March 27th. His ashes were interred in Burslem Cemetery.

PIERRE BONNARD (1867 – 1947)

He was a French painter and printmaker and co-founder of the artists' group Les Nabis.

Born October 3rd, 1867 at Fontenay-aux-Roses, near Paris, into a prosperous family, he had a secure childhood. His father was a top official in the Ministry of War who encouraged his son to study law.

In 1887, Bonnard enrolled at the Académie Julian to take art classes. There he met Paul Sérusier, Mauris Denis, Henri Ibels and Paul Ranson. Together they founded Les Nabis, meaning 'The Prophets'; they wanted their work to be spiritual and symbolic.

Bonnard studied next at the Ecole des Beaux-Arts in Paris, where he met Ker-Xavier Roussel and Edouard Vuillard who both joined Les Nabis. He won a poster design competition

for French champagne which influenced another friend, Toulouse-Lautrec, in his poster designs of Parisian café society.

Bonnard persuaded his father that he was not suited to the law and was able to rent a small studio. From 1891, he exhibited paintings at the Société des Artistes Indépendants (Salon) and later a collective show with the other Nabis artists.

In 1893, he met Marthe de Méligny who inspired many of his paintings. He painted a series of her in the nude or bathing. They did not marry until thirty-two years later.

From 1906, Bonnard began to have solo exhibitions; his style was influenced by the Impressionists and Gauguin's use of colour. He often took photos of his subject first then produced drawings before adding paint in his studio.

He moved to Cannes in the South of France in 1910, where he met Aimé Maeght (see page 186) who began to sell prints of his paintings in his shop. Later, he moved to Saint-Paul de Vence, then in 1926 he bought a house called 'Le Bosquet' near Le Cannet, where he lived until his death.

Before World War I he travelled around Europe and North Africa. During the war he made a few sketches but seemed unable to paint the reality of war unfolding around him.

In 1937, he was commissioned to decorate the French pavilion at the Exposition Universelle in Paris but he was disappointed with his creation. The Art Institute of Chicago hosted a major exhibition of his work together with that of his friend Eduoard Vuillard the following year.

During World War II, he remained in Le Cannet but when his wife died in 1942, he became withdrawn and rarely ventured out, visiting Paris finally in 1945. He completed his last painting, 'The Almond Tree in Flower', shortly before he died on January 23rd, 1947 at Le Bosquet.

The Museum of Modern Art in New York City had planned an exhibition to celebrate Bonnard's 80th birthday, but instead mounted a retrospective exhibition.

HENRY BROUGHAM
(1803 – 1870)

An English writer and politician who argued for the abolition of the slave trade, designed the Brougham carriage and founded modern day Cannes.

Born on the 19th September 1778, in Edinburgh, he went to Edinburgh High School and then to university at 14, where he studied maths, science and law.

In 1803, he moved to London, where he became interested in politics. He wrote a book about colonial policy, attacking the slave trade. He gained a seat in the House of Commons representing Camelford but lost it in 1812, winning another in 1816 for Winchelsea.

In 1819, he married Mary Anne Spalding and they had two daughters neither of whom outlived their father.

He defended Queen Caroline in 1820 during the legal battle when the king tried to divorce her. The ensuing publicity helped his legal practice to flourish.

In 1830, he became Lord Chancellor and was given a peerage as Baron Brougham. He fought to abolish slavery and argued for the right to education for all. He also promoted the 1832 Reform Bill but lost his position when Robert Peel came to office as PM.

In 1834, Brougham made a trip to Genoa in Italy but an outbreak of cholera forced him to stay in Cannes. Charmed by the small fishing village, he bought some land overlooking the sea and built a chateau which he called "Eleanore-Louise" in 1836.

He helped to build the port in Cannes too as more and more English gentry stopped in Cannes, many to visit Brougham. They were followed by the Russians who were also eager to escape the debilitating winters at home. All along the coast, grand homes and hotels were built. With the advent of the railway in 1863 many more tourists arrived on the south coast.

He died in May 1868, aged 89, while on a visit to Cannes with his family. He was buried in the local cemetery.

A statue of Brougham stands in the centre of Cannes.

BETTY DE ROTHSCHILD (1805 – 1886)

A famous socialite, philanthropist and patron of the arts, best-known for her interior decorating style. Born into the de Rothschild family, Betty Salomon von Rothschild had a sheltered upbringing in Frankfurt. At 19, she married her uncle, James Mayer de Rothschild, whose father had sent him to France to establish a branch of the family banking business in 1811. He became the most powerful financier in France, funding the country's industrial growth as well as becoming one of the richest men in the world.

Betty's dowry was worth a princely 1.5 million francs, and the couple received many wedding gifts from all over Europe – jewels, furs, silver and gold objects.

Betty established a famous salon in her Paris home and encouraged numerous musicians, artists and writers including Balzac, Chopin, Rossini, George Sand and Heinrich Heine who said of her taste in decorating: *"...here the genius of the visual arts competes with the genius of Rothschild... One must admire the flair with which everything had been done, as much as the costliness."*

She was also a supporter of many charities. The couple built an astonishing art collection much of which was eventually donated to the Louvre.

King Louis XVIII refused to receive Betty at court because she was Jewish so her husband ceased doing business with the king.

They had five children; Charlotte, Mayer Alphonse, Gustave Samuel, Salomon James and Edmond Benjamin between 1825 and 1845. In 1847, Chopin dedicated his Valse Op. 64, N° 2 in C sharp minor to their daughter Charlotte. In 1848, Ingres painted Betty's portrait. (see below)

In February 1848, Napoleon III came to power. Her husband James found he was able to work with the new regime and his business interests flourished. In 1854, the couple built a chateau east of Paris, the Château de Ferrières, then in 1868, they bought Chateau Lafite in the Bordeaux region where they now cultivate the famous wine. Betty set

JEAN INGRES' PORTRAIT OF BETTY DE ROTHSCHILD FROM ROTHSCHILD COLLECTION, PARIS.

about renovating the chateau in an opulent style known as *le gôut Rothschild.* Her husband died later that year on November 15th.

Betty commissioned a new villa in Cannes, which was built in 1881, combining classical and baroque elements in the design.

Betty died in 1886. The villa in Cannes was occupied by the Germans during World War II and then bought by the town council in 1947. The Villa Rothschild now houses the Cannes library and has been listed as a historical monument.

PROSPER MERIMEE (1803 – 1870)

He was a French playwright, translator and short story writer.

He was born on the 28th September 1803, the son of a chemist. His mother was a painter. He studied law initially and worked as a secretary to the Count D'Artois, a minister. He was friends with the Montijo family which he visited in Spain. He began writing plays at 19, and frequented an international literary salon where he met Stendhal and the critic Delescluze.

He travelled to Spain in 1830 to visit his friend the Countess of Montijo and made friends with the Count de Teba and his wife, whose daughter would become the future Empress of France.

The trip inspired his novella *Carmen* about gypsy culture which was published in 1845 and which inspired Bizet's opera *Carmen.*

He studied Russian so he could read Pushkin's works and translated *Queen of Spades* himself, wrote a sketch about Gogol and the preface to Turgenev's *Fathers and Sons* in 1864.

He travelled to Corsica in 1839 which led to his novella *Colomba* which dramatised the vendetta culture in Corsica.

In 1841, Merimee and his lover George Sand discovered the tapestries of 'The Lady and the Unicorn' during a stay at the Château de Boussac in the Limousin.

His last work was *Lokis,* a horror story set in Lithuania about a man who was half bear, half man.

He died in Cannes, on September 23rd, 1870, and was buried in the Cimetière du Grand Jas. After his death, more of his works were published, including a story titled *The Blue Room.*

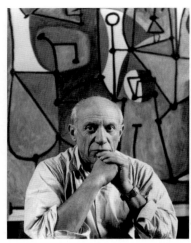

PABLO PICASSO
(1881 – 1973)

"Every act of creation is first an act of destruction."

A Spanish-born artist, potter and sculptor who lived in France, best known for co-creating Cubism (with Braque) and for transforming 20th century art.

Born in Malaga, Spain on October 25th, 1881 as Pablo Ruíz y Picasso, he was the son of a painter and art teacher. By 13, Picasso's skill as an artist had surpassed his father's. At school, he spent most of the time day-dreaming and sketching out his ideas.

In 1895, his family moved to Barcelona where he enrolled at the School of Fine Arts, but again he spent most of his time sketching rather than attending classes. At 16, he went to study at the Royal Academy in Madrid where he spent his time painting gypsies, tramps and prostitutes in the streets or visiting the Prado to see the art collection of paintings by great masters.

By 1900, he had moved to Paris where his loneliness and poverty spilled over into his art, producing realistic paintings of isolation and desolation, known as his Blue period.

By 1905, his Rose period had begun. He was in love with artist Fernande Olivier and his new American patrons Gertrude and Leo Stein were introducing him to the work of avant-garde painters. He also became interested in African tribal art. This led him to create *Les Demoiselles d'Avignon* (1907) and later, with Georges Braque, to develop Cubism.

During World War I, his girlfriend Marcelle (Eva) Humbert died, and Picasso returned to classical painting for a while. He also became involved with the Ballets Russes, where he met Diaghilev and Cocteau. He married ballerina Olga Khokhlova in 1918, and they had a son, Paul, but Picasso never remained faithful for long and they separated in 1927 when his affair with a younger blonde model, Marie-Thérèse Walter, became known.

Marie-Thérèse Walter had a daughter, Maya, with Picasso in 1935, but by then she had a rival, the moody, artistic photographer Dora Maar (see page 110). She collaborated with Picasso on several projects and promoted Surrealism. This led to one of the greatest 20th century paintings, *Guernica* (1937), a complex anti-war painting, in response to the German bombing of Guernica during the Spanish Civil War, painted in black and white (see below).

He stayed in Paris during the German Occupation but was unable to exhibit his work. At the end of the war, he began a relationship with a young art student, Françoise Gilot. They had two children together, Claude and Paloma, but Gilot grew tired of his infidelities and abusive behaviour, which she described in her book *Life with Picasso* (1964).

From 1919, Picasso had been spending the summer on the Côte d'Azur and he finally left Paris and moved to Vallauris in 1946, living and working in different places around the Riviera.

He was unwilling to divorce his first wife Olga Khokhlova, not wishing to share his wealth with her. She died in 1955 and instead of marrying Gilot, he chose to marry his long-term mistress Jacqueline Roque in 1961.

Picasso died on April 8th, 1973, in Mougins, aged 91. He was buried at the Chateau de Vauvenargues near Aix-en-Provence, where he and Roque had previously lived.

Roque did not allow Claude and Paloma to attend their father's funeral. She committed suicide in 1986; Marie-Thérèse Walter had previously committed suicide in 1977.

The Picasso Museum in Antibes houses many of his works.

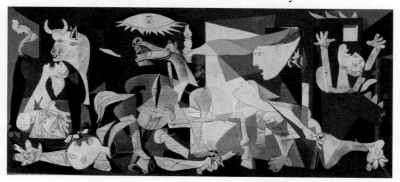

GUERNICA, MUSEO REINA SOFIA

TOBIAS SMOLLETT
(1721 – 1771)

"The capital is become an overgrown monster; which like a dropsical head, will in time leave the body and extremities without nourishment and support."

A Scottish novelist, travel writer and physician.

He was born on March 19th, 1721 in Cardross, Dumbartonshire in Scotland. His father died when he was 2 and his grandfather, Sir James, the laird of Bonhill, provided for the family, sending Smollett to be educated at the local grammar school and Glasgow University.

Smollett was initially apprenticed to a surgeon, and then became a surgeon's mate on the HMS Cumberland which was involved in the battle of Cartegena against the Spanish. He later arrived in London and set up a medical practice while writing satirical poems, plays and novels about his experiences.

His novels include: *The Adventures of Roderick Random,* and *The Adventures of Peregrine Pickle,* which influenced later novelists such as Walter Scott and Charles Dickens.

In 1747, he married Anne Lascelles, who was said to be a wealthy Jamaican heiress, and they had a daughter, Elizabeth. When his daughter died in April 1763, his wife implored him to leave England for a while to recover from his grief. They travelled to Nice, Genoa, Rome, Florence and around Italy. He wrote a detailed but cantankerous account of the trip titled: *Travels through France and Italy* (1766) which was the first travel guide of its kind and led to others making the same tour of Europe.

Back in London, he wrote a satire on the immorality of public affairs titled, *The History and Adventures of an Atom* (1769) but his health worsened so he returned to Italy. In 1770, he wrote the humourous *The Expedition of Humphrey Clinker,* his last work.

Smollett died, aged 50, on September 17th, 1771 in Livorno, Italy and was buried there. A small monument was later erected to his name in Renton, near Dumbarton.

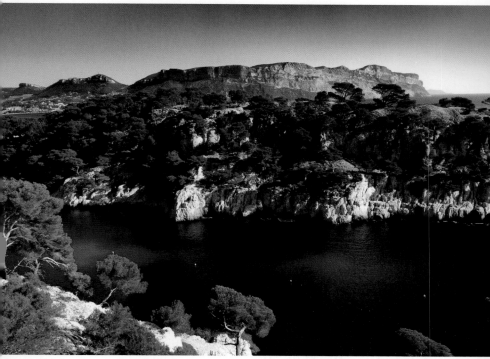

A CALANQUE

CASSIS (BOUCHES-DU-RHONE)

Inhabited since prehistoric times, the Romans developed the port of Carcisis to trade stone, wine and coral with North Africa. Owned by the bishops of Marseille in medieval times, when its numerous sheltered coves were perfect for pirates or barbarian invasions, the inhabitants retreated to a castle on the clifftops.

Today, the picturesque port of Cassis, situated 20km east of Marseille, is famous for its dramatic cliffs, spectacular rocky inlets and for the quality of its local wine. Limestone from the area is particularly durable and has provided stone for ports such as Piraeus, Algiers as well as the Suez canal. It was even used for the base of The Statue of Liberty.

The combination of the sunny climate, the sandy beaches and the natural beauty of the area – Cap Canaille is the highest cliff in Europe – made it a favourite summer haunt of the English in the 1920s and 30s, and was nicknamed Bloomsbury-on-sea.

Today the many inlets known as calanques are popular for scuba diving, kayaking and boating. Or you can hike along the cliff paths to see them from on high, except in the summer months when the paths are closed to stop forest fires.

PLACES
The Calanques, Port Miou, Port Pin and En Vau – take a boat trip from the port.
Cap Canaille, between Cassis and La Ciotat, 394 m high, drive or hike to the clifftop for the view.
Municipal Museum in Place Baragnon, items dating back to antiquity and fine arts.
Salle Voutees art gallery located on the main square.
The Four Banal, exhibition of peasant life.
Chateau de Fontcreuse, local wines (see Vanessa Bell).

www.cassis.fr

PEOPLE
WINSTON CHURCHILL (1874 – 1965)
An English politician, orator, writer and artist, famous for leading Britain during World War II.

Born on November 30th, 1874, into an aristocratic family at Blenheim Palace in Oxfordshire, his father, Lord Randolph Churchill, was in politics too. Churchill was sent to Harrow School then Sandhurst Military College. He then joined the army, serving on the North-West Frontier of India and the Sudan. He acted as a war correspondent and was captured during the Boer War, but managed to escape.

In 1900, Churchill became the MP for Oldham, but he lost faith in the Conservative Party and switched to the Liberals in 1904, just before they won the 1905 election. Churchill was first appointed to the Colonial Office then promoted to the Cabinet as President of the Board of Trade, before becoming Home Secretary in 1910.

Churchill met Clementine Hozier in 1904 at a ball in Crewe House then four years later at a dinner party. They married in 1908 and the first of their five children was born the following year.

In 1911, Churchill was put in charge of the navy as First Lord

of the Admiralty but resigned after the disastrous Dardanelles campaign. In 1924 he switched his allegiance back to the Conservative Party and was Chancellor of the Exchequer for five years under Stanley Baldwin.

Churchill stayed in the Panorama Hotel in Cassis in the 1920s and developed his painting while staying there on holiday. He painted for relaxation, mainly landscapes in oil, many of which can be seen in his studio at Chartwell, his country home in the UK. He enjoyed the South of France, often visiting Coco Chanel, The Duke and Duchess of Windsor and Lord Beaverbrook at his villa in Monaco. In the 1930s, he became depressed while out of office and used his painting to rid himself of his 'black dog.' He was taught to paint by his friend, Paul Maze, an artist he'd met in the trenches of World War I.

When war broke out in 1939, Churchill resumed his role at the Admiralty but when Neville Chamberlain resigned, Churchill became Prime Minister. His passionate speeches during World War II, inspired the country. His ability to form alliances with the USSR and the USA helped to end the war.

In 1945, Labour swept to power. Churchill remained leader of the Conservative party and following the next election in 1951 he became Prime Minister again. He resigned in 1955, but remained an MP until shortly before his death.

He wrote many books, mainly histories and memoirs and won the Nobel Prize for Literature in 1953.

He visited his friend Emery Reves in 1956 at Chanel's former villa La Pausa and returned there many times over the following three years.

Churchill died on 24th January, 1965, in London, and was given a state funeral by Queen Elizabeth II.

He is featured on the new five pound note.

RAOUL DUFY
(1877 – 1953)

"My eyes were made to erase all that is ugly."

A French Fauvist painter, illustrator and designer whose decorative style changed fashion and textile design.

He often painted public events in a theatrical way, celebrating life. He also illustrated books, was a printmaker, a designer of furniture, interiors and theatrical sets.

Born at Le Havre on June 3rd, 1877, he began to attend evening classes at the Municipal Ecole des Beaux-Arts in 1892, where he met Othon Friesz and Georges Braque. After military service, he won a scholarship in 1900 to the Ecole des Beaux-Arts in Paris.

Influenced at first by Pissarro and Monet and then the Fauvist style of Matisse he embraced bold, vivid colours and sweeping brush strokes. His first solo show was held at the Galerie Berthe Weill, in 1906. He was briefly influenced by Braque's cubism in 1908 then toned down his palette as he came to appreciate the work of Cézanne.

He began to design and print fabrics using woodcuts for the fashion designer Paul Poiret in 1911, then made tapestries and designed ceramics and home interiors. From 1920 he made frequent visits to Vence, Nice and Cassis and painted landscapes, seascapes and social events in bright colours.

In 1935, Dufy began to use new oil paints that were more like watercolours. He created *The Electricity Fairy* with these, an enormous mural created for the Palace of Light at the 1937 International Exposition in Paris. He was awarded the main prize at the 1952 Venice Biennale, a year before his death. Dufy died at Forcalquier, on 23rd March, 1953, and was buried near Matisse in the cemetery at Cimiez Monastery in the hills above Nice.

VANESSA BELL (1879 – 1961)

An English painter and designer, member of the Bloomsbury Group and sister of the writer Virginia Woolf. She was born Vanessa Stephen on May 30th, 1879 in Kensington. Her father, Leslie Stephen, was an author and mountaineer, whose home was often full of well-known authors. At 16, Vanessa's mother died. It was said that both Vanessa and her sister Virginia were sexually abused by their elder half-brothers from their mother's previous marriage.

Vanessa studied first under the tutelage of portrait painter Arthur Cope then at the Royal Academy of Art under John Singer Sargent (1901). She and her sister Virginia moved to Bloomsbury in 1904 and met with friends of their brother, Thoby, from Cambridge University. The Bloomsbury Group, as the circle of friends became known, included Clive Bell, E. M. Forster, Duncan Grant, Leonard Woolf, Lytton Strachey, John Maynard Keynes, David Garnett, Desmond MacCarthy and Arthur Waley.

Vanessa was initially cool towards the advances of Clive Bell, but following the death of her brother Thoby from typhoid fever, she married him in 1907. They had an open marriage with both parties taking lovers. They had two sons, Julian (1908) and Quentin (1910) and Vanessa later had a daughter, Angelica (1918), with Duncan Grant.

In 1910, Clive Bell met Roger Fry and they organised an exhibition of French avant-garde art in Mayfair. The work sparked controversy but was liberating for Vanessa's own painting as she was one of the first British painters to move away from a representational style.

In 1911, Vanessa began an affair with Fry who organised an exhibition entitled "British, French and Russian Artists" in 1912 and included four of Vanessa Bell's paintings alongside work by Duncan Grant, Percy Wyndham Lewis, Spencer Gore, Pablo Picasso, Henri Matisse, Paul Cézanne and Wassily Kandinsky. She sold her first painting 'The Spanish Model' to the Contemporary Art Society in August.

Roger Fry first discovered Cassis and encouraged Vanessa

Bell and her companion Duncan Grant to come and paint there too. At first they stayed in the Hotel Cendrillon in the port, rented the Villa Mimosa and then a cottage called La Bergère in the grounds of the Chateau Fontcreuse, owned by a retired British army officer, Colonel Teed.

Every summer the circle of friends descended on the South of France and Cassis became known as Bloomsbury-on-Sea. Virginia Woolf wrote of Cassis in 1925: *"Nobody shall say of me that I have not known perfect happiness."*

She began her novel *To the Lighthouse* there and conceived *The Waves* (originally called *The Moths*) after Vanessa wrote to her about the huge moths that flew at the windows of La Bergère.

Vanessa Bell's first exhibition was at the Independent Gallery in London in 1922, followed by several solo shows over the next few years. She later co-

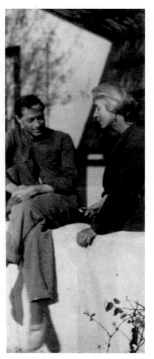

VANESSA BELL WITH DUNCAN GRANT AT LA BERGERE IN CASSIS

designed ballet sets with Grant, the interior of a cruise liner and a church at Berwick. They decorated their house in Charleston with bright colours and murals.

Although his parents were pacifists, Julian Bell decided to volunteer for the Spanish Civil War and was killed by shrapnel from a bomb in 1937. Vanessa was grief-stricken and then in 1941, received a further blow when her sister, Virginia, committed suicide by drowning herself in the River Ouse, near her home in Rodwell in Sussex.

Vanessa lived in London and travelled widely. She enjoyed spending her time with her family and Duncan Grant, painting with him at her home in Charleston in Sussex.

She died of heart failure, on April 7th, 1961, at her home in Charleston. She was buried in Firle Parish Churchyard.

CHATEAU DE LA CHEVRE D'OR

EZE (ALPES-MARITIMES)

This enchanting village is divided between the old fortified village accessible via the Moyenne Corniche road and the lower part, Eze-Bord-de-Mer, accessible via the Basse Corniche road.

There is an ancient temple to the goddess Isis, now part of the church, Notre Dame de l'Assomption. The Romans first occupied this eagle's nest for its important sightlines over the surrounding territory, followed by the Saracens who remained for nearly a century before being driven out by William I, Count of Provence,

following a battle in 973. It came under the control of the Counts of Savoy in 1388 and they fortified the village. It was later fought over by the Turks, the Spanish and the French until officially becoming part of France in 1860.

In the old vllage, high up above the ocean, with its maze of cobbled alleyways, beautiful medieval buildings and spectacular views, you can feel as if you have gone back in time. Artisans sell their wares from the many small stone houses.

In the lower village by the sea, you can find the sumptuous villas of rock stars, royalty and African warlords.

PLACES
Chateau Eza.
Chateau de la Chevre d'Or.
Church of Notre-Dame de l'Assomption, retains an Egyptian ankh from an earlier temple.
Chapelle Sainte-Croix built in 1306 by the White Penistents.
L'astrorama, col d'Eze, for stargazing.
The Exotic Garden, cacti, aloe and yucca plants, sculptures and superb views, surrounding the ruins of an ancient Saracen castle.
Le Chemin de Nietzsche, a walking trail that links the upper and lower parts of the town.
Parfumerie Fragonard.
Mount Bastide.
Oppidum of the Castellar.
Beach at St Laurent d'Eze.

FESTIVALS
Medieval Festival, July.
Musical concerts, July-August.

www.cote.azur.fr/ville_eze

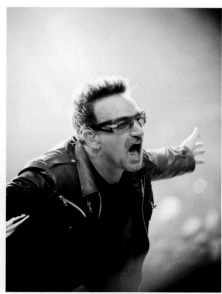

360 TOUR 2011 PHOTO: PETER NEILL

PEOPLE
BONO (1960 –)

An Irish rock star with Dublin-based band U2, he has organised benefit concerts for charities and campaigned against world poverty and AIDS, highlighting the needs of African people.

Born on May 10th, 1960, in Dublin, Paul Hewson went to Mount Temple Comprehensive School where he was nicknamed 'Bono vox' meaning 'good voice' and met his band mates. Over the years, his songwriting and performance helped to create a rebellious image for the band which has mellowed as the group have matured.

Bono has recorded with numerous celebrated singers from Pavarotti to Kylie Minogue and received many awards including 22 Grammys and a Golden Globe (2003) for his song *The Hands that built America.*

Bono met his wife Alison Stewart while they were at school, and they now have four children. The couple own a pink villa on the beachfront at Eze-Bord de-mer, with the railway line running behind it. Bandmate 'The Edge' also has a house nearby.

Criticised for U2's tax avoidance in Ireland, Bono is on the board of a private equity company, Elevation Partners, which has invested in Facebook and Forbes Media Group among other business ventures.

He has been nominated for the Nobel Peace Prize three times and was granted an honorary knighthood by Queen Elizabeth II in 2007.

Former Prime Minister Tony Blair wrote to him: *"You have tirelessly used your voice to speak up for Africa."*

WALT DISNEY (1901 – 1966)

"Laughter is America's most important export."

An American entrepreneur, innovator, artist, film and TV producer and theme park creator.

He was born on December 5th, 1901, in Chicago, Illinois. His father worked on the railway. He married Flora Call in 1888 and they had five children. The family tried farming in Missouri in 1906 but when this failed they moved to Kansas City. At school, Disney made friends with Walter Pfeiffer whose family introduced him to theatre and film. He then studied art and photography at McKinley High School in Chicago.

At 16, Disney was too young to enlist for the army so he joined the Red Cross and drove an ambulance for a year in France during World War I. His love of France led him to return many times.

In 1925, Disney married graphic artist, Lillian Bounds and they had a daughter, Diane and adopted another, Sharon.

In 1928, Mickey Mouse was a hit in *Steamboat Willie* and in 1932, his first colour cartoon *Flowers and Trees* won him the first of twenty-two Academy Awards. In 1937, *Snow White and the Seven Dwarfs* won eight Oscars. This was followed by *Pinocchio, Fantasia, Dumbo, Bambi* and dozens of others.

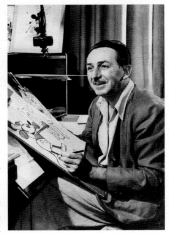

Disney often stayed in and around Eze on holiday. In 1953, he was visiting the restaurant at the Chateau de la Chevre d'Or and persuaded the owner, Robert Wolf, to buy up many of the small houses in the village to convert them into a hotel.

In 1954, Disney moved into TV production and developed his *Wonderful World of Color* in 1961.

Disney created the Disneyland Park in 1955 at a cost of $17 million. He had plans for another park in Florida but died in 1966, aged 65, from lung cancer. His brother Roy opened the first Walt Disney World theme park in 1971 in Orlando, Florida.

FRIEDRICH NIETZSCHE (1844 – 1900)

A German poet and philosopher, whose questioning of society, religion, and philosophy had a profound influence on philosophy in the 20th century.

He was born on October 15th, 1844, near Leipzig in Prussia, the son of a pastor who died when he was 5. The family had to move in with his grandmother. He studied at the Schulpforta Abbey school in Naumburg from 1854 and later at the Universities of Bonn and Leipzig where he read the works of Schopenhauer and Darwin.

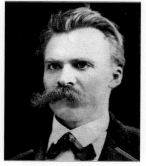

At 24, he took up a post as professor of philology at the University of Basel in Switzerland and became friends with the composer Richard Wagner. From 1870 to 1871, he served in the medical corps during the Franco-Prussian war which

affected his health badly. His first book, *The Birth of Tragedy* (1872) met with little success. Due to ill-health, he resigned his post at the university.

To recuperate, he spent many winters in and around Nice. He had the ideas for *Thus Spake Zarathrustra* while staying in Eze and walking the coastal paths.

In 1889, aged 44, Nietzsche had a breakdown after witnessing a horse being brutally flogged in the street in Turin. He was hospitalised and diagnosed with tertiary syphilis.

He was unwell for many years and had to be cared for by his mother until her death in 1897, then by his sister Elisabeth Förster-Nietzsche. He suffered a stroke and died on August 25th, 1900, aged 55, in Weimar, Germany.

PRINCE WILLIAM OF SWEDEN (1884 – 1965)

Prince Wilhelm of Sweden and Norway, Duke of Södermanland, was the second son of King Gustav V of Sweden and his consort Victoria of Baden. He wrote many books and was a keen photographer.

Born Carl Wilhelm Ludvig at Tullgarn Palace on June 17th, 1884, he married Grand Duchess Maria Pavlovna of Russia in 1908 and they had one son, Lennart, in 1909. They did not get along and divorced in 1914. He then lived with his French girlfriend Jeanne for over thirty years at the Stenhammar summer residence south of Stockholm, near Flen, in Sweden. They spent many holidays together in France, often staying at the Chateau

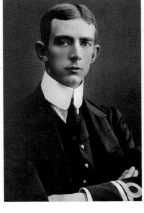

d'Eza where William did much of his writing including *Wild African Animals I have known* (1923).

Jeanne was tragically killed in a car accident in 1952, when William was driving back to Stenhammar castle during a snowstorm, after visiting his son.

He never got over the event and died in Stockholm on June 5th, 1965. He was buried next to Jeanne in the Flen graveyard, at their local parish church rather than in the royal burial ground.

JEAN MARCELIN PLACE

GAP (HAUTES ALPES)

Said to be the sportiest town in France, Gap is a good base for winter sports and family holidays.

Founded by the Gauls, the Emperor Augustus invaded in 14 BC and named the town Vapincum. The Romans built a new road, the Via Domitia, which ran through the town linking Italy to Spain.

Gap was ruled by a Bishop from the 10th century until it became the capital of the new Hautes-Alpes department during the Revolution. It had been annexed by the French crown in 1512.

The plague decimated the town in 1650, wiping out over half the population and in 1692 most of the houses were destroyed by fires set by Savoy troops.

Napoleon Bonaparte passed through Gap on his way to Paris, following his escape from Elba in 1815. Today, the Tour de France often passes through Gap en route for Nîmes.

PLACES

Cathedral de Notre-Dame, 2 Place Saint Arnoux.
Departmental Museum of the Hautes-Alpes, ave Maréchal Foch.
La Grange Eymery, arts centre, La Placette.
Chapel of the Penitents, 21 rue de l'Imprimerie.
The Chateau de Charance and its park and lake.

VISIT

The Tallard Chateau, D942, Tallard.
The Demoiselle Coiffées, unique rock formations, in Theus.
Train museum Cheminot Veynois, rue du Jeu de Paume, Veynes.
Agricultural Ecomuseum, 31 bis, route de l'Audet, Charance.
The ruins of the village of Chaudun, Cirque de Chaudun.
Les Ecrins National Park, glaciers, forests, meadows, wildlife; the largest national park in France with skiing and hiking trails.
Boscodon Abbey, near Embrun and the Serre-Ponçon lake.
Stade Nautique de Fontreyne, ave de Provence.
Fishing in the Serre-Ponçon lake, March-October.
Water sports, 2 bis, rue Cyprien Chaix.
La Maison du Berger, Alpine cultural centre, Les Borels, Champoléon.
La Ferme du Col, petting farm, Le Col, Jarjayes.
Abiland Nature, Bee museum, vivariums, honey, Rousset.
La Chèvrerie de Céuse, goats'cheese farm with pigs, ponies and rabbits, Les Guérins, Sigoyer.
Cheese Museum, Laiterie du Col Bayard, RN 85, Laye.
Muséoscope du Lac, audio-visual exhibition, Rousset.
The Chateau de Montmaur, between Gap and Devoluy.
Briançon and Mont-Dauphin, UNESCO World heritage sites.

FESTIVALS

The Alps Carnival, March.
International Folk Dancing Festival, July.
Tour de France, June-July.
Gap en Fa Mi Sol, Summer Festival
Gap Town Festival, September.
Gap Motor Show, Rally. September-October.

http://www.gap-tourisme.fr/

CHRISTIAN AUDIGIER
(1958 –)

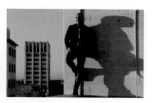

A French fashion designer and entrepreneur, famous for his ability to set trends. Nicknamed Le Vif (the fast one), he was born on May 21st, 1958 as Christian Ginutti.

He began in fashion as a teenager by designing jeans with a rock n roll look for MacKeen jeans then went on to designing freelance for Guess, Fiorucci, Levi's, Diesel, Lee, Kookai and NafNaf.

He joined Von Dutch in 2002 as chief designer and created a trend for trucker caps. He likes to work with a counterculture design figure and transform their ideas into the essence of cool clothing.

His celebrity clients include: Britney Spears, Madonna, Kanye West, Ashton Kutchner, Sylvester Stallone, Paris Hilton, Hilary Duff and Justin Timberlake.

In 2004, he launched the Ed Hardy brand, which was inspired by the tattoo artist Don Ed Hardy, and he has since licensed the brand to products ranging from energy drinks to air fresheners. His Ed Hardy T-shirts with a classic tattoo design on the front became popular worldwide.

Some of his other brands include Smet with French singer Johnny Hallyday, C-Bar-A, Savoir Faire, Evel Knievel, Rock Fabulous, Paco Chicano and a brand named after his daughter Crystal, called Crystal Rock.

Audigier has diversified into perfume, jewelry, furniture, handbags, shoes, skateboards, drinks, fine wines and chocolates. He is a co-owner of a nightclub in the Treasure Island Hotel in Las Vegas decorated in his iconic rock n roll style.

He has appeared on TV many times including the show *Next Top Model* and on MTV's *Cribs*.

His products are sold in thousands of shops around the world as well as in his own signature stores in Los Angeles, New York and Paris.

THE SINGING PRIESTS

À LA CATHÉDRALE DE GAP
Les 16 et 17 avril 2010 à 20h30

Inspired by Irish band The Priests, Gap Bishop Jean-Michel Falco persuaded three members of his clergy to make a record to raise funds for the construction of a new church in the village of Notre Dame de Laus, near Gap.

The result was an album called *Spiritus Dei*, by a boy band called Les Prêtres. With covers of Leonard Cohen's *Hallelujah* and Jacques Brel's *Quand on a que l'amour* as well as religious tunes such as *Amazing Grace*, the album became an instant hit, selling over 100,000 copies.

The trio of singers includes two real priests – Jean-Michel Bardet, curate in the centre of Gap, who is a trained musician and Charles Troesch who had previously been a member of a famous children's choir. The third member is Dinh Nguyen Nguyen, a seminarist.

Royalties from the DVD are also helping to fund a school in Madagascar. A recent tour of churches by the Singing Priests has been extremely popular.

SEBASTIEN OGIER (1983 –)

A French rally car driver who was the winner of the 2013 World Rally Championship.

Ogier was born on 17th December 1983 in Gap and by 2007 he had won the French Peugeot 206 Cup. He next won the Junior World Rally Championship in 2008, driving a Super 1600 class Citroën C2 for the FFSA team.

He then drove for the Citroën World Rally Team and took his first WRC victory in the 2010 Portugal Rally, leading from stage four to the end and finishing 7.9 seconds ahead of Loeb. He joined Volkswagen with co-driver Julien Ingrassia in 2011.

With 13 victories in the World Rally Championship, he is the third most successful French driver after Sébastien Loeb and Didier Auriol.

He recently won the 2014 Monte Carlo Rally.

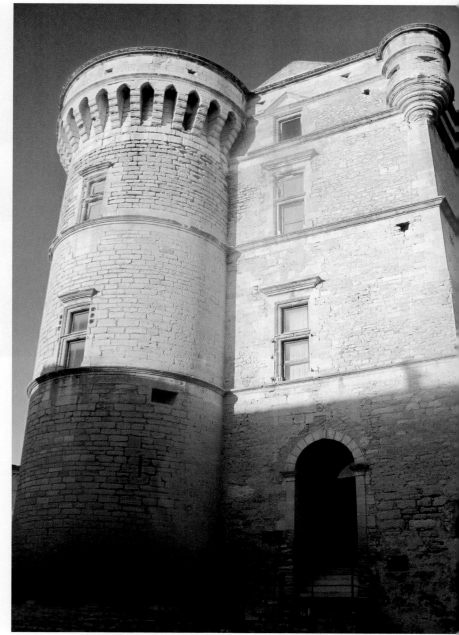

CHATEAU IN GORDES

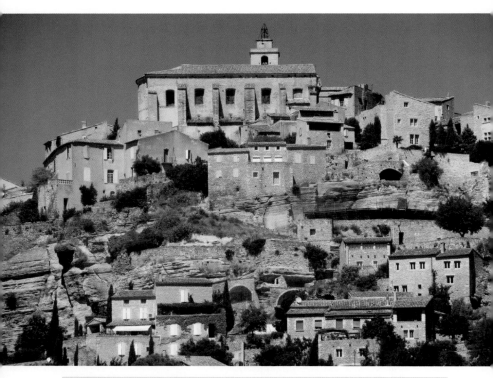

GORDES (VAUCLUSE)

Perched on a hilltop, on the edge of the Monts Vaucluse, with breathtaking views of the Luberon valley, Gordes has been described as one of the most beautiful villages in France.

At its centre is a 12th century castle, which now houses the municipal museum and artworks by Flemish painter Pol Mara. It was built to protect the inhabitants from the many invasions in the Middle Ages and the wars of religion. The colourful church of St Firmin is still standing despite a large crack caused by an earthquake in 1904. The village was on the ancient Catholic pilgrimage route to Santiago de Compostela in Spain.

Gordes was an active centre of the resistance in World War II and the village was partially destroyed by the Germans in 1944 in an act of reprisal. In recent times, many artists and celebrities have stayed in the village. Roman Polanski and Cameron Mackintosh are a few who are said to have summer homes here.

PLACES

Gordes Chateau and museum (see page 83)
Pol Mara Museum, art works by modern Flemish painter displayed in the chateau.
Church of St Firmin.
St Firmin Palace Cellars.

VISIT

Senanque Abbey, 12th century abbey, home to Cistercian monks, open to public.
Montgolfier tour, a hot air ballon ride over the Luberon valley.
Museum of Glass and Stained Glass, near Cavaillon, also on the same site – **Bouillon Oil Press,** antique oil press in working order
Lavender Fields The Sault area is the nearest area for lavender production. Visit from June - October. Full bloom June - July before the harvest.
Lavender distillery in Apt, Borde Bernadette, Hameau les Coulets, Route de Rustrel, Apt.
Roussillon, ochre quarries and cliffs streaked with red and gold ochre sands. Follow the ochre trail.
The Bories village, (below) ancient dry stone huts with sheep-pens, bread ovens, wine vats, dating back thousands of years.

FESTIVALS

St Vincent Wine Feast, January.

Almond Tree Festival, March.

Arts Festival, August.

Wine Festival, August.

Lavender Festivals, Apt, July.

Sault and Digne-les-Bains, August.

Beckett Festival, performances of the dramatist Samuel Beckett's plays, Roussillon, July.

International String Quartet Festival, Roussillon, July.

Jazz en Luberon Festival, April – May.

www.gordes-village.com

SENANQUE ABBEY

PEOPLE
WILLY RONIS (1910 – 2009)

"It is the typical that interests me, not the scoop."

A French photographer, famous for his images of ordinary people in Paris in the 1940s. He influenced the development of photo-reportage in the years after World War II.

Born on August 14th, 1910, his parents were Jewish refugees, escaping pogroms. His father ran a photography shop in Montmartre while his mother gave piano lessons. Although he intended a career in music, he had to take over the family business, aged 26, when his father died of cancer.

In 1936, he photographed a demonstration showing the marchers with their fists in the air, banners flying. In 1938, he covered a strike at a car factory resulting in a series of striking images which helped establish his reputation for photo journalism.

During the German Occupation, he escaped to the south, where he worked on films such as *Les Enfants du Paradis.* There he met Marie-Anne Lansiaux, a communist painter. They married after the war and she was the subject of his highly popular photo, *Provençal Nude* taken at their home in Gordes in 1949. It shows his wife washing herself, naked – the moment is rendered with a tender, timeless quality. *"I have never been so anxious as when I developed that film,"* Ronis said of it.

In 1946, he joined the Rapho Agency and was the first French photographer to have his work published in *LIFE* Magazine. In 1953, the exhibition *Five French Photographers,* at the Museum of Modern Art in New York, saw his work alongside that of Henri Cartier-Bresson, Robert Doisneau, Izis and Brassaï. In 1957, he was awarded the Gold Medal at the Venice Biennale.

He taught photography from 1957 in colleges in Provence. In 1979, he received the French Grand Prix for Arts and Letters for Photography. Ronis photographed his wife, Anne Marie, suffering from Alzheimer's disease before she died in 1991.

He died on September 12th, 2009, aged 99.

VICTOR VASARELY
(1906 – 1997)

A French-Hungarian artist widely regarded as the father of Op-Art.

Born in the city of Pécs, Hungary April 9th, 1906, he studied medicine initially at university then switched to study the arts in 1927 at the Muhely school which promoted the ideas of Bauhaus. He married a fellow student, Claire Spinner, in 1930 and they had two children.

Influenced by Mondrian, he began painting in an abstract style and had his first exhibition in 1944 at the Denise René Gallery. By 1949, he had evolved a new style using geometric shapes inspired by pebbles on the beach at Belle Isle. From 1948, he spent his summers in Gordes where the white stone houses inspired his series of paintings titled *Gordes/Cristal*. Next, he explored visual distortion and produced his *Yellow Manifesto* (1955) receiving the critics' award in Brussels and a Gold Medal at the Milan Triennial.

'The Responsive Eye' at New York's Museum of Modern Art (1965), included his work with other op-art artists like Bridget Riley. The exhibition had a profound influence on fashion, design and advertising. Thereafter, Vasarely was internationally famous and his work was included in exhibitions around the world.

In the late 60s he introduced vivid colour into his work and in 1964, he won The Guggenheim Prize. In 1967, he was chosen to design the French Pavilion at the Montreal World Fair Expo.

In 1971, the Chateau at Gordes opened the first Vasarely Museum where it continued until 1996. A much larger museum was built in Aix-en-Provence in 1976, to house the artist's work. There are two other Vasarely museums in Pecs and Budapest, Hungary.

Vasarely died in Paris on March 15th, 1997, aged 90.

His estate has been subject to a family dispute.

POL MARA (1920 – 1998)

A Belgian painter and illustrator who became a well-known Pop artist. His name was an acronym for *Pour Oublier Laideur – Metamophoses Amour Rêve Amitié,* which means: To forget the ugliness – Metamorphosis, Love, Dream, Friendship.

Born in Antwerp as Leopold Leysen on December 8th 1920, he studied at the Academy of Fine Arts from 1935 and the National Institute of Higher Education from 1941 until 1948. He began working in the tradition of Flemish Impressionism then switched to surrealism before becoming more interested in formal abstraction. His first exhibition was held in 1952 and in 1955 he won a prize for Young Belgian Artists. In 1958, he co-founded G-58 Hessenhuis, along with Paul Van Hoeydonck, Mark Verstockt and Filip Tas Dan Vanseveren, a group based in Antwerp.

He began to combine photographic elements into his art, particularly images from the media, often those of scantily clad women. His work seemed to depict a beautiful dream world. He wanted to protest against the injustice and the ugliness in society. This led to comparisons with artists such as Robert Rauschenberg; he had his first exhibition in New York in 1965.

He won numerous international prizes, such as the 1967 Ninth Tokyo Art Biennale and was subsequently given the honour of being a cultural ambassador for Flanders and Flemish art.

From 1972, he lived in Gordes for health reasons, finding inspiration in the scenery of the Luberon. He became an honorary citizen of Gordes in 1990.

A museum dedicated to his work opened in 1996. Over two hundred artworks are on display over three levels in the Chateau de Gordes (see page 83).

In 1975, he made a series of murals entitled *Thema* for the Montgomery Metro station in Brussels and he received numerous Belgian honours including Officer of the Order of the Crown in 1990. Belgian stamps were issued several times showing his work. There is a room dedicated to his work in the Antwerp Museum.

He died on February 10th, 1998.

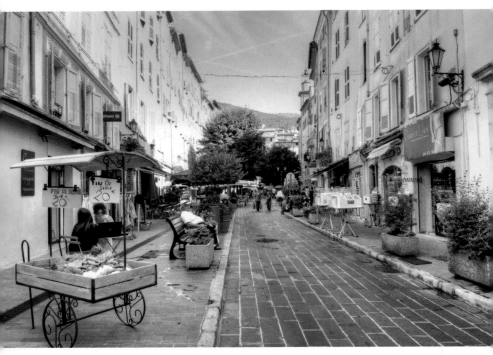

GRASSE (ALPES MARITIMES)

Grasse is a beautiful historic town, often considered the perfume capital of the world, producing over half of all French scents and flavourings.

In the 13th century, Grasse was a centre for leather and tanning. In the Renaissance, a tanner called Galimard sent Queen Catherine de Medici a pair of perfumed gloves which hid the strong smell of the leather. These became popular with the Queen and her retinue and the fashion spread throughout Europe.

Galimard Perfumery was established in 1747 by Jean de Galimard, who was a friend of Goethe, to provide King Louis XV and his courtiers with perfumes, pomades and olive oil.

Jasmine had been introduced by the Moors in the 16th century and this formed the basis for many perfumes. Due to its microclimate, Grasse was ideally located to grow the flowers required to make the different scents as well as having the leather industry to produce the gloves.

PLACES

Galimard Perfumery, the oldest one in Grasse.
Molinard Perfumery, visitors can create their own perfume.
Fragonard Perfumery, an old factory and museum that explains the history of perfumery over 5,000 years. Free.
International Perfume Museum and gardens, the evolution of perfumery and the importance of Grasse to perfume making.
Marine Museum, with model ships on display.
Museum of Provençal Costume and Jewelry.
Saracen Tower, 30m high.
Monumental Gate of the Hotel de Ville.
Grasse Cathedral, Notre Dame du Puy, 11th century, altar piece by Louis Braca, paintings by Rubens and Fragonard.
Church of Placassier, built in 1644.
Gardens of Princess Pauline, panoramic view towards the coast.

VISIT

Trou du Curé, cave 60m underground.
Saint Sauveur waterfall and cave.
Loup valley.

FESTIVALS

Rose Expo, May.
Jasmine Festival, August.

www.grasse.fr

PEOPLE
DIRK BOGARDE OBE
(1921 – 1999)

"It's all in the game and the way you play it."

An English author and movie star best known for his *Doctor in the House* films and *Victim* which helped to change the law relating to homosexuality.

Derek Van den Bogaerde was born in Hampstead on March 28th, 1921. His mother, a celebrated beauty, encouraged him to act, while his father, the art editor of *The Times,* wanted him to follow a career in the arts.

During World War II, he served in the Air Photography Intelligence Service and had the traumatic experience of helping to liberate the concentration camp at Bergen-Belsen.

After the war, he was signed to Rank, appearing in *The Blue Lamp, The Sea Shall Not Have Them* and many other films, but it was the *Doctor* series which made him a star. In 1961, after over thirty films, he starred in *Victim,* about a barrister who decides to go public rather than suffer blackmail on account of his homosexuality. His fans deserted him so he accepted low budget films with director Joseph Losey, such as *The Servant* and *Modesty Blaise.* He also worked with many European directors, including Visconti on *Death in Venice* (1971), Cavani on *The Night Porter* (1974) and Resnais on *Providence* (1977). He won BAFTAs for *The Servant* (1963) and *Darling* with Julie Christie in 1965.

From 1970, Bogarde began to restore an old farmhouse called "Le Haut Clermont" near Grasse where he lived with his partner and manager Tony Forwood. Forced back to England in 1983, he nursed Forwood through a terminal illness until 1988.

His autobiography was a success as were his novels, including *West of Sunset (*1984). Promoted to Commander in the French Order of Arts and Letters (1990), he was also knighted by the Queen in 1992.

Aged 78, he died on May 8th, 1999. His ashes were later scattered at "Le Haut Clermont"in Grasse.

IVAN BUNIN (1870 – 1953)

"It takes half an hour to climb to our villa, but there's not another view in the whole world like the one that's facing us"

A Russian writer who won the Nobel Prize for Literature in 1933 and was seen as the successor to Tolstoy and Chekhov.

Born in Vorónezh on October 22nd, 1870, he grew up on his father's estates in the countryside. His father's gambling debts impoverished the family and Bunin had to leave school temporarily in 1886 until his school fees were paid by his older brother.

In 1890, he taught himself English and translated Longfellow's *Song of Hiawatha*, then moved to St. Petersburg and finally Moscow where he met more established writers. He worked as a journalist and had his first short story collection published in 1897 followed by poetry in 1900. His rich language was called Bunin 'brocade'.

He married Anna Nikolaevna Zakhni in 1898 but when their son died at the age of 5, the marriage broke down.

In 1906, he married Vera Muromsteva and they travelled to the Middle East but his infidelity caused problems.

He won the Pushkin Prize and was elected to the Russian Academy of Sciences in 1909. He wintered in Capri with Maxim Gorky and was inspired to write *The Gentleman from San Francisco* about the death of an American travelling in Europe. He fell out with Gorky and wrote for an anti-Bolshevik newspaper until the revolution, when he left for France, settling near Grasse.

Best known for *The Village* (1910) *Dry Valley* (1912), *The Life of Arseniev* (1939), *Dark Avenues* (1946) and *The Accursed Days* (1926), he was awarded the Nobel Prize for Literature in 1933, gave

100,000 francs of the prize money to charity and became the voice for Russian émigré writers in France.

During the war he lived in "Villa Jeanette" with his wife and two other writers, high up in the mountains. He sheltered a Jewish writer despite the proximity of a German outpost.

He died on November 8th, 1953 and is buried in the Sainte-Genevieve-des-Bois Russian Cemetery.

ANDRE GIDE (1869 – 1951)

"Believe those who are seeking the truth. Doubt those who find it."

A French novelist, critic and winner of the Nobel Prize for Literature (1947), he was often in conflict with religious conventions of the day.

He was born into a protestant family in Paris on November 22nd, 1869, the son of a law professor who died in 1880. Gide was bullied at school and eventually realised he was gay during a trip to Algeria in 1893. He met Oscar Wilde and Lord Alfred Douglas there in 1895. He married Madeleine Rondeaux the same year but the marriage remained unconsummated. *The Notebooks of André Walter* (1891) helped him to establish himself as a writer at a young age.

In 1908, he started the *Nouvelle Revue Française* and formed a literary circle in Paris. He formed a friendship with Elisabeth van Rysselberghe and they had a daughter, Catherine. But Gide had already started a close relationship with a 15-year-old boy, Marc Allegret, the son of a friend, in 1916, and they travelled together first to London in 1918 then around Africa, with Gide writing critically of French colonialism in 1927–1928. *Corydon* was published in 1924 to controversy, due to Gide's espousal of male sexual love. Other novels include: *The Immoralist,* (1902) *Straight is the Gate* (1909) and *The Counterfeiters* (1925). The Roman Catholic Church later banned all his books.

He flirted with communism until he visited Russia in 1936 where he was disillusioned by the inhumanity he witnessed. He first stayed at "Villa La Messuguière" in Cabris in 1939 then regularly visited the area around Grasse for holidays and relaxation.

During the German Occupation he went to live in North Africa, writing his journal, which was published in three volumes.

He died in Paris on 19th February, 1951. A street in Cabris is named after him.

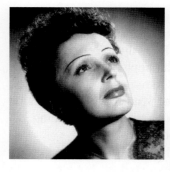

EDITH PIAF (1915 – 1963)

A French singer who became a national icon, nicknamed 'The Little Sparrow.'

She was born on December 19th, 1915 as Édith Giovanna Gassion in Belleville, Paris. Her father was a street performer and her mother was a café singer who abandoned her. She was brought up in her grandmother's brothel in Normandy. When she was 14, she joined her father's act. At 17, she had a daughter, Marcelle, with boyfriend Louis Dupont. But Piaf was unable to care for the child, who died of meningitis, aged 2.

At 20, she was discovered by nightclub owner Louis Leplée. She sang at his Paris club and began a recording career. When Leplée was murdered in 1936, Piaf teamed up with Raymond Asso and developed friendships with Cocteau and Maurice Chevalier. She brought Yves Montand into her act and the pair became the most popular entertainers in France, performing at the Paris Olympia.

Her hits included: *La Vie en rose* (1946), *Non, je ne regrette rien* (1960), *Hymne a l'amour* (1949), *Milord* (1959), *La Foule* (1957), *L'Accordeoniste* (1955), and *Padam... Padam...* (1951).

After World War II, she began touring internationally and helped to promote Charles Aznavour as her support act. The pair were badly injured in a car accident which led to Piaf developing a morphine addiction to add to her alcohol problems. Rehab failed to free her from her dependencies.

She was slow to win over American fans but by the end of the 50s she was a regular on the *Ed Sullivan Show* on American TV and she performed at Carnegie Hall twice.

Piaf was married to Jacques Pills from 1952–56. In 1962, she married Theo Sarapo (Lamboukas), a young Greek singer. They sang together during her last performances.

Piaf had a house in Cap-Ferrat but lived in Plascassier, near Grasse. She died of liver cancer on October 11th, 1963. She is buried in the Père Lachaise Cemetery in Paris next to her daughter.

H. G. WELLS (1866 – 1946)

An English writer best-known for his science fiction.

Born in Bromley on September 21st, 1866, the son of a tradesman, he left school aged 14 and worked as an apprentice draper before becoming a pupil-teacher at Midhurst Grammar School. At 18, he won a scholarship to the Royal College of Science where he became interested in biology and evolution but left before finishing his degree. He later completed a BSc in Zoology.

He married his cousin Isabel in 1891 but they separated in 1894 and Wells then married Amy Catherine, a student, but went on to have several relationships with other women, fathering four children by three different mothers.

He published the popular novels, *The Time Machine* (1895), *The Island of Dr. Moreau* (1896), *The Invisible Man* (1897) and *The War of the Worlds* (1898) all of which were later adapted as films. He also wrote about technology and the future including: *The Discovery of the Future* (1902) and *Mankind in the Making* (1903); he joined the intellectual Fabian Society where he argued for urgent social change but fell out with George Bernard Shaw.

He visited Russia in 1914 and 1920 and met Lenin; what he saw changed his thinking about revolution. His book *The Outline of History* (1920) was hugely successful. He argued for the advent of the League of Nations but it was unable to prevent World War II.

In 1923, he became involved with French socialite Odette Keun. They lived near Grasse in Magagnosc and Malbosc, building their own villa, 'Lou Pidou'. He wrote his collection of short stories and

The Work, Wealth and Happiness of Mankind there.

He was writing about the dangers of nuclear war when he died on August 13th, 1946, at his home in Regents Park, London.

HYERES-LES-PALMIERS (VAR)

The port was established in the 4th century BC by the Greeks as Olbia. The old town was established in Roman times and the ruins of its medieval castle, which was destroyed by Cardinal Richelieu in the 17th century, remain visible on top of the hill. In the 19th century, many wealthy winter residents built elegant villas in the town, creating the first luxury resort on the Côte d'Azur.

Palm trees line the avenues that lead up to the cobbled squares of the old town where the Place Massillon with its 12th century tower can be found. Above the Place Massillon you can explore a maze of alleyways leading up to the Castel St-Claire or the Villa Noailles and there are fine views towards the sea.

There is a seaside resort on the coast, a yacht marina and a nearby nature reserve which is home to many species of birds around the salt marshes next to the road to the Giens peninsula.

There, you can take a ferry to the nearby Iles d'Or, comprising the unspoilt nature reserve of Port-Cros, the naturist resort of Le Levant and the most popular, the Porquerolles.

PLACES
Villa Noailles, modernist villa, now an arts centre.
Park St Bernard, offers view of Giens, the bay and the islands.
Castel St Claire, a former convent and home to Edith Wharton.
Templars Tower, in Place Massillon, now an art gallery.
Hyères Museum, ave Joseph Clotis.
Archaeological Site of Olbia, Almanarre.
Almanarre Beach, famous windsurfing and kite surfing beach.
Port of Hyères, marina and restaurants.
Museum of the Mine, Le Pradet, mineral exhibition in a mine.
Bormes-les-Mimosas, a beautiful old hill *village fleuri*.
Carquerainne (right), seaside resort with summer theatre venue in a fort.

VISIT
Giens Peninsular, take a ferry to the Iles d'Or (or Porquerolles).
The Iles d'Or, unspoilt islands with a wildlife reserve and a naturist resort. The largest has sandy beaches, hotels and bars.
Plage de Bregançon, unspoilt beach, not commercialised.

FESTIVALS
International Youth Arts Festival, Theatre Denis, February.
Mimosa Festival at Bormes-les-Mimosas, February.
Go Play One, exhibition of video games and Manga comics, June.
MIDI music festival, July.
Hyères Festival on the beach, July-August.

www.hyeres-tourism.com

JOSEPH CONRAD (1857 – 1924)

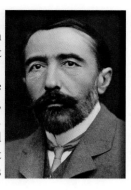

A Polish-born writer famous for his novels in English, regarded as a precursor of modernist literature.

He was born in Berdichev, a part of the Ukraine owned by Poland, on December 3rd, 1857, as Jozef Teodor Konrad Korzeniowsk. His father was part of the intelligentsia and was imprisoned for political activism. At 12, both his parents died of TB and he was brought up by his uncle.

In 1874, he left Poland to avoid conscription and joined the French merchant navy in Marseille but was unable to continue without permission from the Russian authorities. He ran up gambling debts and tried to shoot himself. Later, he joined the British merchant navy and worked his way up to the rank of captain over many years at sea. It was while he was recovering from his trip to the Congo on a steamer that he began writing *Almayer's Folly* (1895). His novels and stories were heavily influenced by his experience of sea-faring. He often based his characters on real people he had met. His anti-heroes often give in to the dark impulses that are driving them on.

In 1896, Conrad married the much younger Jessie George and they had two sons, Borys and John. He was able to read Polish, French and English but chose to write in English because he found a ready market for his work which was initially published in magazines and journals. His novels include: *Lord Jim* (1900), *Heart of Darkness* (1902), *Typhoon* (1903), *Nostromo* (1904) and *The Secret Agent* (1907), all of which have inspired films with *Apocalypse Now* (1979) directed by Francis Ford Coppola being the most well-known example.

Conrad suffered from ill-health and often spent the winters in the milder climate of Hyères. His last novel, *The Rover* (1922), is set on the Giens Peninsula.

On August 3rd, 1924, he died and was buried at Canterbury near his home in Kent. A monument to him was erected at Gdynia, on the Baltic coast in Poland and a plaque in Sydney's Circular Quay in Australia commemorates his visits there as a sailor.

HENRY JAMES
(1843 – 1916)

An American-born English writer, one of the leading exponents of literary realism, numbering Zola, Flaubert, Tennyson and Turgenev among his friends. Born on April 15th, 1843, in New York City, he was the son of a wealthy theologian whose intellectual circle included Thomas Carlyle, Ralph Waldo Emerson and Henry David Thoreau. Tutored in Europe, his brother William became a psychologist and his sister Alice, a notable diarist.

Henry James lived in Paris briefly before moving to London in 1876. He wrote short stories and reviews for magazines, notably the ghost story *The Turn of the Screw* (1898) before writing novels which explored the diferent world views of Americans and Europeans. He moved to Rye in East Sussex in 1897 and became a British subject in 1915, after World War I.

His novels include: *The American* (1877), *Washington Square* (1880), *Portrait of a Lady* (1881), *The Bostonians* (1886) and *The Ambassadors* (1903). Many of his novels have been adapted into films, such as Jane Campion's *Portrait of a Lady* (1996).

He visited the French Riviera frequently and wrote about it in *A Little Tour In France* (1884). He often resided with fellow American Edith Wharton in Hyères but never married, with biographers hinting at homosexual liaisons.

He was awarded the Order of Merit by King George V.

He died in London on February 28th, 1916 and in 1976 was honoured in Poets' Corner at Westminster Abbey. His ashes are interred in the USA at Cambridge, Massachusetts.

HENRY JAMES BY JAMES SINGER SARGENT, NATIONAL PORTRAIT GALLERY UK.

ROXANE MESQUIDA IN 'RUBBER'
PHOTO: MAGNOLIA PICTURES 2010

ROXANE MESQUIDA (1986 –)

A French actress and model based in Los Angeles.

Born on October 1st, 1981, in Marseille, France, she grew up in Le Pradet, a small town near Hyères. Her mother, Françoise Mesquida, is a writer of French/Spanish origins and her father is an American of Italian descent. Multi-lingual, she can speak English, French, Spanish, Italian and German.

Discovered by French director Manuel Pradal walking along the street at the age of 11, she was soon in her first film *Mary from the Bay of Angels* (1998). At 14, she was signed to Elite Model Agency and has appeared in numerous magazines including *Vogue, Harper's Bazaar* and on the cover of French *Playboy*. Her style has been admired by many fashion writers.

She appeared with Isabelle Huppert in *The School of Flesh* (1998) by Benoît Jacquot. But it was female director Catherine Breillat who developed her talent, first in *Fat Girl* (2001) then in *Sex Is Comedy* (2002), and then again in *The Last Mistress* (2006).

In 2006, Mesquida also appeared in horror flick *Sheitan*, by Kim Chapiron, alongside star Vincent Cassel. She then moved to the USA and gained a role in *Kaboom,* by indie director Gregg Araki then *Rubber* by Quentin 'Mr. Oizo' Dupieux.

From 2011 to 2012, she became a familiar face on TV as Béatrice Grimaldi, the sister of Louis Grimaldi (Hugo Becker) in the fifth season of the American series *Gossip Girl.*

She also starred in the New Zealand film *The Most Fun You Can Have Dying* by Kirstin Marcon, as well as *Kiss of the Damned* by Alexandra Cassavetes (the daughter of John Cassavetes), and *Homesick* by young independent filmmaker Frédéric Da.

She now divides her time between Paris and Los Angeles, where she lives in Charlie Chaplin's former house in West Hollywood.

VICOMTE CHARLES DE NOAILLES (1891 – 1981)

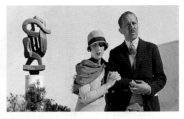

Charles de Noailles was a French aristocrat, horticulturalist and patron of contemporary arts. He was born in Paris on September 26th, 1891, the son of an English mother and the French Prince Poix. He married Marie-Laure, an extrovert heiress and descendant of the Marquis de Sade, in 1923.

Charles had an interest in the avant-garde and in 1923 he commissioned Picasso to paint a portrait of his wife as well as contracting modern architect Robert Mallet-Stevens to build a new villa in Hyères. They began to collect paintings and sculptures by artists like Giacometti, Ernst, Miro, Klee, de Stael, Mondrian and Picabia. Composers and writers such as Poulenc and Cocteau were invited to become part of their circle. By 1929, they were financing surrealist films such as Dali and Bunuel's controversial *L'Age D'Or,* Man Ray's *Les Mysteres du Chateau de Dé* (1929) and Jean Cocteau's *Le Sang d'un Poete* (1930).

They had an open marriage with Charles regularly taking male lovers. Marie-Laure was involved with many men including Michel Petitjean, radical editor of *La Fleche*, a German officer during the Occupation and a Spanish painter, Oscar Dominguez who is reported to have switched her Picasso paintings for fake ones and sold them.

A keen horticulturalist, Charles de Noailles wrote a seminal book called *Plantes de Jardins Mediterranéens* with Roy Lancaster. He commissioned a triangular garden by Gabriël Guévrékian at Villa Noailles (left) and created a more traditional garden at his country

house near Grasse. He also helped restore the gardens at Fontainebleau around the house of the King's mistress, Madame de Pompadour.

Charles outlived his wife by forty years. He died on April 28th, 1981, at the age of 90.

Villa Noailles is open to the public.

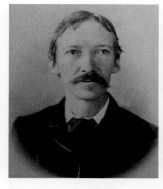

ROBERT LOUIS STEVENSON (1850 – 1894)

"I wish to God I had died in Hyères."
A Scottish poet, novelist and travel writer, best-known for his books *Treasure Island* (1883), *Kidnapped* (1886) and *The Strange Case of Dr. Jekyll and Mr. Hyde* (1886).

Born in Edinburgh on November 13th, 1850, the son of an engineer. He studied engineering at Edinburgh University, then law, but due to poor health, he went to Menton to convalesce in 1873. This began a life-long love of France and inspired him to write travel stories such as *An Inland Voyage* (1878) and *Travels with a Donkey in the Cevennes* (1879). He visited artist colonies near Paris and became friends with Rodin.

It was in Paris in 1876 that he met an American named Fanny, estranged from her husband, and followed her and her children back to California where they later married. He began to write short stories including his series of Arabian Nights stories which were first published in magazines. Sir Leslie Stephens – Virginia Woolf's father – was one of his early advocates.

On holiday in Scotland in 1881, he developed the idea of 'Treasure Island' to amuse his 12-year-old stepson and this led him to write more children's stories and boys' adventure tales which earned enough money for him to live from his writing. In 1883, he went to Hyères and stayed at the Grand Hotel, then later rented a villa in Rue Victor-Basch. He wrote then: *"That spot in our garden and our view are sub-celestial. I sing daily with Bunian, that great bard. I dwell next door to Heaven!"*

In 1888, he travelled around the Pacific islands, finally settling in Samoa with his wife and family. His stepdaughter worked as his secretary. His writing took on a new realism, reflecting the harsh ways of life among the traders and sailors in the South Seas .

In later years he wrote from his retreat in Valima: *"Happy (said I); I was only happy once; that was at Hyères."* He died in December 1894 and was buried on Mount Vaea in Samoa.

CASTEL SAINTE-CLAIRE

EDITH WHARTON (1862 – 1937)

An American novelist, short story writer and garden designer, she became the first woman to win the Pulitzer Prize for Literature.

Born in New York City, September 24th, 1862, into a privileged family, she was encouraged to write by Longfellow and became friends with Theodore Roosevelt and Henry James. At 23, she married Edward Wharton but his depressive illness became gradually more serious and she eventually divorced him in 1913.

She designed and built 'The Mount' in 1902 in Lenox, Massachusetts. The people she met in the small villages near Lenox, gave her material for *Ethan Frome* (1911).She also enjoyed satirising upper-class social conventions and wrote the bestselling *The House of Mirth* (1905).

She lived in Paris in the winter from 1907, travelling with her husband and Henry James through France by car and writing *A Motor-Flight through France (*1908). She met and had an affair with *Times* journalist Morton Fullerton which lasted three years. Her husband also had an affair in Boston and spent his wife's money on his mistress. Wharton raised money for the relief of refugees, for sick soldiers and orphans during and after World

War I, which led to her award of the French Legion of Honour.

She first visited Hyères in 1915 with the French author, André Gide, and was a regular guest of Paul Bourget at his villa in Hyères. She finished her novel *The Age of Innocence*

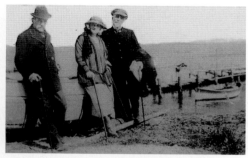

EDITH WHARTON WITH PAUL BOURGET (LEFT) AND JOSEPH CONRAD AT LA MADRAGUE IN GIENS, HYERES.

in 1920, for which she won the Pulitzer Prize.

In 1923, she was the first woman to receive an honorary Doctorate of Letters from Yale, returning to the USA to receive it. She was also the first woman elected to full membership of the American Academy of Arts and Letters in 1930 .

In 1927, she purchased a former convent, Castel Sainte-Claire, which had been the home of naval officer Olivier Voutier who had discovered the Venus de Milo statue. Located in the hills above old Hyères, Wharton had many guests at the villa, including Henry James, Marie-Laure de Noailles and Jean Cocteau. The gardens, which she designed, are now classified as Notable Gardens of France and are open to the public.

Her stories have been adapted for theatre, radio and film many times from the 1920s onwards. Martin Scorsese remade *The Age of Innocence* (1993) and her last unfinished novel, *The Buccaneers,* was developed into a TV mini-series in 1995. In 2000, *The House of Mirth* was given a new film adaptation starring Gillian Anderson.

Wharton died at her home near Paris on August 7th, 1937 and is buried in the American Cemetery, Versailles.

GARDENS AT CASTEL SAINTE-CLAIRE

LACOSTE (VAUCLUSE)

Lacoste is a medieval hilltop village overlooking the Grand
Luberon Mountains to the east. Tiny ancient houses and cobble-
stoned streets give the impression of going back in time. The ruins
of the ancient chateau once owned by the notorious Marquis de
Sade loom large over the village and from there you can enjoy
a great view over the surrounding countryside. The chateau was
looted during the French Revolution. Locals removed many of
the stones for other houses in the village and it gradually fell into
disrepair.

In 1952, college professor André Bouer took on the job of
restoring it, then in 2001 fashion designer Pierre Cardin bought
the chateau and continued the restoration works. The apartments
of the Marquis de Sade are now open to the public and an annual
music and theatre festival brings tourists to the village in the
summer. In 1970, an American professor, Bernard Pfriem, created
a school of the arts which attracts international artists and tourists
and gives the village a lively feel. Recently awarded Village en
Poésie status, poetry events are now a regular feature in the village.

PLACES

The Chateau de Lacoste (see opposite page).
The Old Temple, for arts events.
Pont Julien, from 3 BC, Roman bridge on former Roman road.
The Cedar Forest, via D3 to Menerbes.
Outdoor Cinema, Bonnieux, Menerbes, summer only.
Hot Air Balloon Flight, Roussillon (www.montgolfiere-luberon.com)
L'Eglise Louise Bougeois, Bonnieux, paintings by the artist.
Bakery Museum, 12 Rue de la Republique, Bonnieux.
Corkscrew Museum, at Domaine de la Citadelle, Menerbes.
Dora Maar's house, Menerbes.
The Château de la Canorgue, where they filmed Ridley Scott's *A Good Year,* near Bonnieux.
Musée d'Histoire et d'Archéologie du Pays d'Apt, 27 rue de l'Amphithéâtre, Apt.
Musée de l'Aventure Industrielle du Pays d'Apt, 14 Place du Poste.
Site archéologique de Tourville, Gondonnets, Saignon.
Truffles Market, December, Menerbes.

FESTIVALS

Lacoste Arts festival, July.
Kite Flying Festival, Viens, July.
Cinéma en Luberon Month, Saignon, Théâtre de Verdure, July-Aug.
Creche Festival, December-January, Bonnieux.

www.lacoste-84.com

PEOPLE
PIERRE CARDIN (1922 –)

A French fashion designer and restaurateur born in Venice, Italy on July 2nd, 1922 but educated in France.

Cardin began in tailoring, but by 1945 he had worked his way up to collaborate with top designer Elsa Schiaparelli. He met Cocteau and helped design masks and costumes for his film *La Belle et La Bête*. In 1946 he joined the new Christian Dior company and by 1950, he began his own business.

His bubble dress was a hit in 1954 and in 1957 he went to Japan where he further developed his design ideas, introducing bold geometric shapes and unisex styles. Not content with designing women's wear, he expanded to offer menswear, children's wear, ceramics, perfume and jewelry.

In 1970, he launched the Espace Pierre Cardin in Paris which housed a theatre, restaurant and cinema. He has received the Golden Thimble award for innovative fashion design three times.

He visited China in 1978 and expanded his business internationally opening shops in China and Europe. In 1981, he opened his first Maxim's restaurant in Paris. A chain of Maxim's restaurants and hotels around the world followed.

Many retrospectives of his design work have been held at museums in New York, Paris, Tokyo, London, Montreal and Vienna. Cardin bought a palazzo in Venice named 'Ca' Bragadin' which some say was once the home of Giacomo Casanova, while others say it was the home of the Bishop of Verona.

He became a UNESCO Goodwill Ambassador in 1991 and designed jewelry that was sold in aid of the Chernobyl disaster.

In 1994, he opened his own Design and Fashion Institute and in 1997 became a Commander of the French Legion of Honour. In March 2001, he bought the chateau at Lacoste and in July launched the first arts festival there. He has since restored the chateau, opening parts of it to the public. He has bought over twenty houses in the village creating employment and attracting tourism.

MARQUIS DE SADE
(1740 – 1814)

Donatien Alphonse Francois Comte de Sade, the Marquis de Sade, was a French philosopher and writer of erotic fiction who advocated sexual freedom and opposed the Catholic church. His enjoyment of inflicting pain on others led to the term sadism.

Born to an aristocratic family in Paris on June 2nd, 1740, he had a privileged but emotionally deprived upbringing at court; his father left and his mother retired to a convent while he was a young child. He was said to have fought physically with the child prince and been sent away to the South of France in disgrace. When he was 10 years old he was whipped for misbehaving at school which created an obsession with the punishment.

As a young man he frequented prostitutes and was arrested for blasphemy due to a sex act involving a cross. His father married him off to the daughter of a wealthy government administrator, Renée-Pelagie, with whom he had three children.

The chateau saw numerous orgies involving local girls which led to further scandal. The Marquis' repeated acts of abuse, sodomy and rape of minors and servants led to his exile to Italy and his eventual imprisonment. There, he wrote numerous novels, plays, short stories and political tracts including *Justine* and *120 Days of Sodom.*

He was released during the French Revolution claiming to be an enemy of the aristocracy but his chateau was looted and partially destroyed. In 1810, he was sent to live in the Charenton asylum by Napoleon Bonaparte's administration. He still managed to conduct a sexual relationship with a 13-year-old girl while there.

He died on December 2nd, 1814.

DORA MAAR (1907 – 1997)

A French photographer and painter of Croatian descent, who became one of Picasso's lovers and the muse for his weeping woman portraits in the 1930s.

She was born in Paris, on November 22nd, 1907 as Henriette Théodora Markovitch. Her father was an architect and the family moved to Buenos Aires for his job, where she grew up speaking Spanish. Her family returned to Paris in 1926, and she began studying art and photography.

As a photographer, she took on the name Dora Maar, and she became part of the Surrealist movement with André Breton, Man Ray and Paul Eluard. She met Picasso in 1936 and their affair began following a meeting in Les Deux Magots, a café in St.Germain-des-Prés, where she cut her hand playing a knife game.

Picasso painted her portrait several times, his *Weeping Woman* (1937), being the most well-known painting. They photographed each other frequently and she documented his painting of *Guernica* (1937). That year she had her first photography exhibition at the Galerie de Beaune in Paris. She persuaded Picasso to join the Communist Party in 1944 but he soon moved on to a much younger lover, Françoise Gilot. Dora had a nervous breakdown in 1945 and took many years to recover.

Picasso left her his house in Menerbes and gave her some of his paintings. Dora gave up on her photography in the 1950s until the 1980s, but continued to paint, write poetry and became increasingly religious. She exhibited some of her paintings in Paris and London. She began a relationship with James Lord, fifteen years her junior and he wrote a book: *Picasso and Dora: A Personal Memoir.* Picasso sent her a mis-shapen chair as a gift

at one stage. However, she survived him by twenty-four years, and died in Paris on July 16th, 1997.

Picasso's painting 'Dora Maar with Cat' was auctioned for $95.2 million in 2006. Her home in Menerbes is now a centre for young artists.

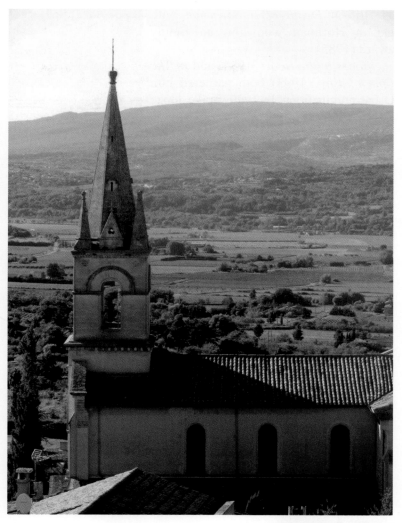

VIEW FROM BONNIEUX

JOHN MALKOVICH (1953 –)

An American actor, producer and director who has also created a fashion label called Technobohemian.

Born in Christopher, Illinois on December 9th, 1953, one of five children, he did many jobs before taking acting classes. In 1976, he joined the Steppenwolf Theatre Company in Chicago. *True West* saw him win an OBIE award then his Broadway debut

as Biff in *Death of A Salesman* with Dustin Hoffman won him an Emmy award (1985).

*Places in the Heart (*1984) and *In The Line of Fire* (1993) both garnered him Oscar nominations. In 1999, Spike Jonze directed him in *Being John Malkovich, a* surreal comedy.

Malkovich has co-produced many indie films including *Juno* and has appeared in more than seventy movies including *Dangerous Liaisons* where his relationship with co-star, Michelle Pfeiffer led to divorce from his first wife Glenne Headly. He later met Nicoletta Peyran on the set of *The Sheltering Sky.* They were married in 1989 and have a farmhouse near Bonnieux. Fluent in French, he also became involved in a local theatre near Saint-Tropez.

He lost $2m in the Madoff ponzi scheme and left France in a dispute over taxes in 2009. Since then he has lived in Cambridge, Massachusetts, USA.

TOM STOPPARD OBE (1937 –)
A British playwright and screenwriter knighted in 1997.

Born Tomás Straüssler on July 3rd, 1937, in Zlín, Czechoslovakia, his family fled the Nazis and he grew up in Singapore where his father was killed during the war. He moved to England in 1946 with his mother and stepfather, and got his first job as a journalist with the Western Daily Press (1954). In 1962, he became a theatre critic for *Scene* magazine and began

writing plays for radio and TV including *Rosencrantz and Guildenstern Are Dead* (1966) which premiered at the Edinburgh Fringe before transferring to London and Broadway where it won a Tony Award for Best Play (1968).

Travesties (1974) was first staged by the Royal Shakespeare Company then transferred to New York where it also won a Tony Award for Best Play (1975).

Inspired by his friendship with Czech dissident Viktor Fainberg, he wrote *Every Good Boy Deserves Favour* (1976) and campaigned for dissidents including Vaclav Havel, who later became the last president of Czechoslovakia and the first president of the new Czech Republic (1993). *Professional Foul* was written for Amnesty International's Prisoner of Conscience Year (1977).The Tom Stoppard Prize he created in 1983 is awarded to authors of Czech origin. His play *Rock n Roll* (2006) deals with the artistic dissent against communism from the 60s to the 90s.

The Coast of Utopia (2002), was a trilogy set in 19th century Russia and produced by the National Theatre in London in 2002.

Married twice, first to Josie Ingle (1965–1972) and then to Dr Miriam Stoppard (1972–1992), he has two sons from each marriage, one of whom is actor Ed Stoppard. He was also in a long-term relationship with actress Felicity Kendal which led to the break-up of his second marriage.

Tom Stoppard bought a property in Lacoste in 1994 and extensively remodelled the villa which he called 'Utopia'. He co-wrote the screenplay for *Shakespeare in Love* there. He later won an Academy Award for Best Original Screenplay for *Shakespeare in Love*. He sold the property in 2007.

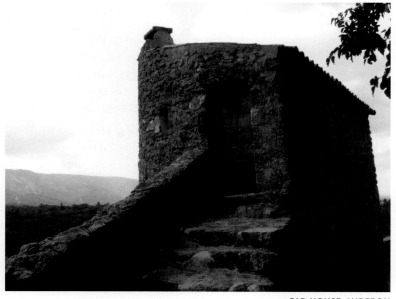

OLD HOUSE, LUBERON

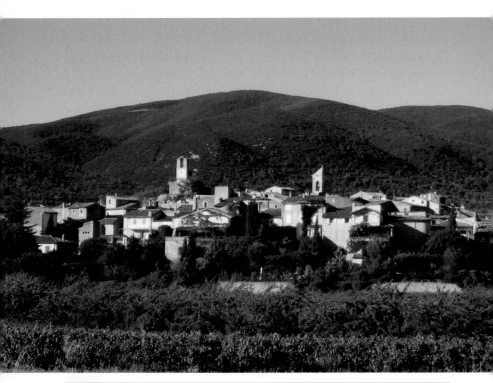

LOURMARIN (VAUCLUSE)

Lourmarin is a picturesque village at the heart of Provence. People have lived at the foot of the Luberon Mountains for thousands of years. In the 12th century, a castle fortress was built and then fortified in the Renaissance. But the town was destroyed by fire in the 16th century in a religious conflict between protestants and catholics. The castle was restored in 1920.

PLACES

The Chateau.
The Temple.
The Bell-tower.
The Artists' Studios, Art Gallery, 12 rue H. of Savornin.
Camus Tour, Tuesdays 10am
Bosco Tour, Thursdays 10am
Village Tour, Fridays 10am

http://www.lourmarin.com

PEOPLE
HENRY BOSCO
(1888 – 1976)

A French poet and novelist who wrote about life in Provence.

Bosco was born on November 16th, 1888 in Avignon into a family of Piedmontese origin. Through his father, he was related to Saint John Bosco, of whom he wrote a biography. His father was a lyric singer, frequently away from home on singing engagements. He was home-schooled by his mother and wrote his first novel aged 7. At 10 years old, he went to school in Avignon and at 16 won a prize for poetry.

He fought in World War I and reached the rank of sergeant, before being hospitalised in Alexandria. After the war he taught at the French Institute in Naples where he met Max Jacob and visited Pompeii. His first novel, *Pierre Lampedouze* was published in 1924. In 1930, he married Madeleine Rhodes and accepted a teaching post in Rabat, Morocco, where he wrote novels and poems and held a literary salon.

In 1945, he was awarded the Prix Renaudot for his novel *The Old Farm Théotime.* He also wrote many books for children, such as *The Child and The River* (1960) and *Fox Island* (1967).

He received the Prix des Ambassadeurs (1949), the Grand Prix National des Lettres (1953), the Prix de l'Académie de Vaucluse (1966), the Grand prix de la Mediterranée (1967), and the Grand prix de l'Académie Française in 1968 for his body of work. Bosco was made a Commander of the French Legion of Honour. He returned to France aged 67 and lived in Cimiez in Nice.

He died on May 4th, 1976 and was buried at the cemetery of Lourmarin.

ALBERT CAMUS (1913 – 1960)

A French Algerian writer and philosopher, awarded the Nobel Prize for Literature in 1957 and an exponent of absurdism.

He was born in Mondovi, Algeria on January 7th, 1913. His father was killed during World War I and his mother moved the

family to Algiers to live with her mother.

Camus won a scholarship to university but TB hindered his studies and his hopes of becoming a professional goal-keeper. He passed his philosophy degree in 1935.

He married actress Simone Hie in 1934 and they set up a theatre company but she had a drug problem and they divorced in 1940. He began working as a journalist in 1938 in Algiers but moved to work on *Paris-Soir* at the start of World War II.

Camus remarried in 1940 to Francine Faure and they had twins in 1945. He published his first novel *The Stranger* (1942) and wrote *The Myth of Sisyphus* exploring man's vain search for meaning. He also joined the resistance movement and worked as the editor of *Combat,* an underground paper.

He wrote plays too: *Caligula* (1942) *Cross Purpose* (1944) and *Les Justes* (1948). After the war he met Koestler, Sartre, Simone de Beauvoir and Maria Casares. He began an affair with Maria.

He went on a lecture tour of the USA in 1946 and published *The Plague* (1947) to acclaim. But from 1949–51 he suffered another bout of TB and moved to Grasse to recuperate. His book *The Rebel* (1952) led to a fall-out with Sartre who was critical of it. He became depressed and wrote *The Fall* (1956) which was well-received. He was the second youngest writer to be awarded the Nobel Prize for Literature (1957) for his writings on human rights and his essay against capital punishment *Reflections on the Guillotine.* The next year he bought a former silk-maker's house in Lourmarin and carried on writing and working in the theatre.

On January 4th, 1960, Camus died from his injuries in a car accident at Villeblevin, on his way back to Paris. He'd wanted to go by rail but his friend, the publisher Michel Gallimard, persuaded him to go by car. He died in the accident too.

In 2009, Nicholas Sarkozy wanted to move Camus' remains from Lourmarin to the Pantheon in Paris, but Camus' son Jean rejected the idea, saying his father would have disliked the honour.

PETER MAYLE (1939 –)

"Silence, that endangered blessing, is still to be found by those who want it. The sky is still a dense and unpolluted blue. And unlike so many other beautiful parts of the world that progress and ease of access have made crowded, bland and predictable, the Vaucluse has somehow managed to retain its individual flavour and quirkiness."

A British author and former advertising executive, Peter Mayle has written many books but he is best-known for *A Year in Provence* (1989). It was adapted for TV, translated into thirty-eight languages and sold more than five million copies. Peter's novel *A Good Year* (2005) was adapted for the screen by Ridley Scott, starring Russell Crowe and filmed at the Chateau La Canorgue near Bonnieux. His books have led to an increase in tourism in the Luberon. He was honoured as a Chevalier in the French Legion of Honour (2002).

He was born in Brighton on June 4th, 1939. His father was posted to Barbados by the Foreign Office and Mayle grew up there. Aged 16, he left school and returned to England and got a job in advertising with Ogilvy as a junior account executive. He worked his way up to become creative director but left in 1975 to write educational books. Following *A Year in Provence* which was about an ex-pat living in Menerbes, he has written *Toujours Provence, Encore Provence, Hotel Pastis* and children's stories.

He left Provence for New York when tourists kept visiting him there but has since returned to Lourmarin. He has been married three times and has five children.

JEAN GIONO (1895 – 1970)

A French novelist whose love of nature imbued his work, much of which was set in the Provence region.

He was born in Manosque on March 30th, 1895. His father was a shoe repairer and his mother a laundry woman. He spent the majority of his life in Manosque. Forced by poverty to leave school, he got a job in a bank in 1911. He joined the army for World War I and was gassed, one of only a handful of survivors

at Verdun. Shocked by the horror of war, he became a pacifist for the rest of his life. He went back to his job in the bank in 1919 and became interested in reading the classics.

In 1920, he married Elise Maurin with whom he had two children. Following the success of his first novel, *Colline* (1929), he left his job to write full time. In his 'Pan Trilogy' the characters are peasants and the natural world is imbued with the spirit of Pan.

In Paris, he attended meetings for peace and joined the Association of Revolutionary Writers and Artists, but when the Communists advocated war, he left the movement. *To the Slaughterhouse* (1931), *Refusal to obey* (1937), and *Letter to the farmers on poverty and peace* (1938) were pacifist writings. Each year he gathered with a group of pacifists in the hamlet of Contadour, and published the *Cahiers du Contadour*. He was imprisoned briefly for his pacifism in 1939.

That my joy might remain (1935) suggests that real wealth lies in the ideal of the rural community which should resist the drive towards industrialisation.

During World War II many of his reactionary ideas chimed with those of the Vichy regime but his play *The carriage rides* was banned by the government. He was put on a writers' blacklist by French Liberationists and imprisoned for five months at the end of the war by the French resistance who disliked his pacifist ideas. André Gide spoke in his defence and he was released without charge. He became disillusioned with politics. He was elected to the Academy Goncourt in 1954 and was inducted into the French Legion of Honour.

He received the Prix Bretano and the Prix de Monaco for his work. Marcel Pagnol based three of his films on Giono's books, *Jofroi, The Baker's Wife* and *Regain*.

Giono died in Manosque on October 8th, 1970 of a heart attack.

There is a centre which honours his work in Manosque.

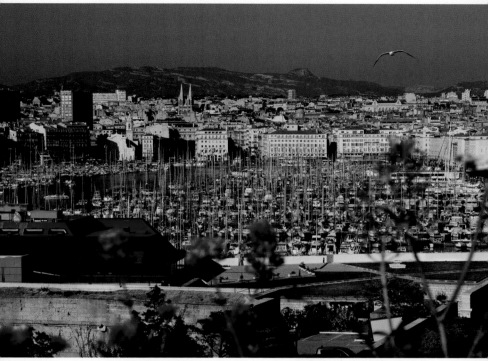

PHOTO: ANTON DENISENKO

MARSEILLE (BOUCHES-DU-RHONE)

The oldest city in France, with Greek and Roman origins, dating back some 2600 years. It's the second biggest city in France too, with over one million residents and is the capital of the Provence-Alpes-Côte d'Azur Region.

In the 19th century, Marseille was the main port connecting France with the developing French Empire in North Africa and the Orient. The opening of the Suez Canal in 1869 increased trade, and the coming of the railway linking Paris and Marseille in 1848 increased tourism. The port is still a main embarkation point for mediterranean cruise ships as well as a busy port for commercial shipping. Due to its historic links with North Africa, a large community of immigrants from the continent has settled there. In 2013, Marseille was a European Capital of Culture.

La Marseillaise is the national anthem of France and was first sung by soldiers in the city in 1792. It was then known as the

War Song for the Army of the Rhine. It was adopted as the anthem of the new French Republic in 1795.

Nowadays, Marseille is a major centre for black music.

PLACES

Basilica of Notre Dame de la Garde, (la Bonne Mere) dominates the city from its highest point. A lighthouse, fort and holy place it now has a museum explaining its 800 year history (see page 122).

Natural History Museum, Longchamp Palace.

Palace of Fine Arts, French, Italian and Nordic school of painting.

Pharo Palace, built by Napoleon III for Empress Eugenie, gardens and view of the bay.

The Opera House, fine example of art deco style.

History Museum, 2, rue Henri-Barbusse.

Marseille Cathedral, Byzantine-Roman style built 1852.

Fort Saint Jean, Old Port.

Museum of European and Mediterranean Civilization, Old Port.

Museum of Folk Culture at Château-Gombert.

Museum of Contemporary Art, 69 ave Haifa.

Museum of Arts from Africa, America and Oceania, Centre de la Vieille Charité, 2 rue de la Charité.

Museum of Mediterranean Archeology, Centre de la Vieille Charité (1st floor).

Cantini Museum, contemporary art collection, 19 rue Grignan.

Borely Museum of decorative art and fashion.

Cabinet of Coins and Medals, 10 rue Clovis-Hugues.

Motorcycle Museum, 18 traverse Saint-Paul,Quartier du Merlan.

Buzine Castle and gardens.

Abbey of Saint-Victor, from 5th century.

VISIT

Frioul Islands by ferry from the port, bird and wildlife sanctuary.
Chateau d'If (right), a fortress located on the island of If, in the Bay of Marseille, famous due to Dumas' novel *The Count of Monte*

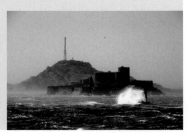

PHOTO: VINCENT

Cristo (1844). Once a prison for revolutionaries, troublesome aristocrats and anti-royalists. More recently used as a location for the films *The French Connection* (1971) and *The Bourne Identity* (2002).

Basilica of St-Maximin-la-Ste-Baume, with relics of Mary Magdalene.

FESTIVALS

Open 13, Men's Tennis Tournament, mid-February.
Spring Carnival and Parade, mid-March.
Russian Festival, Théâtre Toursky, mid-March-April.
Sailing Festival, early April, attracts stars of the sailing world.
Marseille Festival, dance, theatre, music, visual arts June-July.
Garden Blues Festival, Jardin de la Barasse-St. Marcel, local and international blues performers over three days in June.
Soshi Freestyle Cup, an international festival of extreme and sea sports, with live music, end of June.
Bastille Day Festival, music and dance, parade and fireworks in the Old Port, 13th-14th July.
FID Marseille, documentary film festival, July.
Gay Pride Festival, July.
Five Continents Jazz Festival, Longchamp Palace, July.
MIMI Festival of avant-garde music, Ratonneau Island, July.
Festival of the Virgin – a procession of St Mary through the Panier district from the Eglise Saint-Laurent, August.
Marsatac, electronic music festival, Sep.
Festival of the Wind, international Kite-flying festival, Plage du Prado, September.
Regatta for the Juris' Cup, teams of lawyers compete in a sailing race which starts at Quai Marcel Pagnol, September.
International Fair, Parc Chanot exhibition centre, Sep-Oct.
La Fiesta des Suds, world music festival, Oct.
Tasting Week, a celebration of French gastronomy, Oct.
Winegrowers and Farmers Fair, Parc Chanot Centre, Nov.
Santon Fair, allées de Meilhan, Nativity Creche, Nov-Dec.

www.marseille.fr

INTERIOR NOTRE DAME DE LA GARDE

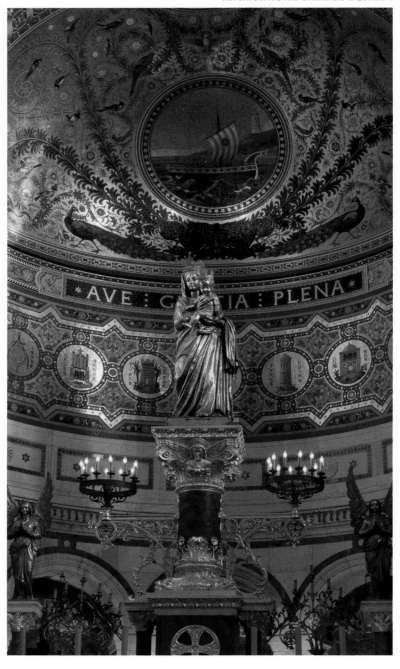

PEOPLE
ANTONIN ARTAUD
(1896 – 1948)

"No one has ever written, painted, sculpted, modelled, built or invented except literally to get out of hell."

A French playwright, poet, theatre director and actor, responsible for changing modern theatre.

Born in Marseille on September 4th, 1896, as Antoine Marie Joseph Artaud of Greek ancestry, he suffered from meningitis as a young child, which led to a nervous disposition and frequent depression.

In 1920, he moved to Paris and became involved with theatre, initially as an actor. In 1925, he became a leading exponent of the Surrealist movement and he wrote the scenario for the first Surrealist film, *The Seashell and the Clergyman* (1928) said to have inspired Dali and Bunuel.

From 1926–28, he ran the Alfred Jarry Theatre, along with Roger Vitrac, directing many plays. In 1931, his manifesto for a 'Theatre of Cruelty' was published advocating an end to bourgeois theatre and its replacement with a more primitive, ritual theatre of violence and blood, to put the audience in touch with its base instincts. He tried to demonstrate his theories with a stage version of Shelley's *The Cenci,* but this closed after only 17 performances.

He went to Mexico, where he came off heroin but took peyote and wrote *Voyage to the Land of the Tarahumara.* During a trip to Ireland in 1937 his mental health deteriorated and he spent the rest of his life in mental hospitals.

The Theatre and Its Double (1938) contained the two manifestos of the Theatre of Cruelty. His work *To Finish with God's Judgement* was banned on French radio in 1948 and not given a broadcast until thirty years later.

Artaud wrote some of his best poetry in his final years. He was diagnosed with cancer and died on March 4th, 1948, alone, in a mental hospital. Susan Sontag wrote that Western theatre can be divided into: *"...before Artaud and after Artaud."*

ERIC CANTONA (1966 –)

"I try to find different ways of expressing myself. Without that I'll die."

A retired French international footballer, now an actor, living in Le Beaume, near Marseille.

Cantona was born on May 24th, 1966 in Marseille. His father was a goal-keeper. Cantona began with his local team, SO Caillolais, also as a goal-keeper, but tried out several other positions during the two hundred matches he played for them.

Other teams he played for in France included Auxerre, Martigues, Marseille, Bordeaux, Montpellier and Nimes. He moved to Leeds United in the UK before he went to Manchester United, where he became a firm favourite with the fans who nicknamed him 'King Eric'. He also made forty-five appearances for the French National team and scored twenty goals.

At Manchester United, he won four Premier League titles in five years and two League and FA Cup Doubles, helping to revive the fortunes of the club. His Number 7 shirt had been sported formerly by George Best and Bryan Robson, and after Cantona, it was worn by David Beckham and Cristiano Ronaldo. He played one hundred and forty-four times for the team, scoring sixty-four goals.

After retiring from football, he moved into acting in advertisements, films and theatre. He has been in over 20 films including: *Elizabeth* (1998), starring Cate Blanchett, Ken Loach's *Looking for Eric (*2009) and as a police detective in *Switch* (2013). He has recently been cast as the Stallion in a French erotic comedy *Meetings After Midnight* (2014). In 2010, he had his stage debut in *Face au Paradis,* a French play directed by his second wife, Rachida Brakni.

He has been married twice and has three children.

Cantona joined the New York Cosmos as Director of Soccer in 2011 with the aim of reviving the team to its former top position in the USA.

PHOTO: LESRENCONTRESDAPRESMINUITLEFILM

THE FONKY FAMILY
(1994 –)

"Dans les yeux de mes frères
J'ai vu ce qu'ils m'ont laissé voir
Et alors?
J'ai vu le meilleur comme le pire
J'ai vu la maîtrise de l'imprudence
Un ouragan de haine dans les pupilles
J'ai vu que la bonté s'éfritte
J'ai vu l'amour du danger
Le fruit de l'impatience
Le besoin des défis"

La Fonky Family (shortened to La Fonky or La FF) are a French hip hop crew which hailed from Marseille. Original line-up was: Le Rat Luciano, Menzo, Don Choa and Sat, the producer Pone, DJ Djel, the dancer Blaze, the singer Karima, Flex (fetus) Nandell. Their manager was known as Fafa.

Fonky Family launched in 1994, after IAM, another Marseille-based band had a string of successes with their anti-racist message launched in response to the Front National's Jean-Marie Le Pen.

In 1995, the Fonky Family appeared in the song titled 'Les Bad Boys de Marseille' on *Meteque et mat*, the first solo album by IAM's Akhenaton. They launched their first album, *Si Dieu veut* in 1997 which soon went gold. Karima subsequently left the group.

They collaborated with Akhenaton on the soundtrack of Luc Besson's film *Taxi* in 1998, and the resulting track topped the French charts. After numerous collaborations with different members of IAM on their solo albums, the group released an extended play (EP) record with six live and edited titles, named *Hors serie* volume 1, in spring 1999. Their second album, *Art de rue,* came out in 2001 then they chose to pursue solo careers: Le Rat Luciano released a solo album in 2000, and Sat and Don Choa followed in 2001 and 2002 respectively. DJ Djel produced two compilations in 2001 and 2003.

In January 2006, Fonky Family released their third album *Marginale Musique* (Jive/Sony BMG), which went straight to number one in the French charts.

MARCEL PAGNOL (1895 – 1974)

A French novelist, playwright and filmmaker who is best-known for his novels *Jean de Florette,* and *Manon des Sources,* which were made into films starring Gerard Depardieu.

He was born in Aubagne on February 28th, 1985. His father was a schoolteacher and his mother a seamstress who died when he was 9 years old. His studies at university were interrupted by World War I. Discharged in 1916 due to poor health, he finished his degree then married Simone Colin in Marseille.

In 1926, he began a relationship with English dancer, Kitty Murphy, with whom he had a son, Jacques. In London, Pagnol saw one of the first talkies and suggested to Paramount Pictures that they adapt his play *Marius* to the screen. Alexander Korda directed the film and its success enabled Pagnol to start his own production company near Marseille in 1932.

Pagnol began making his own films – writing, directing, funding, translating and promoting them. In 1947, he was the first filmmaker to be elected to the Academie Française.

In 1945, Pagnol married actress Jacqueline Bouvier with whom he had two children, Frédéric and Estelle. When Estelle died aged only 2, he went back to Paris and began writing novels.

Pagnol died in Paris on April 18th, 1974. He is buried at the cemetery at La Treille, next to his family. His childhood friend, David Magnan, who died during World War I, is buried nearby.

There is a plaque in Aubagne marking his birthplace and the Office of Tourism runs a Pagnol tour with routes that take in his holiday home at La Treille and other sites that provided inspiration for his many stories about rural life in Provence.

PIERRE PUGET (1620 – 1694)

A French Baroque painter, sculptor, architect and engineer. Born on October 16th, 1620 near Marseille, by the age of 14 he was carving the decorations on ships. By 16, he was overseeing the entire construction of a ship.

He walked to Rome in 1640 where he met artist Pietro da Cortona, who employed him to decorate palace ceilings.

By 1643 he was back in Marseille working both as a painter and a carver of figureheads for warships. He received a commission in 1656 to create a sculpture for the Hôtel de Ville in Toulon.

In 1659, he went to Paris, and was commissioned to create a statue of Hercules by one of Louis XIV's ministers. But while in Italy buying marble, his patron lost his position so Puget stayed on working in Genoa, where he was commissioned to build a church.

In 1669, he returned to work in the dockyards at Toulon but fire destroyed the arsenal he built there. He was commissioned to create sculptures for the French court. His difficult and somewhat arrogant temperament made him unacceptable to Louis XIV's powerful minister Colbert, and it was only late in life that he achieved some degree of court patronage. His 'Milo of Crotona' created over several years was acquired for Versailles in 1683 and in 1684, the palace acquired his 'Perseus and Andromeda' but his 'Alexander and Diogenes' was not accepted.

Puget fell foul of court intrigue and his commissions from the court dried up. He never finished his last work, a bas-relief of the 'Plague of Milan' but it still graced the council chamber of the town hall of Marseille. He died on December 2nd, 1694 in Marseille where they named a mountain after him, the Mont Puget.

In 1882, a statue of Hercules by Puget was discovered in the grounds of a chateau at Biéville-Beuville.

Puget's bust of Louis XIV resides in the museum at Aix-en-Provence. His 'Milo of Crotona' is in the Louvre, in Paris. (see right)

GIRAUDON ART RESOURCE, NEW YORK

ARTHUR RIMBAUD (1854 – 1891)

A French teenage prodigy whose poetry influenced the Symbolists, Surrealists and Dadaists. Later, he became the first European coffee trader in Ethiopia.

Born in Charleville, France on October 20th, 1854, Jean Nicolas Arthur Rimbaud had a mostly absent father who was an army captain and a devout Catholic mother whom he nicknamed 'Mouth of Darkness.' She was controlling and home-schooled her children until they were 8 or 9 years old.

At school, Rimbaud won several prizes and at college, his teacher Georges Izambard became a mentor and friend, developing Rimbaud's poetry. *Ophelie*, which he wrote at 15, showed promise.

When the school closed in 1870 due to the outbreak of war, Izambard left and Rimbaud ran away to Paris. He was arrested for fare dodging. He was then invited to stay with Paul Verlaine who was impressed with Rimbaud's poetry, especially *The Drunken Boat*. A homosexual relationship ensued between the two, although Verlaine was married and his wife had recently given birth to a son.

Rimbaud was rude, awkward and unstable and he and Verlaine led a wild, vagabond existence, smoking hashish and drinking absinthe. They went to London in 1872, living in squalor until the affair ran its course. Verlaine went back to Paris. In June 1873, he wrote to Rimbaud and asked him to meet in Brussels but they both drank heavily and by July were so hostile to each other that Verlaine shot Rimbaud in the hand, landing Verlaine in prison. Rimbaud subsequently wrote *A Season in Hell* but by 1875 he'd decided to give up writing poetry altogether. They met again after Verlaine was released from prison but by then Rimbaud had decided to seek his fortune abroad.

He joined the Dutch Colonial army in 1876 and travelled to Java, but soon deserted and found work in Cyprus and Yemen before finally trading coffee and arms in Ethiopia. In 1891, he became seriously ill with cancer and returned to Marseille where he was hospitalised. The doctors amputated his leg but his cancer had spread. He died on November 10th, aged 37.

In 1895, Verlaine published Rimbaud's complete works and they influenced writers, artists and musicians for years to come.

ZINEDINE ZIDANE (1972 –)

A retired French footballer and sporting director at Real Madrid. He is also an assistant coach.

Born in Marseille on June 23rd, 1972, of Berber descent, his parents came to Paris before the French-Algerian war in 1953. By the age of 10, he had joined the junior team of La Castellane and by 14 he was spotted by a scout at a football academy and signed to join AS Cannes where he made his professional debut in 1986, aged 16. In his first full season, the club qualified for the UEFA cup and finished fourth in the league.

In 1992, he moved to Bordeaux and by 1996 was Ligue 1 Player of the Year. He then joined Italy's Juventus where he immediately made his mark. Juventus won the 1996–97 Serie A title and the 1996 Intercontinental Cup. In 2001, Zidane signed a four-year contract with Real Madrid for a record fee of €75 million. Zidane helped Real Madrid to win the 2002–03 La Liga and was named the FIFA World Player of the Year. In 2004, fans voted him best European footballer for fifty years in a UEFA poll. He won FIFA World Player of the Year three times in all.

Zidane also played for France over 100 times where he became a national hero, scoring 31 goals and helping to win the 1998 FIFA World Cup, and Euro 2000. He captained France for the 2006 World Cup Final where he'd been awarded the Golden

Ball, but during the match Marco Materazzi insulted Zidane's sister and Zidane headbutted the Italian player in the chest and was sent off. He had previously announced his retirement and did not go back on the decision.

He helped Qatar win their bid to host the World Cup in 2022 and has been a UN Goodwill Ambassador since 2001.

He is married and has four sons.

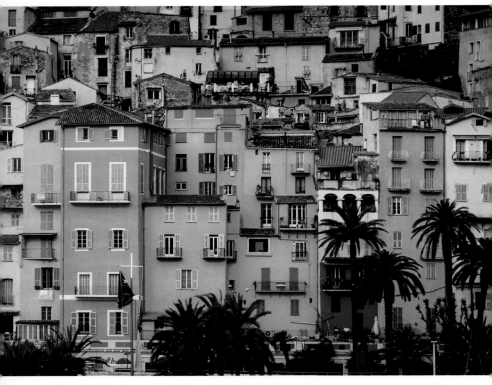

MENTON (ALPES-MARITIMES)

Known as the 'Pearl of France', Menton has been inhabited since the Stone Age. In Roman times, the Via Julia Augusta ran through the town from Italy to Arles.

In the 11th century, the Count of Ventimiglia built the Château de Puypin on Pepin hill, then in the 13th century the town became part of Genoa in Italy until Charles Grimaldi, Lord of Monaco, acquired it in 1342.

The French Revolution annexed Menton as part of France, but it was passed back to Monaco and protected by Sardinia before a vote was taken which resulted in Menton becoming part of France in 1860.

During World War II, Menton was invaded by the Italians and occupied by the Germans until liberation by US and Canadian troops in September 1944.

PLACES

Jean Cocteau Museum, opposite the beach, near the old market.
Basilica of Saint-Michel-Archange, built in 1619.
The Bastion Museum, decorated by Cocteau, in the port.
Marriage Hall, (Mairie) Cocteau decorated a function room.
Fine Arts Museum, 3 ave de la Madone.
Contemporary Art Gallery, Palais de L'Europe, 8, avenue Boyer.
Prehistoric Museum, rue Loredan-Larchey.
The old market, built in 1898 in Belle Epoque style.
Jardin Serre de la Madone, 74 route de Gorbio, gardens.
Botanic gardens, "Le Val Rahmeh", ave St Jacques.
Villa Fontana Rosa, built in 1922, gardens open to the public.
Centre Nautique, watersports centre, promenade de la Mer.

FESTIVALS

Lemon Festival and parade, February.
Classical Music Festival, August, main and fringe events.
Christmas Festival, Casino Gardens.

www.tourisme-menton.fr

PEOPLE

AUBREY BEARDSLEY
(1872 – 1898)

"I have one aim – the grotesque. If I am not grotesque I am nothing."
An English illustrator and author and a leading figure in the Aesthetic movement influencing Art Nouveau.

Born in Brighton on August 18th, 1872, Beardsley's family lived off a small inheritance. He began drawing cartoons at school and then, influenced by Lautrec's posters, began illustrating books in pen and ink, notably Sir Thomas Malory's *La Morte d'Arthur.*

Inspired by Japanese shunga, he drew erotica and illustrated Oscar Wilde's play *Salomé* as well as *Lysistrata.* When he converted to Catholicism he asked his publisher to destroy these.

A co-founder of the Savoy magazine, he published his writing as well as his art. Suffering from TB, he moved to Menton in 1896, where he died on March 16th, 1898 at the Cosmopolitan Hotel.

LESLEY BLANCH MBE (1904 – 2007)

"It is always useful to be near a frontier, in case you need to make a dash for it."

An English traveller and historian, author of twelve books. Born in Chiswick, London, on June 6th, 1904, to a well-off family, she attended St. Paul's Girls School then studied art at the Slade from 1922–24. She began by painting portraits and designing book jackets then wrote articles and became features editor for *Vogue* (1937-44). She worked with photographer Lee Miller to report on women in the forces.

As a teenager, she ran away to France with a Russian friend of the family, twenty-five years her senior, but the relationship fell apart. Her marriage to Robert Bicknell in 1930 was also dissolved. In 1941 she married the author and French diplomat Romain Gary which led to an itinerant life in numerous postings such as Bulgaria, Switzerland and the USA. In Beverley Hills, the couple were friends with Hollywood writers and actors and this led to the breakdown of her marriage in 1961 when her husband had left her for Jean Seberg.

She returned to Paris and saw old friends the Windsors, Nancy Mitford and Rebecca West. She continued to write and travel in the Middle East. In the 70s she moved to Menton where she had previously escaped as a teenager with her Russian lover. She wrote about her affair in *Journey into the Mind's Eye* (1968). Her book *The Wilder Shores of Love* (1954) about four Victorian adventuresses, has never been out of print. In 1971, she wrote a series of articles called 'Behind The Veil' for the *Sunday Times*.

In 1994, her house "Kucuk Teppe" in Menton burned down and she lost her books and all of her mementos of her travels. She had the house rebuilt. Her ex-husband, Romain Gary, committed suicide in 1980. She wrote a memoir of their life together.

A Fellow of the Royal Society of Literature, Lesley Blanch was appointed MBE in 2001, and in 2004 the French government awarded her the honour of Officer of the Order of Arts and Letters.

She died on May 7th, 2007, aged 102.

JEAN COCTEAU (1889 – 1963)

A French poet, film director and writer who spent much time on the Côte D'Azur.

He was born on July 5th, 1889 in Maisons-Lafittes near Paris. His father was a lawyer who committed suicide when Cocteau was about 10 years old. Expelled from school in 1904, he ran away to Marseille. He wrote poetry, publishing his first collection at 19. He met Sergei Diaghilev at the Ballet Russes and wrote a libretto called *The Blue God.*

In 1917, Diaghilev asked him to collaborate on a ballet with Picasso designing the sets, Leonide Massine choreographing and Apollinaire writing the libretto. Called *Parade,* it was further developed into an opera with music by Satie, Poulenc and Ravel.

He published his own work as well as musical scores by a group of composers known as Les Six. In 1918, he began a relationship with Raymond Radiguet, then 15 years old and promoted Radiguet's novel *Le Diable au corps* to win a literary prize. Radriguet died from typhoid fever in 1923 and this sent Cocteau into a depression which he tried to relieve with opium. His battle with his addiction led him to create the play *Orpheus,* the novel *The Enfants Terribles*, and a diary about his opium addiction.

He was highly productive in the 30s, writing his first film *Blood of a Poet* (1930), the plays *The Infernal Machine* and *The Human Voice, The Knights of the Round Table* (1937), *The parents terribles* (1938), *Intimate Relations* and *The Typewriter* (1941). A relapse into opium addiction slowed his output until his collaboration with actor Jean Marais, with whom he made the films *Beauty and the Beast* (1945) and *Orpheus* (1950). In 1959, he directed his last film, *The Testament of Orpheus,* with cameos from many of his friends including Picasso, Yul Brynner and Jean-Pierre Léaud.

Cocteau painted the Marriage Hall in Menton in 1957 and helped create the Bastion museum to which he donated drawings, tapestry and set designs. A new modernist Museum now graces the seafront with a much larger collection of his works.

He had a heart attack and died, aged 74, at his chateau in Milly-la-Foret, on October 11th, 1963 following the news that his long-time friend, the singer Edith Piaf, had recently passed away.

WILLIAM WEBB ELLIS (1806 – 1872)

An Anglican clergyman who invented Rugby football whilst a pupil at Rugby School, where there is now a statue of him.

He was born on November 24th, 1806, in Salford, Lancashire. His father was an officer in the Dragoon Guards, killed in battle in 1811. His mother moved to be near Rugby school, so her two sons could attend it for free. Webb Ellis attended Rugby school from 1816–25 and it was in 1823 that he broke the rules and ran with the ball during a game of football, thereby inventing the game of rugby.

He went to Oxford and became a clergyman, never married and retired to Menton where he died on February 24th, 1872.

The William Webb Ellis Cup is presented to the winners of the Rugby World Cup. In 1958, his grave in Menton was rediscovered and has since been renovated by the French Rugby Federation.

BLASCO IBANEZ (1867 – 1928)

A Spanish writer, screenwriter and politician. He was born on January 29th, 1867, Vicente Blasco Ibáñez, to a well-off family. At the age of 18, while studying law, he was sent to prison for writing an anti-monarchist poem. In 1891, he started the republican journal *El Pueblo* to campaign against the government. He was elected to parliament in 1901 but left Spain in 1914 and went to Paris where he published his novel *The Four Horsemen of the Apocalypse* (1916). When he returned to Spain, he was successfully re-elected several times before he left again in 1923 in protest at the the military dictatorship of Miguel Primo de Rivera.

The Four Horsemen of the Apocalypse was filmed by Rex Ingram in 1921, and launched Rudolph Valentino to fame. Ingram filmed another of Ibanez' novels, *Mare Nostrum,* in Nice. Greta Garbo appeared in two films, *The Torrent,* and *The Temptress,* both based on Ibanez' books. He lived in Menton for the last years of his life and became a member of the French Legion of Honour.

He died on January 28th, 1928 and is buried in Valencia.

KATHERINE MANSFIELD (1888 – 1923)

"I, a woman, with the taint of the pioneer in my blood."

A New Zealand short story writer who influenced modernist literature in the UK. She was born on October 14th, 1888 in Wellington, New Zealand, as Katherine Mansfield Beauchamp. Her father was a successful businessman and her cousin was the best-selling Australian author, Elizabeth Von Arnim.

She went to London to study languages in 1903, where she met Rhodesian Ida Baker and they became firm friends. She returned to Wellington briefly in 1906, then persuaded her father to send her back to London for musical training in 1908. Once there, she began an affair with violinist Garnet Trowell, became pregnant, impulsively married another man, G.C. Bowden, then left him. When her baby was stillborn she relied on her friend Ida for emotional support. Her mother took her to a Bavarian spa to try and restore her health. There, she met a Polish translator, Florian Sobienowski, who encouraged her to read Chekhov's short stories. This led to her first published collection, *In a German Pension* (1911).

Back in London, she met and soon moved in with John Middleton Murry, the founding editor of *Rhythm,* a radical modernist journal. A few years later, Murry was bankrupt and they left London to be near D.H. Lawrence and his wife Frieda with whom they were involved in an intense relationship.

Virginia Woolf published Mansfield's story *Prelude* (1918). But Mansfield had contracted TB and spent the winters in Bandol then later Menton to recuperate. She stayed with Ida in the Villa "Isola Bella" from 1920–22 where she wrote *Miss Bull* and *Passion.*

She went to the Gurdjieff Institute at Fontainebleau in October 1922 and died on January 9th, 1923, before the publication of *The Garden Party and Other Stories,* which cemented her reputation as a leading Modernist.

A street in Menton is named after her. In New Zealand a short story competition is also named in her honour.

Biographies, plays and a TV mini-series starring Vanessa Redgrave have explored her short, stormy life.

GRAHAM SUTHERLAND (1903 – 1980)

An English modernist artist who created natural abstraction. He was born Graham Vivian Sutherland on August 24th, 1903 in Streatham. His father was a lawyer who wanted his son to be an engineer. But in 1921 Sutherland switched to study art and engraving at Goldsmith's College where he met Kathleen Barry. He converted to Catholicism before their marriage in 1927.

Following the financial crash in the 1930s, he was unable to sell his etchings, and after a visit to Pembrokeshire, he switched to painting. In 1936, he exhibited his work at the International Surrealist Exhibition, while teaching engraving to earn an income. His first exhibition of his landscape paintings was held at the Paul Rosenberg and Helft Gallery in 1938.

During World War II, Sutherland was employed as a war artist covering bomb devastation, mining and quarrying, notably producing 'Working on a Cliff Face' (1943). In 1944, he was commissioned to paint 'The Crucifixion' for St Matthew's Church, Northampton. Then followed a commission to design the tapestry for the new Coventry Cathedral. He also painted portraits, including Churchill's, Beaverbrook's and Somerset Maugham's.

After the war, the light in the South of France attracted him and he spent several months each year working there, buying a house in Menton in 1955.

His work was exhibited at the ICA (1951), Venice Biennale (1952) Musée National d'Art Moderne, Paris (1952) and São Paulo Bienal, Brazil (1955). Retrospectives of his work have been held at the Tate (1982), the Musée Picasso, Antibes (1998) and the Dulwich Picture Gallery in 2005.

He was awarded the Order of Merit in 1960 and set up a museum of his work in Picton Castle which closed in 1995. He died in Kent on February 17th, 1980.

Coventry School of Art and Design has named a building in his honour. His work is said to have influenced other artists including Francis Bacon.

HANS-GEORG TERSLING
(1857 – 1920)

A Danish architect who designed and built many of the grand buildings on the French Riviera during the Belle Epoque.

He was born on December 7th, 1857 on a farm north of Copenhagen, Denmark. His father, who was a lawyer, died when he was 3. He trained as a carpenter before attending the Royal Academy of Architecture in Copenhagen, graduating in 1879, at just 22.

A friend, L.T.T. Schidte, helped him find work in Menton from 1880 and he began on the site of the new casino designed by Charles Garnier in Monte-Carlo then worked under Gustave Rives, in Menton on both new buildings and repairing those damaged by an earthquake in 1887. His style was inspired by the Italian Renaissance.

He married a Mlle Sabatier in 1883 and built a villa called "Les Citronniers", in rue Flavie, (now visible from rue Pasteur, behind the Palais de l'Europe).

In 1888, he built The Metropole Hotel in Monte-Carlo then he was commissioned by Mr White of Black & White Whisky to design the Grand Hotel at Cap Martin. The hotel attracted the Emperor Franz Joseph I of Austria to stay there frequently and earned a reputation for luxury and style.

More commissions followed with "Villa Cyrnos", built for Eugénie de Montijo, the last Empress consort of the French, the Russian Orthodox Church in Menton, commissioned by the Russian Empress Consort, the Hotel Bristol at Beaulieu and a large villa on the Promenade des Anglais for French politician Victor Masséna in Nice, now the Musée Masséna.

In 1905, Tersling won a competition to design the Hotel Hériot in Paris. In Menton, he also designed the Imperial Hotel and the Palais de l'Europe (1909), now a contemporary arts museum.

World War I brought an end to the Belle Epoque. Tersling's many wealthy clients disappeared and he was left in debt. He died on November 13th, 1920, and is buried in a modest grave at the cemetery of the Vieux-Chateau.

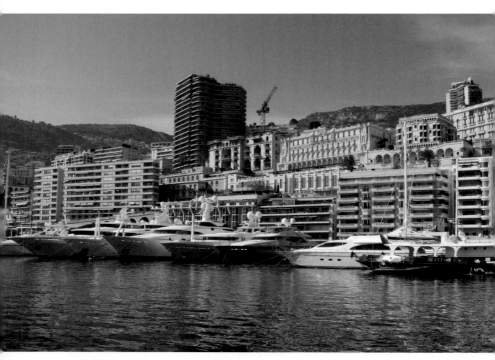

MONACO

Less than 2 km², on paper, Monaco is one of the most densely populated nations on earth. But of its 35,000 residents, around half may be absent at any time. In winter, in particular, when the residents tend to head for the sun elsewhere, Monaco can feel quite empty. As in any small community, one frequently meets the same people in the cafés and restaurants, supermarkets and shops; what makes these people different is that they tend to be successful business people from other countries who have come to Monaco to 'manage their investments'.

Apart from the famously low tax regime, the lifestyle benefits of Monaco include the Mediterrranean climate, not much crime, a packed calendar of sporting and cultural events and its proximity to both France and Italy. Jack Nicholson likened its concrete towers based around a very large rock to 'Alcatraz for the rich'. But for celebrities, there is one significant benefit, as U2 rock star Bono noted: 'Best thing about Monaco? No f****** paparazzi!'

PLACES

The Old Town on the rock, great views.

The Prince's Palace, Place du Palais, visit the state apartments.

The Oceanographic Museum, founded by Albert II's grandfather.

The Exotic Garden, blvd du Jardin Exotique, Cacti and other succulents, cave with stalactites.

Albert's Vintage Car Collection, Terrasses de Fontvieille.

Museum of Stamps and Coins, Terrasses de Fontvielle.

The New National Museum housed at Villa Sauber, 17, ave Princesse Grace and at Villa Paloma, 54, blvd du Jardin Exotique, regular exhibitions.

Museum of Old Monaco, 2, rue Emile de Loth, on the rock.

Museum of Prehistoric Anthropology, 56 bis, blvd du Jardin-Exotique.

Museum of Napoleonic Souvenirs and Historical Archives, Place du Palais – Monaco-Ville.

The Cathedral, 4, rue Colonel-Bellando-de-Castro, old town.

Port Hercules, La Condamine, check out the super-yachts.

The Casino and Opera House, Place du Casino.

The Japanese Gardens, ave Princesse-Grace.

The Beach and promenade with famous footballers' foot imprints.

Sainte-Dévote Church, Place Sainte-Dévote, La Condamine.

Grimaldi Forum, various events throughout the year.

Jimmy'z, Sporting Club, 26 ave Princess Grace.

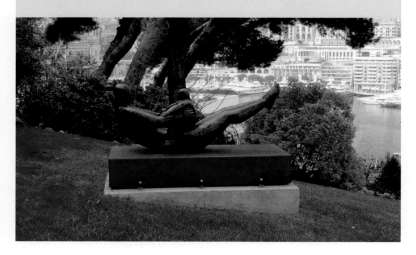

VISIT

La Turbie and the Roman Trophy of Augustus.
Roquebrune village and castle.
Villa Kerylos, Beaulieu-sur-Mer.
Peillon, hilltop village, with great walks.
Take a ferry or helicopter trip to Nice.

FESTIVALS

International Circus Festival, January.
Monte-Carlo Rallys, January.
Feast of Saint-Dévote, 27th January, a small boat is set alight.
Spring Arts Festival, music, theatre, art and dance events.
Monte-Carlo Tennis Masters, April.
Monaco Formula 1 Grand Prix, May.
Monte-Carlo TV Festival, June.
International Swimming Meeting, June.
Monte-Carlo Philharmonic Orchestra Summer Concerts at the Prince's Palace.
World Amateur Theatre Festival, every four years.

www.visitmonaco.com

PEOPLE

ALBERT II, PRINCE OF MONACO (1958 –)

One of the wealthiest royals and a keen advocate for environmental issues.

Born March 14th, 1958 in the Prince's Palace, Monaco, Albert's mother was Grace Kelly the film star and his father was Prince Rainier III. He grew up in Monaco attending the local high school then studied at Amherst College in Massachusetts, USA, graduating in 1981. He is multi-lingual.

He competed in the bobsled at the Winter Olympics and is now a member of the International Olympic Committee.

In 2005, Albert was enthroned as Sovereign Prince when his father died. He created his own charitable foundation in 2006. He is the only royal to have visited both the North and South Poles.

He has fathered two children with different mothers, and married Charlene Wittstock, a former Olympic swimmer in 2011.

SHIRLEY BASSEY DBE (1937 –)

A Welsh singer best-known for the theme songs to the James Bond movies, she has sold 135 million records and has the longest chart career in history.

She was born January 8th, 1937, in Cardiff. Her father was a merchant seaman from Nigeria and her mother was English. She left school at 15 and got a job singing in a musical based on the life of Al Jolson, followed by another show *Hot from Harlem.* At 16, she became pregnant and had a daughter, Sharon.

By 1955, she was back on stage in *Such is Life* in London's West End and by 1959, she had her first number one with *As I Love You,* followed by several other hits. But it was *Goldfinger* (1964), *Diamonds Are Forever* (1971), and *Moonraker* (1979) from the James Bond films which propelled her to international stardom.

The hits went on with *Big Spender, No Regrets* and *Something* and in the 70s she had her own TV show on the BBC.

For her 60th birthday in 1997, she gave concerts at Castle Howard and Althorp Park which were recorded live as *The Birthday Concert.* The album received a Grammy Award nomination for Best Traditional Pop Vocal Performance. She changed direction in the 90s, working with younger recording artists such as the Propellerheads, Groove Armada and Mantronix.

She headlined at the launch of the Welsh Assembly (1999) and sang *World In Union* with Bryn Terfel for the Rugby World Cup in 2000. She performed at Glastonbury (2008), headlined at the BBC's Electric Proms (2009), sang at Carnegie Hall (2010), performed for the Queen's Diamond Jubilee (2012) and at the Academy Awards (2013).

She married in 1961 and had another daughter, Samantha, but divorced in 1965, following an affair with the actor Peter Finch. She became a tax exile in 1968, married Sergio Novak, who became her manager and she adopted her grand-nephew Mark. She divorced Novak in 1979. Bassey now has four grandchildren.

She has lived in Monaco for several years and was inducted into the French Legion of Honour in 1999 and made a Dame in 2000.

COCO CHANEL (1883 – 1971)

Founder of the Chanel fashion empire, she was an innovative fashion designer whose sense of style and expansion into perfume, jewelry, shoes and handbags revolutionised the fashion industry.

Born August 19th, 1883, in Saumur, Gabriel Bonheur Chanel was sent to an orphanage when she was 12 after her mother died. She learnt to sew there. At 18, she moved to a Catholic boarding house in Moulins where she met Etienne Balsan, an ex-cavalry officer.

She moved in with Balsan, living in luxury at his chateau, joining an elegant social circle. She developed an interest in men's clothes and hat design. In 1908, she began a relationship with an upper class Englishman, Arthur Capel who helped her open her first hat shop in in Paris in 1910, followed by a shop in Deauville in 1913, selling luxury leisure and sportswear. By 1919, she'd launched her Maison de Couture in Paris, but the death of her former lover Capel in a car accident led to a period of mourning and drug addiction.

She often spent the summers on the French Riviera, and like the Americans, took up sunbathing. She began a relationship with the Duke of Westminster in 1923 and the Prince of Wales also fell under her spell. Her beautiful house "La Pausa", at Roquebrune–Cap Martin (now Villa Egerton) was the site of continual parties.

She developed a perfume line in 1924 with the Bourgeois company but this led to a long struggle to gain control of her own brand. In 1931, Chanel met MGM head, Sam Goldwyn who offered her a million dollars to go to Hollywood and design costumes. Although she went to California, her designs were not glitzy enough for the big screen and she hated the movie business.

During the German Occupation, the SS paid her to write a letter to Churchill to negotiate a truce. After the war she was regarded as a collaborator by the French, who shunned her and her clothes.

In 1954, she relaunched her fashion house and built it into the international brand it is today. There are now over 300 stores.

Chanel died on January 10th, 1971, aged 87, at the Ritz Hotel in Paris but was buried in Lausanne in Switzerland.

NOVAK DJOKOVIC (1987 –)

A Serbian professional tennis player, and World Number One, nicknamed 'The Joker' for his send-ups of other players.

Born on May 22nd, 1987, in Belgrade, Serbia, his family owned a sports company with a tennis academy. He was only 4 when he began playing tennis. He and his family were affected by the bombing of Belgrade. He went to the Pilic Academy in Germany at 13 and by 14 he was European Junior Champion. From age 16, he won five ITF tournaments and competed for Serbia in the 2008 Olympics, winning a bronze medal in the Men's singles tennis.

In 2010, he led the Serbian national team to win the Davis Cup for the first time. In 2011, he had a run of 43 consecutive matches, unbeaten, including winning Wimbledon and three grand Slams. This made him the World No. 1 tennis player, a title he kept in the ATP rankings for 101 weeks.

He won the Tennis Masters Cup in 2008, 2012 and 2013 and he won the Australian Open three years in a row. However, he lost Wimbledon in the semi-finals to Roger Federer in 2012 then to Andy Murray the following year.

He is the recipient of many awards, including the 2012 Best Male Tennis Player ESPY Award. He has won the ATP World Tour Player of the Year twice consecutively, in 2011 and 2012. He was also given the Order of St. Sava by the Serbian Orthodox Church and the Order of the Star of Karadorde which is the highest civilian award given by the Republic of Serbia.

His charity work includes the Champions for Peace club, a Monaco-based international organisation. He is a frequent guest

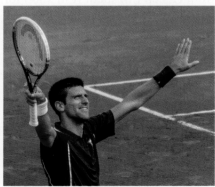

on TV shows, and is fluent in four languages. In 2010, the Serbian rock band Zona B recorded the song "The Joker", and dedicated it to Djokovic.

From 2005, Djokovic has been in a relationship with Jelena Ristic.

He is based in Monaco.

PHOTO: YANN CARADEC

STELIOS HAJI-IOANNOU OBE (1967 –)

A British entrepreneur of Greek-Cypriot origin who created the easyGroup empire and is nicknamed 'big Stel' by the press.

Born February 14th, 1967 into a wealthy shipping family, he studied in England and Athens, then at the LSE where he achieved a BSc and at Cass Business School in London where he achieved an MSc in Shipping, Trade and Finance. He began work for his father at Troodos Shipping.

In 1992, he launched Stelmar with family funding and due to the success of the shipping company he was encouraged to start a budget airline. At age 28, he set up easyjet in 1995, again with family funding and grew the airline company rapidly then floated it on the London Stock Exchange in 2000. He floated Stelmar on the New York Stock Exchange in 2001. His family still own 38% of easyjet and Stelios is the major shareholder.

He expanded his private company easyGroup into other business areas such as buses and hotels, car rental and finance with mixed results. His attempt to stop the use of the word 'easy' by other businesses has been met with outrage by other small business owners.

He received a knighthood from Queen Elizabeth II in 2006 for services to entrepreneurship. In 2009, he was also made Honorary General Consul for the Republic of Cyprus in the Principality of Monaco, where he is based.

With a large fortune at his disposal, his focus is now on his philanthropic foundation and making a difference to society.

He divides his time between Monaco, London and Athens.

PHOTO: TOM COLLINS

LEWIS HAMILTON MBE (1985 –)

A British Formula One racing car driver who was the 2008 Formula One World Champion.

Born on January 7th, 1985, in Stevenage, Hertfordshire, his parents moved to Britain in the 1950s from Grenada. His father was a black IT manager, while his mother is white but they separated when Lewis was 2 years old. He lived with his mother until he was 12 then attended a Catholic high school while living with his father. His father bought him his first go-kart when he was 6 and he began racing at 8 and was soon winning all his cadet races. At 10, he told McLaren's Ron Dennis that he wanted to race for the team and he was signed up a few years later. In 2007, he made his Formula One debut, driving for McLaren.

In his first season, he finished second in the championship, one point behind Kimi Räikkönen. He won the World Championship in 2008. But due to his rivalry with Alonso, he suffered racist abuse in Spain, with the FIA launching a 'Race against Racism' campaign.

In 2009, he was in trouble with the race stewards and has had a difficult relationship with them ever since, joking in 2011, *"Maybe it's because I'm black."*

In 2012, he won the Canadian, Italian and Hungarian Grand Prix then joined the Mercedes-Benz team in 2013, winning the Hungarian Grand Prix.

He moved to Switzerland in 2007 then to Monaco in 2012. He had a relationship with Nicole Scherzinger from Pussycat Dolls which ended in 2013. He was awarded an MBE in 2009 in the UK's New Years' honours List.

AT THE MALAYSIAN GRAND PRIX

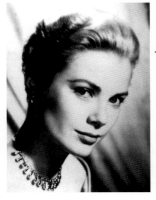

GRACE KELLY (1929 – 1982)

"I don't want to be married to someone who feels inferior to my success or because I make more money than he does.

An American film actress who became Princess of Monaco.

Born in Philadelphia on November 12th, 1929, her father John Kelly, was an Olympic sculler with three medals and her mother, Margaret Majer, became the first woman head of the Phys Ed. Dept. at the University of Pennsylvania. Two of her uncles were involved in the movie business and she studied at the American Academy of Dramatic Arts in New York, modelling part-time. In 1950, she began performing on Broadway, but soon moved on to TV and films. Gary Cooper promoted her and she appeared in *High Noon* (1952) and *Mogambo* (1953) for which she received a Golden Globe Award and an Academy Award nomination. She also had a brief affair with co-star Clark Gable while filming in Africa.

Kelly made three films with director Alfred Hitchcock: *Rear Window* (1954), *Dial M for Murder* (1954) and *To Catch a Thief* (1955). But it was her role in *The Country Girl* (1954), which finally won her an Academy Award for Best Actress.

She met Prince Rainier III while visiting the Cannes Film Festival in 1955 and he proposed to her the same year. Her family paid a dowry of $2m for the union to go ahead. Kelly retired from acting once she became Princess Consort of Monaco in April, 1956 at a star-studded ceremony. She and Prince Rainier had three children: Caroline, Albert and Stéphanie.

Although she had appeared in eleven films and over sixty TV productions, Rainier banned her films in Monaco and discouraged her from acting. Instead, she focused on charitable works.

In 1982, she had a stroke while driving, causing her car to go over a cliff, slightly injuring her daughter Princess Stéphanie. Kelly lapsed into a coma and died on September 14th. She was buried in the cathedral in Monaco.

Nicole Kidman portrayed Kelly in *Grace of Monaco* (2014).

ROGER MOORE OBE (1927 –)

An English actor, best known for playing James Bond in seven of the Bond films.

Born October 14th, 1927 in Stockwell, South London, Moore was an only child. His father was a policeman. He was evacuated to Devon during World War II, and went to R.A.D.A. briefly before his National Service where he rose to the rank of captain. After the war, he performed in regional repertory theatres.

In the 1950s, he landed a part in the TV series *Ivanhoe,* appeared on Broadway in *A Pin to See the Peepshow* and had a contract with MGM which led to several mediocre films.

He first gained international fame with his role as Simon Templar in the TV series *The Saint* (1962) followed by another hit with *The Persuaders* with Tony Curtis (1972). He then played James Bond several times bringing a witty portrayal of the character to the part: *Live and Let Die* (1973); *The Man with the Golden Gun* (1974); *The Spy Who Loved Me* (1977); *Moonraker* (1979); *For Your Eyes Only* (1981); *Octopussy* (1983); and *A View to a Kill* (1985). He was voted Best Bond in an Academy Awards poll in 2004.

He became a UNICEF Goodwill Ambassador in 1991, was knighted in 2003 by Queen Elizabeth II and was named as a Commander in the French Order of Arts and Letters in 2008. He was awarded a star on the Hollywood Walk of Fame in 2007.

He first married skater Doorn Van Steyn then singer Dorothy Squires and in 1969, Italian actress Luisa Mattioli with whom he has three children. Moore ended this marriage in 1993 and married Danish-Swedish multi-millionaire Kristina 'Kiki' Tholstrup in 2002. He is now friendly with the Danish Royal family and was invited to the wedding of Prince Albert II and Charlene Wittstock.

He published his autobiography *My Word Is My Bond* (2008) and *Bond on Bond* (2012) a memoir, to tie in with the 50th anniversary of the James Bond films.

He now divides his time between his homes in Switzerland and Monaco.

RINGO STARR MBE (1940 –)

"I lived in nightclubs for three years. It used to be a non-stop party."

An English musician and actor, best-known as the drummer for the Beatles.

Born as Richard Starkey on July 7th, 1940, Liverpool, England to parents who loved singing and dancing. When he was 3, they separated and his mother took on cleaning jobs and bar work to support her family.

As a child he was hospitalised for lengthy periods with peritonitis then TB. While in hospital, he became interested in percussion. He had fallen behind with his schoolwork and preferred to stay at home and listen to music. At 17, he joined the Eddie Clayton Skiffle Band and at 19 he was playing drums for Rory Storm and the Hurricanes. He got the nickname Ringo because of all the rings he wore. In 1962, he joined the Beatles replacing Pete Best on drums. The following year Beatlemania exploded and the band swept the USA.

The Beatles made several films including *A Hard Day's Night* (1964) and *Help!* (1965) which gave Starr a chance to act. He has since appeared in numerous films including *Lizstomania!* He also co-wrote and sang on a number of Beatles' tracks. He received his MBE from the Queen in 1965.

After the Beatles' break-up in 1970, Starr released a successful solo album *Sentimental Journey* and recorded with each of the former Beatles on their solo efforts. He was voted the fifth-best drummer of all time by readers of Rolling Stone Magazine in 2011.

Married twice, he had three children with his first wife Maureen. He married the actress Barbara Bach in 1981, six years after the divorce from his first wife. In 1988, the Beatles were inducted into the Rock 'n' Roll Hall of Fame. He and Bach were treated for alcoholism that same year. In 1989, he created and has successfully toured with his All-Starr Band which has gone through several variations in its line-up.

In 2010, he received a star on the Hollywood Walk of Fame. Starr divides his time between Monaco, UK and Los Angeles.

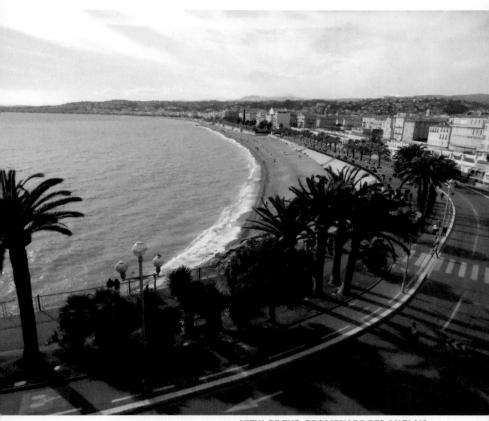

VIEW OF THE PROMENADE DES ANGLAIS

NICE (ALPES MARITIMES)

With its delightful fruit and flower market, narrow alleys and tall Italianate buildings, the old town of Nice remains relatively untouched by modernity and provides the heart of the city, around the Cours Saleya.

Originally settled by the Massalians, a tribe of Greek invaders from Marseille around 250 BC, Nice was named after Nike, the Greek goddess of Victory. Its port and strategic location have been much fought over through the centuries.

The Promenade des Anglais along the seafront was built for English tourists who came in the 19th century. Popular with European aristocracy until World War II, when the Italians and then the Germans invaded, Nice now attracts 4 million tourists a year.

MATISSE MUSEUM, CIMIEZ

PLACES

Old Town and flower market, cours Saleya.
Promenade des Anglais, seafront walk.
Colline du Chateau, amazing views from park on top of the hill.
Contemporary Art Museum, promenade des Arts.
Matisse Museum, 164 ave des Arènes de Cimiez.
Marc Chagall Museum, 39 ave Dr Menard, Cimiez.
Fine Arts Museum Jules Cheret, 33 ave des Baumettes.
Massena Museum, 65 rue de France.
Museum of Asian Arts, 405 promenade des Anglais.
Terra Amata Museum, blvd Carnot, prehistoric site.
Cimiez Archeological Museum, Roman ruins, bronze age tools.
Franciscan Monastery Museum, Place du Pape Jean-Paul II.
Hotel Negresco, 37 promenade des Anglais.
Nice Opera, 4-6 rue Saint-François-de-Paule.
Lascaris Palace, 15 rue Droite, collection of old musical instruments.
Russian Orthodox Cathedral, ave Nicolas II, Bd Tzarévitch.
Cathedral Ste-Reparate, Place Rosetti.
Notre-Dame Basilica, ave Jean Médecin.
Côte d'Azur Observatory, summit of Mont Gros, Grande Corniche.
Theatre of Photography, 27 blvd Dubouchage.

NICE CARNIVAL FIGURE

VISIT

Grimaldi Castle Museum at Cagnes-sur-Mer.
Discovery tours by car, bike, foot.
Many walking paths along the coast or on Mount Boron.
Train de Merveilles from Nice, scenic railway trip with guide.
Mercantour National Park, 2 hours north of Nice. See bronze age rock drawings, go hill-walking in summer and skiing in winter.

FESTIVALS

Nice Carnival, Place Massena, mid-February to March.
Côte D'Azur Boat Show, port, March.
Baie des Anges Regattas, April and May.
Summer Music Festival, June.
Book Festival, author talks and readings, mid-June.
Jazz Festival, July.
Feast in the Port, August.
Blues Festival, Palais Nikaïa, October.

www.nicetourisme.com

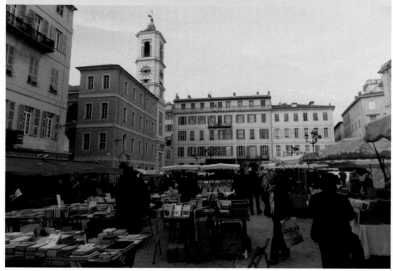

PEOPLE
SURYA BONALY (1973 –)

A French-born figure skater, who was World Junior Champion aged 17, she also won the French Figure Skating Championships nine times, the European Championships five times and was a Silver medallist at the World Figure Skating Championships three times, narrowly missing the Gold due to her athletic approach.

Born in Nice, on December 15th 1973, as Claudine, she was adopted at 18 months by Suzanne, a PE teacher, and Georges Bonaly, an architect who renamed her Surya. She took part in competitive gymnastics as a child then switched to competitive skating aged 10, and was coached by Didier Gailhaguet.

She is the only known skater in the world capable of doing a back flip and landing on one blade; she is also known for having tried a quadruple toe loop jump at the 1991 World Figure Skating Championships.

She now lives in Las Vegas, where she teaches skating and became an American citizen in 2004. She toured with the Champions on Ice skating show and was a guest skater at Ice Theatre of New York's benefit gala in 2008 where she successfully performed her signature back flip.

JULES CHÉRET (1836 – 1932)

A French painter, illustrator and graphic designer who has been called the father of the modern poster.

He was born in Paris on May 31st, 1836. His father was a typeographer who found an apprenticeship for his son at 13 with a lithographer. Cheret studied art briefly at the École Nationale de Dessin and went to museums to look at the paintings.

He began by selling sketches and

CHERET AND LAUTREC

received his first commission to design a poster for an operetta *Orpheus in the Underworld* in 1858. Unable to earn a living, he went to London in 1859 where he designed book jackets and did drawings for the Maple Furniture Company among others. He returned to Paris in 1866 and designed perfume packaging for Rimmel which helped him set up his own company.

This led to hundreds of commissions for posters for the music halls, theatres, railways, medicines and for Nice Carnival. The liberated, female figures in his posters were nicknamed his 'Cherrettes' and they added to the lively atmosphere of 'gay Paris'.

In 1890, he was inducted into the French Legion of Honour .

Chéret retired to Nice. He died on September 23rd, 1932. He was interred in the Cimetière Saint-Vincent in Paris.

In 1933, a posthumous exhibition of his work was created at the Salon d'Automne in Paris. Chéret's posters have become collectors' items and can be seen on display in the Fine Arts Museum in Nice.

J.M.G. LE CLEZIO (1940 –)

A French-Mauritian writer, awarded the Nobel Prize for Literature in 2008.

Born Jean-Marie Gustave Le Clézio on April 13th, 1940 in Nice while his father, who was a Mauritian-born doctor in the British Army, was in Nigeria. In 1948, his family joined his father in Nigeria. He studied at both the University of Bristol and then at Nice's Institut d'Etudes Littéraires, taking his masters degree at the University of Provence.

He travelled extensively in the 70s to Asia, Africa and South America. He has lived in England, South Korea and New Mexico. He achieved success with his first novel *The Interrogation* (1963), which won the Prix Renaudot and was shortlisted for the Prix Goncourt. Since then he has published over thirty books, including short stories, novels and several children's books.

He has won numerous literary prizes but few of his books have been translated into English. He was made an Officer of the French Legion of Honour in 2009.

ISADORA DUNCAN
(1877 – 1927)

"All true artists are revolutionists."

An American dancer whose innovative approach transformed dance; known as the 'mother of modern dance'.

She was born on May 26th, 1877 in San Francisco, California. Her father's bank failed and her parents divorced in 1880. Her mother was a piano teacher who loved the arts. By the age of 10, Duncan was teaching local dance classes with her sister to earn money. She joined Augustin Daly's theatre troupe in New York in 1895 but by 1902 she had developed her own barefoot and free-flowing style wearing a greek toga and was playing to sell-out audiences in Europe performing her own choreography.

In 1899, she moved to London where she met the set designer Gordon Craig and had a daughter, Deirdre, with him in 1906. She set up her first dance school in 1905 in Berlin with her students being dubbed 'The Isadorables'. She later had a relationship with Paris Singer, heir to the Singer Sewing machine fortune and they had a son, Patrick, in 1910. Singer funded a new dance school in Paris but tragically, Duncan's children drowned with their nanny in a car accident in the Seine river in 1913.

Heartbroken, Duncan went to Corfu to recover. Later, she had a relationship with an Italian actress, Eleonora Duse, in Viareggio.

Duncan went to Moscow to set up another dance school. She met and married poet Sergey Yesenin in 1922, to help him gain entry to America. They toured Europe and America together but Sergei had mental health issues and eventually committed suicide.

Duncan loved the Côte d'Azur and was living there in her later years, despite mounting debts. She died tragically outside the Hotel Negresco in Nice on September 14th, 1927, when her trailing silk shawl became trapped in the spokes of the wheel of a car and it broke her neck.

Her life has inspired dozens of books, movies, paintings, sculptures, poems and plays.

MAX GALLO (1832 –)

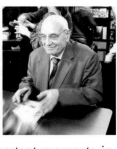

A French journalist, historian, politician and bestselling author from Nice.

Born on January 7th, 1932, in Nice, Max Gallo is the son of Italian immigrants.

While teaching at the Lycée du Parc in the 1960s, Gallo wrote his acclaimed *Mussolini's Italy*, which led to journalism, writing for television and fiction. His novels recount important moments in history, through the lives of great historical figures such as Charles de Gaulle, Victor Hugo and Napoléon.

His novels *La Baie des Anges* (a trilogy) tell the story of a family of Italian immigrants through the 20th century against a backdrop of the city of Nice.

In 1974, he joined the Socialist Party. In 1984 he became a Euro MP. He was elected to the French Academy in May 2007.

GIUSEPPE GARIBALDI (1807 – 1882)

"The papacy, being the most harmful of all secret societies, ought to be abolished."

An Italian general and politician considered one of Italy's founding fathers.

Born Joseph Marie Garibaldi on July 4th, 1807 in Nice. Garibaldi's family were sea traders and he spent ten years as a mariner, gaining his Captain's certificate in 1832. In 1833, he met Giuseppe Mazzini, an activist for Italian unification and this became his goal. A year later he was involved in a failed mutiny in Piedmont and had to go into exile. Then he became involved in the political struggles of Brazil and Uruguay. He met Anita Ribeiro da Silva who became a comrade in arms. Married in Montevideo, Uruguay, they had four children.

Wearing a red shirt, Garibaldi and his followers were involved in numerous battles in South America where he honed his revolutionary ideas. When Pope Pius IX was elected in 1846, Garibaldi's thoughts turned back to Italy. He led troops into battle

many times in the three Italian wars of Independence and other battles. His wife Anita died while his troops were in retreat.

In 1867, he invaded the Papal States, but France came to the aid of the Pope, and Garibaldi was taken prisoner and sent back to his home on Caprera Island.

He switched sides, fighting for the French Republic in 1870 and in 1871 was made a deputy in the French National Assembly from which he later resigned. He took a seat in the Italian Parliament in 1874 and accepted a pension from the government.

In 1879, he created the League of Democracy to promote universal suffrage, the emancipation of women, the abolition of Church property and maintenance of a standing army.

In 1880, he married Francesca Armosino, with whom he had previously had three children. He died on June 2nd, 1882, in Caprera and is buried next to his wife Francesca.

ELTON JOHN CBE (1947 –)

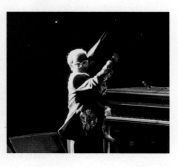

An honorary citizen of Nice, Elton John, is an English singer-songwriter, composer, pianist and actor.

He was born Reginald Kenneth Dwight on March 25th, 1947, in Pinner, Middlesex. His father was a Flight Lieutenant in the Royal Air Force and a trumpet player in the Bob Millar Band. His parents married when he was 6 years old and they encouraged his love of music with piano lessons. At 11, he won a scholarship to the Royal Academy of Music and went there for classes on Saturdays. He went to the local grammar school but left to be in a band. By 1964, he was in *Bluesology* which became the support band for singer Long John Baldry.

In 1967, he met lyricist Bernie Taupin and they wrote their first song together, *Scarecrow*. They have worked together ever since on over thirty albums. John has sold more than 250 million records, making him one of the best-selling artists of all time. *Candle in the Wind* alone has sold over 33 million copies worldwide.

Winner of six Grammy Awards, an Academy Award, a Golden Globe Award and a Tony Award, he was inducted into the

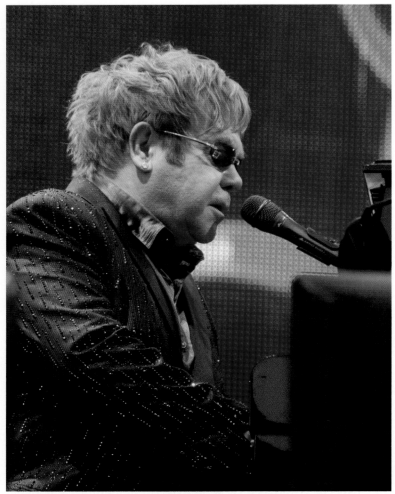

Rock 'n' Roll Hall of Fame in 1994.

In 1992, he created the Elton John AIDS Foundation and has raised over $200 million for the fight against AIDS. In 1998, he received a knighthood from Queen Elizabeth II for his 'services to music and charitable services'.

In 2008, *Billboard* magazine ranked him as the top male solo artist and third overall, behind the Beatles and Madonna.

He was married to Renate Blauel from 1984–88 and married his long-term partner David Furnish in 2005. By surrogacy, they

have two children, Zach and Elijah.

He has long supported Watford Football Club, investing large amounts of money and taking on the role of president.

His home in Nice, atop Mount Boron, has one of the best views along the coast. He also owns properties in London and Atlanta.

GASTON LEROUX
(1868 – 1927)

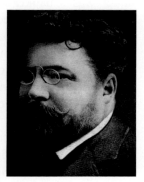

A French writer, journalist and gambler, famous for *The Phantom of the Opera*.

Born on May 6th, 1868, in Paris, Gaston Louis Alfred Leroux, was born into a wealthy ship-building family. He grew up in Normandy and studied law in Paris, graduating in 1889.

When he was 21, he inherited a fortune and found it hard not to spend it or gamble it away.

In 1890, he got a job as a court reporter attending trials. He also became a theatre critic for *L'Echo de Paris* then got a post travelling to other countries to report for *Le Matin*.

A brief marriage in 1899 failed then he fell in love with Jeanne Cayette in 1902, whom he met in Switzerland. They had two chidren together and eventually married in 1917.

He began writing a series of detective stories such as *The Mystery of the Yellow Room* (1908) and was successful enough to

give up journalism. Inspired by Arthur Conan Doyle and Edgar Allen Poe he wrote many mystery stories. But it was his novel *The Phantom of the Opera* in 1910 which brought international fame and numerous film, stage and literary adaptations based on the book.

On April 15th, 1927, Leroux died in Nice, where he loved to gamble at the Casino, and was buried in the Cimetière du Château.

LON CHANEY IN THE PHANTOM OF THE OPERA 1925

HUGO LLORIS (1986 –)

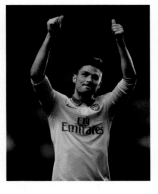

A French football player, goal-keeper and the captain for the French national team.

He was born on December 26th, 1986 in Nice to a well-off family. Lloris' father was a banker and his mother a lawyer. He first started playing tennis, then switched to football and by age 10 had joined Nice's youth academy for football. He went on to play in goal for their under-17 squad in 2003, progressing to the Under-19 French National team that won the 2005 European Under-19 Football Championship.

He joined OGC Nice to play professionally then moved to Lyon in 2008 for a fee of 8.5m euros, spurning Milan. He transferred to Britain's Tottenham Hotspur in 2012 for 10m Euros but has let it be known he'd like to move to Arsenal. Monaco has also been mentioned as a possible next transfer.

He has won the National Union of Professional Footballers (UNFP) League 1 Goalkeeper of the Year Award three times.

In 2010, he captained the French national team for the first time and achieved a 2-1 victory over England at Wembley.

He married local girl, Marine, in 2012 in Nice. They now have a daughter, Anna-Rose.

LLORIS PLAYING FOR FRANCE IN UEFA EURO 2012

HENRI MATISSE (1869 – 1954)

A French artist, print-maker and sculptor who, along with Picasso, helped to transform modern art in the 20th century.

Born Henri Emile Benoît Matisse on December 31st, 1869 in Le Cateau, he grew up in the north of France. His father was a grain merchant and he wanted his son to become a lawyer. Matisse duly became a lawyer but then became ill and while he was recovering, he began to paint. In 1891, he moved to Paris to study art and came into contact with Cézanne and Van Gogh.

He married Amélie Parayre in 1898 and they had three children.

He first exhibited his work in a one-man show at the gallery of Ambroise Vollard in 1904. He visited Saint-Tropez and was inspired to paint *Luxe, calme et volupté* (1904–05) then the next summer spent in Collioure inspired *Open Window* and *Woman with a Hat*. He exhibited these in the 1905 Salon d'Automne exhibition in Paris. He and other avant-garde artists were nicknamed 'fauves' for their use of bright colours and abstract forms, a style which came to be called Fauvism.

His paintings were bought by collectors such as Gertrude Stein and Russian Sergei I. Shchukin and he set up a studio in Paris.

From 1917, Matisse went to the Riviera for the winters, staying at the Hotel Beau Rivage and Hotel de la Mediterranée in Nice. In 1921, he moved to an apartment at 1, Place Félix Faure in old Nice, by the flower market, where he painted in his studio with a view of the sea.

In 1938, he moved to the Hotel Regina in Cimiez, in the hills behind Nice. During the war, he went to St-Paul-de-Vence, where he later designed a chapel. After the war, he returned to Cimiez and due to ill-health stopped painting. Instead, he began making paper cut-outs as printed in his book *Jazz* (1947).

PHOTO: CARL VAN VECHTEN 1933

Matisse died on November 3rd, 1954 at the age of 84. To thank the city of Nice, he made a bequest of some of his art works which are now housed in the Matisse Museum in the "Villa des Arènes" near the cemetery where he is buried in Cimiez.

VLADIMIR NABOKOV (1899 – 1977)

A Russian-born American novelist famous for *Lolita* (1955).

Born Vladimir Nabokov, April 23rd, 1899 in Saint Petersburg, into minor nobility. His father was a lawyer and government minister and his family were tri-lingual. He inherited an estate in 1916 but lost it a year later in the Revolution. In 1919, his family went into exile. Nabokov studied zoology and languages at Trinity College Cambridge, then travelled in Europe.

His father was assassinated in Berlin at a political rally in 1922 by fascists and Nabokov's girlfriend Svetlana broke off their engagement. He went to the South of France to overcome his depression and grief and worked in a vineyard.

In 1925 he married Vera, a Russian Jew, and they had a son Dmitri. They left Germany and moved to France as Germany became increasingly anti-semitic. In 1937 and 1938, Nabokov and his family lived in Cannes, Menton and Antibes. Nabokov embarked on his idea for *Lolita,* but didn't finish it until 1953. In 1940, the family fled Europe to the USA and Nabokov worked as a lecturer at Wellesley College, Harvard and Cornell. Nabokov had written his first nine novels in Russian but switched to English to write *Bend Sinister* (1947).

A scandal erupted after the editor of the *New York Times* accused Graham Greene and the *Sunday Times* of promoting paedophilia by giving *Lolita* a positive review. *Lolita* became a bestseller due to the publicity and was adapted as a movie.

Nabokov moved to Switzerland with his family in October 1961. They returned to Nice in the winter and Nabokov completed the novel *Pale Fire* (1962) while living in an apartment on the Promenade des Anglais. He died on July 2nd, 1977, in Montreux, Switzerland where there is now a statue of him.

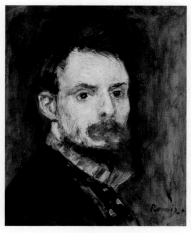

PIERRE-AUGUSTE RENOIR (1841 – 1919)

A French artist who helped develop and launch the Impressionist style.

He was born on February 25th, 1841, in Limoges, into a poor family. His father was a tailor. Renoir began work at 13 in a factory where he painted designs on porcelain.

The family moved to Paris in 1845 and Renoir went to art school in 1862 but could not afford to buy paint. He met Monet, Sisley and Bazille who were exploring an Impressionist style of painting. Renoir exhibited a painting of his mistress Lise Trehot in the 1867 Paris Salon. He and Monet sometimes painted the same scene side-by-side and from 1874 Renoir's work began to receive critical acclaim after the first Impressionist exhibition.

In 1890, he married Aline Charigot, who had been a model many times. He also painted her in the group scene *The Boating Party* (1881). They had three sons: Jean who became a filmmaker, Pierre who became an actor and Claude 'Coco' the youngest.

Renoir reverted to more traditional painting after a trip to Italy in 1881 where he saw works by the Old Masters until 1890 when he decided to return to his earlier Impressionistic style.

He developed rheumatoid arthritis and moved to the Riviera, visiting Beaulieu, Grasse, Saint-Raphael and Cannes, before finally settling in Cagnes-sur-Mer, near Nice in 1907. Renoir lived to see his own works hanging in the Louvre. The house he built, "Les Collettes", where he lived and worked until he died on December 3rd, 1919, is now a museum.

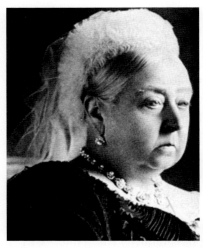

QUEEN VICTORIA (1819 – 1901)

"Oh, if only I were in Nice, I should recover".

Queen Victoria was queen of Great Britain for 63 years and Empress of India from 1876.

Born May 24th, 1819 at Kensington Palace, she was the only daughter of Edward, Duke of Kent, fourth son of George III. Her father died shortly after her birth and she became heir to the throne. She became Queen at 18 when William IV died in 1837. She was educated at home and liked drawing and painting, but led a sheltered life.

She married Prince Albert in 1840 and they had nine children. Victoria bought Osborne House on the Isle of Wight as a family home in 1845, and Albert bought Balmoral in 1852.

When Albert died aged 42, she sank into a depression and for the rest of her reign she wore black. Until the late 1860s she rarely appeared in public and was reluctant to resume her public duties, for which she was criticised. Republican sentiment grew and there were several attempts on her life. But her popularity increased during the 1870s as the Empire expanded and brought prosperity to Britain. She strongly believed in the British Empire, but opposed women's suffrage. Slowly, her power was diminished as the idea of a constitutional monarchy came into force.

Victoria enjoyed travelling by train and she helped to make the Riviera a fashionable place. At the age of 62 she visited her sick son Leopold, Duke of Albany in Menton. She returned in 1887, to Cannes to see the church of St George, built in memory of her son Leopold who had died a few years after her first visit.

In 1891, she returned to Grasse to visit Baroness Rothschild at the Villa Victoria. They named a street after her in Grasse.

The following year, she visited Hyères, to recover from her grief, following the death of her grandson Prince Albert Victor as well as the death of her son-in-law Louis, Grand Duke of Hesse

FORMER EXCELSIOR HOTEL REGINA

and the Rhine. While there, she visited La Londe and Toulon.

In 1895, she received a huge welcome on her arrival in Nice and stayed at the Grand Hotel at Cimiez, where there is now a boulevard in her name. She watched the Battle of the Flowers on the Promenade des Anglais and visited the zoo. She went to see Lord Salisbury in Beaulieu, Alice de Rothschild and Empress Eugenie in Cap Martin.

In 1896, Victoria returned to Nice for three weeks in March-April and again stayed in the Grand Hotel, where members of her family met her. Other visitors included the Emperor Francis Joseph and the Empress and Emperor of Austria.

In March 1897, she returned to Nice with Abdul Karim in her entourage and stayed in the Excelsior Hotel Regina (above). She went to see a play featuring the actress Sarah Bernhardt. Each day, dozens of carriages assembled near the hotel so that people could watch the Queen come and go.

She returned to Nice in March 1898 and extended her visit in 1899, with many visitors including Prince Albert I of Monaco.

Victoria died at Osborne House on the Isle of Wight, on January 22nd, 1901. Her reign of almost sixty-four years was the longest in British history.

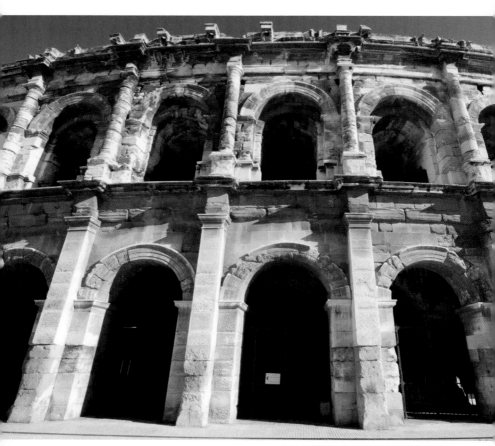

LES ARENES, ROMAN AMPHITHEATRE

NIMES (LANGUEDOC-ROUSSILLON)

Now the capital of the Gard department in the Languedoc, the city sits just over the western border of Provence, close to the Camargue and south of the Cevennes Mountains. The founding of Nîmes goes back to the 6th century BC when a Celtic tribe settled there because of the plentiful spring water. The town's name is thought to be derived from the Celtic god Nemausus.

Its crocodile emblem comes from a Roman coin minted in the town to commemorate Octavius' defeat of Anthony and Cleopatra's fleet in the battle of Actium. The Romans settled in Nîmes in the 1st century BC and splendid monuments were built to promote Roman ideals in Gaul.

Connected by the Via Domitia, a road which ran from Rome to Spain, the town expanded to over 25,000 inhabitants.

During the Middle Ages, the town declined and it wasn't until the Renaissance that trade in wine, textiles and coal brought renewed prosperity. The name denim comes from *'de nime'*.

PLACES

The Roman Arena, amphitheatre still in use.
The Temple of Diana.
The Maison Carrée Temple part of the Roman forum.
The Castellum, connected to the aqueduct.
The Gardens Of The Fountain.
The Magne Tower, imperial Roman tower.
Museum of Old Nîmes, with textile industry display.
Museum of Contemporary Art, bv Victor Hugo.
Archeological Museum, off blvd Admiral Courbet.
Bull Museum, rue Alexandre Ducros.
Fine Arts Museum, rue de la Citie Foulc.
Planetarium, rue Georges Bouniol.
The Cathedral, Place aux Herbes.
St-Paul's Church, blvd Victor Hugo.
The Grand Temple, Place du Grand Temple.
St Eugenia's chapel, oldest in Nimes, Rue Ste Eugenie.

VISIT

The Pont du Gard, (below) Roman aqueduct, built by Agrippa.

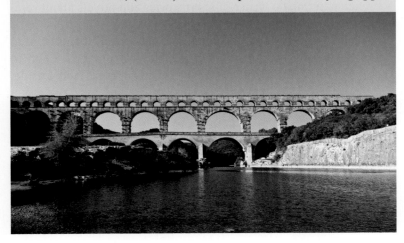

Uzes, quaint medieval market town.
Camargue, wildlife reserve, with flamingos, wild horses and a large yacht marina.
The Cévennes steam train, from Anduze to Saint-Jean-du-Gard by way of the Bambouseraie.
The Trabuc caves.
Museum of the Desert in Mialet, showing the history of Protestantism in the Cévennes.

FESTIVALS

Feria at Pentecost with procession of coloured floats.
Feria at Whitsun, early June, bull fights, parades, concerts, water jousting in the canal.
Wine Harvest Feria, September.
Ambrivados, bulls are let loose in local villages, and spectators try to help them escape their accompanying guardians on horseback.
Encierros, bulls are let loose in local villages and youths run behind them.

www.ot-nimes.fr

PEOPLE

ALPHONSE DAUDET (1841 – 1897)

A French naturalistic writer of short stories and novels about rural life in Provence.

Born on May 13th 1840, in Nîmes, the son of a silk manufacturer. When the family business failed, they had to move to Lyon in 1849. By 1857, the family were in financial crisis and Daudet

had to leave his studies and take a job as a teacher. When he was dismissed he went to Paris to live with his brother, Ernest.

He became involved with Marie Rieu, a model, and published his first volume of poetry, *Les Amoureuses* (1858). He started writing for the newspaper *Le Figaro*.

He met Frédéric Mistral in 1860, and was inspired by his campaign to revive

Provençal language and literature.

He began working as a secretary to the Duke de Morny, a minister and the half brother of Napoleon III until his death in 1865. In 1867 he married Julia Allard, also a writer, with whom he had three children: Léon, Lucien and Esmée.

His humorous *Letters from My Windmill* about a windmill in Fontvieille appeared as a series in *Le Figaro* and were quite popular but his plays failed and his novels based on the character Tartarin, earned little reward.

His next novel, *Fromont the Younger and Risler the Elder* (1874), won an award from the French Academy and brought him both money and fame. He wrote a number of novels which demonstrated his compassion and sense of irony.

His advancing syphilis interfered with his writing, although he wrote about it in *The Land of Pain*, translated by Julian Barnes.

He died on December 16th, 1897, in Paris.

ROBERT LAFONT
(1923 – 2009)

"As a child I lived on a hill... when I opened the door I could see the sun rising behind the old Tower of Magne, whose ancient white stones were coloured pink or pale gold by the sun."
A French linguist, writer, historian and activist for the Occitan language and literature.

Born March 16th, 1923, in Nîmes, he was a member of the Resistance and helped to liberate Nîmes in 1944. In 1945, he set up the Occitan Committee for Study and Action. In 1971 he helped launch the Occitan Struggle and put himself forward as a candidate for President in 1974, without success.

He became a Professor at the University Paul-Valéry in Montpellier. He wrote plays, essays and novels in French, Occitan, Italian and Catalan. He was the Chairman of the Institute for Occitan Studies. In 2007, he was awarded the Grand Literary Prize of Provence.

He married Fausta Garavini and lived later in his life in Italy. He died on June 24th, 2009 in Florence.

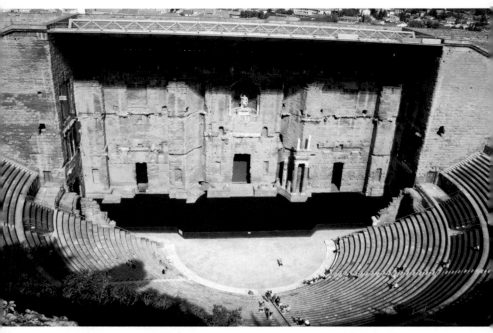

ROMAN ANTIQUE THEATRE

ORANGE (VAUCLUSE)

The Roman town was founded in 35 BC by Octavian (Augustus) and veterans from the Second Roman legion. It was the capital of northern Provence. In common with many Roman towns, a theatre and forum were built. In the 4th century, a small university and a Bishopric were located in Orange and in the 5th century the town was sacked by the Visigoths.

In 793, Orange was recovered from the Saracens by William, Count of Orange and companion of Charlemagne. The Princes of Baux ruled Orange in the 12th century, and the Black Plague killed half the population in the 14th century.

In 1530, it came under the rule of the Princes of Nassau, and was integrated into the Principality of Orange-Nassau. In the 16th century, the Wars of Religion were violent and Protestants were severely treated. William III, Prince of Nassau became King of England in 1689.

In 1869, the first Lyric Festival was held in the Roman Theatre. Sarah Bernhardt performed *Phèdre* there in 1903. The Theatre and

Triumphal Arch are now UNESCO World Heritage sites.

The city is surrounded by vineyards with Chateauneuf-du-Pape and Gigondas wine produced in the vicinity.

PLACES

Antique Theatre, rue Madeleine Roch.
Triumphal Arch, ave de l'Arc de Triomphe.
St Eutrope Hill, great view of the theatre and countryside.
Museum of Art and History, rue Madeleine Roch.
The House of Louis de Silhol, rue de Tourre.
The oak tree planted by Queen Juliana of the Netherlands in 1952.
The Aviation Museum, rue des Pays-Bas ZAC Du Coudoulet.
The LaPise house, near the Mairie.
The Nassau Museum, off rue Madeleine Roch.
The Theatre, 19th century.
The Protestant Temple, Jacobean church from the 16th century.
The Injalbert Sculpture, opposite the Roman Theatre.
Saint-Florent, ancient convent church and cloisters.
The Cathedral of Our Lady of Nazareth.

VISIT

The Harmas Jean Henri Fabre, route d'Orange, Serignan Du Comtat.
St Michel Church at La Garde Adhémar.
The Gabel Chapel, outside Orange.
Museum and Studio of German artist Werner Lichtner-Aix.
Wine Museum, Cave Brotte, Chateauneuf-du-Pape.
Le Carbet Amazonien, Butterfly Farm, Velleron.
Lavender Museum, Coustellet.
The Circus Of Alexis Gruss, route 77, Piolenc.
The Dentelles, small chain of mountains near Vaison-La-Romaine.

FESTIVALS

Camerone, legionnaires' commemoration day April 30th.
Jazz Festival, June.
Choregies, Lyric Festival, July-August.
Roman Festival, re-enactments, theatre, September.
Air Show, every four years.

http://uk.otorange.fr

JEAN-HENRI FABRE (1823 – 1915)

A French entomologist and writer.

Born on December 22nd, 1823 in St-Leons, Aveyron, France into a poor family. He worked hard at school and gained a teaching certificate and began teaching in Carpentras at 19. In 1849 he moved to teach in Ajaccio, Corsica then in 1853 to the Lycée in Avignon.

He is best known for his observations in the study of insects, and is said to be the father of modern entomology. He was also a writer capable of making the lives of insects appealing to the general public as in his *Entomological Souvenirs.*

His work influenced others including naturalist Charles Darwin. In one of his experiments, he watched caterpillars follow the silken trail of preceding caterpillars in a circle for seven days.

Jean-Henri Fabre's home is now a museum. His insect collection is in the Requien Museum in Avignon. He died on October 11th, 1915 at Sérignan-du-Comtat, near Orange.

WERNER LICHTNER-AIX (1939 – 1987)

"...I sensed that here I would find what I had within me, an affinity with the colours of the countryside."

A German painter and mechanical engineer.

Born in Berlin in 1939, Werner Lichtner studied to become a mechanical engineer but wanted to be a painter. When he first visited Provence in 1965, he was so inspired by Aix-en-Provence that he added the name Aix to his surname.

In 1969, he moved to Sérignan-du-Comtat, near Orange with his family, building a house in the ruins of a medieval castle and then a studio nearby where he painted landscapes and local scenes and developed his 'cloud paintings'. He travelled to the Sinai desert, Greece, Morocco and Tunisia.

He died in Munich in 1987, and his studio near Orange is now a museum and gallery.

'MARKET IN PROVENCE'
WWW.MUSEE-LICHTNER-AIX.COM

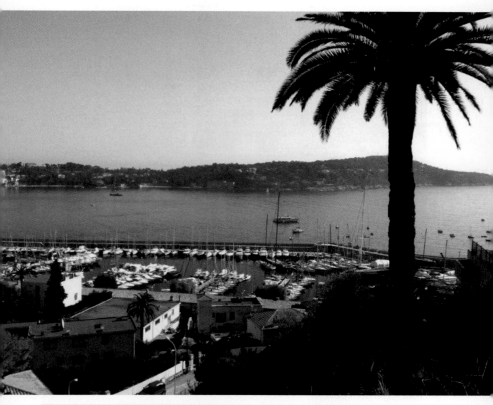

ST-JEAN-CAP-FERRAT (ALPES-MARITIMES)

For two hundred years or more from the 8th century, the peninsula was the home to Saracen pirates. A battle at the Saint Hospice Fort in the 11th century finally saw the Saracens repulsed.

St-Jean was a small fishing village until the 19th century when the onset of tourism transformed the area. In 1908, The Grand Hotel was built, more recently, a yacht marina with cafés and restaurants established.

The tranquility of the peninsula, which also affords privacy, made Cap-Ferrat an oasis for celebrities, European aristocracy, heads of state and the super-rich abroad. King Léopold II of Belgium was the first to build an estate on Cap-Ferrat. He also built several houses and an artificial lake.

In 1905, Béatrice Ephrussi de Rothschild began to build a

Tuscan style palazzo, now known as Villa Ephrussi de Rothschild Museum (below). It took seven years to complete.

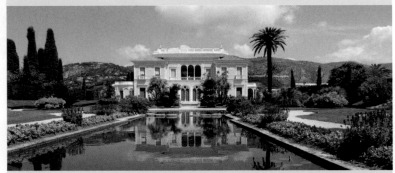

PHOTO: BERTHOLD WERNER

PLACES

Villa Ephrussi de Rothschild Museum, also known as Villa "Ile de France", is at the northern end of the peninsula, comprising seven gardens, a library, a shop and a tea room.
Santo Sospir Villa, with frescos on the walls by Jean Cocteau.
The Zoo Cap-Ferrat, on the peninsula near the tourist office.
Seashells Museum in the old port, over 6000 shells on display.
The St-Hospice Chapel.
The Lighthouse and garden.
The Grand Hotel.
The beaches.

VISIT

Walk the Promenade Maurice Rouvier to Beaulieu-sur-Mer.
Walk the Chemin de Carrière to Passable Beach.
Villa Kerylos, villa built in classical Greek style in Beaulieu.
Eze, ancient hilltop village (see page 77)
Drive along the Grande Corniche.
Villefranche-sur-Mer (see page 238)

FESTIVALS

St-Jean Baptiste celebration, June.
Saint Jazz Cap-Ferrat festival, August.
Les Azuriales Opera Festival, Villa Ephrussi, August.
Giant Christmas Nativity crèche, December-January.
www.saintjeancapferrat.fr

PAUL ALLEN (1953 –)

An American entrepreneur, investor and philanthropist, best known as the co-founder with Bill Gates, of Microsoft Corporation.

Born January 21st, 1953, in Seattle, Washington, he met Bill Gates at Lakeside School when he was 14. Allen dropped out of Washington State University in 1975 to design software and set up the Microsoft company. Gates and Allen redesigned Q-DOS as MS-DOS and sold it as the operating system for IBM's PCs. MS-DOS dominated the market as the main operating system for PCs from 1981.

In 1983, Allen was found to be suffering from Hodgkin's disease and resigned from Microsoft. Three years later, he set up Vulcan Ventures to invest in new opportunities. He has invested around $75 billion in new media, internet and cable businesses.

He has created numerous charitable foundations including the Experience Music Project, an interactive rock 'n' roll museum designed by the architect Frank O. Gehry, in Seattle. He has also invested in SpaceShipOne and the Allen Institute for Brain Science.

He published *Idea Man: A Memoir by the Cofounder of Microsoft* in 2011, the same year he was named as the most generous American for charitable giving. He owns Villa Maryland on Cap-Ferrat overlooking the port of St Jean.

CHARLIE CHAPLIN (1889 – 1977)

"We must laugh in the face of our helplessness against the forces of nature – or go insane."

An iconic English comic actor and film director of the silent film era, best known for his portrayal of 'The Tramp'.

Born April 16th, 1889 in Walworth, South London, his parents were Music Hall entertainers. When his parents split up, he was sent to the workhouse at 7 years old. His mother had mental health

issues and syphilis, while his father was an alcoholic. By the age of 10 he was earning a living performing on stage in a clog-dancing act. A few minor roles on stage and then a comedy act in a Vaudeville troupe saw him touring America for almost two years. On his second US tour he was signed to the Keystone Studios to act in silent films in 1913.

A meteoric rise saw him become one of cinema's first film stars, bringing him wealth and fame by the age of 26. His iconic character The Tramp was launched in 1915. By 1918, he had his own studio and complete control over the making of his films. His older brother Sydney was his business manager.

In 1919, with Mary Pickford, Douglas Fairbanks and D. W. Griffith, he co-founded United Artists which distributed his films.

Director Rex Ingram, who had a studio in Nice, introduced Chaplin to the Riviera.

Chaplin had four marriages: to Mildred Harris and then Lita Grey, with whom he had two sons; to a chorus girl, Paulette Goddard and finally to Oona O'Neil, daughter of playwright Eugene O'Neil with whom he had eight children and a long marriage.

His films made in the 30s: *City Lights, Modern Times* and *The Great Dictator* became classics. But Chaplin's left-wing sympathies forced him to relocate to Europe during the McCarthy era in the early 1950s.

He lived in Cap-Ferrat in one of the oldest villas, "Lo Scoglietto" now "La Fleur du Cap".

On December 25th, 1977, Chaplin died at his home in Corsier-sur-Vevey, Vaud, Switzerland.

Bizarrely, his body was stolen for ransom but police recovered it nearly three months later.

DAVID NIVEN
(1909 – 1983)

An English actor and raconteur best known for his light comedy and dramatic roles as upper class English gentlemen.

Born on March 1st, 1909, in London, England, he was the son of an Army officer, who was killed in the battle of Gallipoli in 1915. His mother then married her long-term lover, and Niven was sent off to boarding schools including Stowe. Sandhurst Military Academy followed where he was commissioned as a Second Lieutenant in the Highland Light Infantry.

Discharged in 1931, he did a range of odd jobs, progressing from film extra in 1935 to supporting roles in a number of Hollywood films. During World War II, he rose to Lieutenant Colonel in the commandos in the British army and Peter Ustinov was said to have served as his batman.

After the war, he had more significant roles in *A Matter of Life and Death* (1946), *The Moon is Blue* (1953) and *Around the World in 80 Days* (1956). He won an Oscar for his role in *Separate Tables* (1958). Other films include: *The Guns of Navarone* (1961), *Death on the Nile* (1978), and the Pink Panther series. He published two entertaining autobiographies *The Moon's A Balloon* (1971) and *Bring On the Empty Horses* (1975).

His first wife Prim Rollo, with whom he had two sons, died accidentally in 1946. His second wife Hjorgis, a former Miss Sweden, with whom he adopted two daughters, joined Princess Grace's social circle and became an alcoholic.

They lived in "Lo Scoglietto" (La Fleur du Cap) in Cap-Ferrat, where a square is named after him. Niven was often seen with friends Roger Moore or Robert Wagner in the village.

He suffered from motor neurone disease and died in Château d'Oex, Switzerland, on July 29th, 1983. In 1985, he was included in a series of British postage stamps, along with Hitchcock, Chaplin, Peter Sellers and Vivien Leigh, to celebrate British Film.

KING LEOPOLD II OF BELGIUM (1835 – 1909)

"I consider the beautiful lands of the Alpes Maritimes and Var region, together with the Principality of Monaco to be earthly sections of Paradise".

A Belgian royal, whose mercenaries committed genocide in the Congo. He reigned from 1865 until his death.

Born in Brussels on April 9th, 1835, the eldest surviving son of Leopold I and Louise of Orléans, he was enthroned on December 17th, 1865.

Leopold worked with Henry Stanley to lay claim to what became the Democratic Republic of the Congo. He exploited the country as a source of rubber and ivory, using a private army which killed or mutilated ten million Congolese. He commissioned many building projects in Belgium with money from the Congo, leading to the nickname 'the Builder King'.

He married Marie Henriette of Austria in Brussels on August 22nd 1853 and they had four children. They separated in 1895.

That year, he came to the Riviera for a visit, and stayed in the Grand Hotel at Cimiez, Nice, with his daughter Clementine. Ever

acquisitive, he bought several plots of land near Beaulieu and began building a palace – The Leopolda – and a villa called "Les Cèdres". At 65, he began an affair with 16 year old Blanche Caroline Delacroix, whom he installed in the villa Radiana nearby. They had two children. When he made her a baroness, it was a step too far. One critic declared that Leopold was: *"not only King of Nice but also King of Belgium ...and that his role was not solely to preside over the Nice Carnival, but also to attend cabinet meetings."*

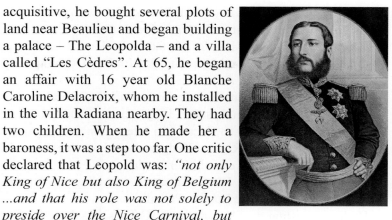

On November 15th, 1902, Italian anarchist Gennaro Rubino made an assassination attempt on the King, when Leopold was passing in his wife's funeral cortege.

On December 17th, 1909, Leopold died in his palace at Laeken with Blanche Caroline at his side. It's rumoured that they were secretly married before his death.

ANDREW LLOYD WEBBER (1948 –)

An English composer, Musical Theatre Producer and President of the Arts Educational Schools.

He was born on March 22nd, 1948, in Kensington, London. His father was a composer and his mother a musician. His aunt

was an actress and encouraged his love of theatre, and he began writing music at an early age. He studied at Westminster School and the Royal College of Music.

In 1965, he began a fruitful collaboration with lyricist Tim Rice and they worked on *Joseph and The Amazing Technicolour Dreamcoat* (1968), *Jesus Christ Superstar* (1970) and *Evita* (1978). Other

musical theatre includes *Cats* (1981), *Phantom of the Opera* (1986), *Sunset Boulevard* (1996) and *The Wizard of Oz* (2011).

He wrote a Requiem Mass for his father, William, who died in 1982. He received a Grammy Award in 1986 for Best Contemporary Classical Composition for *Requiem.*

As a producer his credits include *Daisy Pulls It Off* and *Shirley Valentine.* His awards include seven Tonys, three Grammys, seven Oliviers, a Golden Globe, an Oscar, two International Emmys, the Praemium Imperiale, the Richard Rodgers Award for Excellence in Musical Theatre and the Kennedy Center Honor.

He currently owns six London theatres, including the Theatre Royal, Drury Lane and the London Palladium.

He began casting on TV with the BBC TV series *How Do You Solve a Problem Like Maria?* which won an Emmy award.

Married three times, first, in 1972, to Sarah Hugill with whom he had two children. Then singer Sarah Brightman from 1984–1990 and finally, Madeleine Gurdon in 1991, with whom he has three children.

He was knighted in 1992 and created an honorary life peer in 1997. He sits as a Conservative member in the House of Lords.

He owned the Domaine Chabanne in Cap-Ferrat as a holiday home but has since sold it to a Russian billionaire.

WILLIAM SOMERSET MAUGHAM (1874 – 1965)
"It's very hard to be a gentleman and a writer."
An English novelist, playwright and short story writer.

Born in the British Embassy in Paris on January 25th, 1874, he was the son of an English lawyer who worked for the Embassy. Orphaned by the age of 10, he was raised by his uncle, a reverend,

in Kent. He went to King's School and then Heidelberg University in Germany before training as a doctor. His first novel *Liza of Lambeth,* published when he was 23, made enough money for him to switch to writing full time.

During World War I, he joined the Ambulance Corps and met an American,

Gerald Haxton, with whom he had a homosexual relationship until Haxton's death in 1944. He was also recruited to work for MI6.

In 1915, he had a relationship with interior designer, Syrie Wellcome, with whom he had a daughter, Mary Elizabeth. After Syrie's divorce, they did marry, but Syrie found it difficult to live with Maugham's itinerant lifestyle and they divorced in 1929.

In 1928, Maugham bought "Villa Mauresque" at Cap-Ferrat where he created a vibrant literary circle. The house had been built by King Leopold II for his priest and was designed in a Moorish style.

During World War II, he went to Hollywood and wrote and adapted films. He returned to Cap-Ferrat after the war. He wrote many plays, essays, travel books and novels including *Of Human Bondage* (1915), *The Moon and Sixpence* (1919) and *Cakes and Ale* (1930). In 1947, Maugham created the Somerset Maugham Award, for works of fiction by British writers under the age of 35.

Maugham had a relationship with Alan Searle in the 1940s, adopting him as his son and heir. They lived together until Maugham's death on December 16th, 1965.

His daughter contested the will under French law, but Searle inherited £50,000, the contents of "Villa Mauresque", Maugham's manuscripts and revenue from copyrights of his works for thirty years. After this period, Maugham requested that copyrights were donated to the Royal Literary Fund.

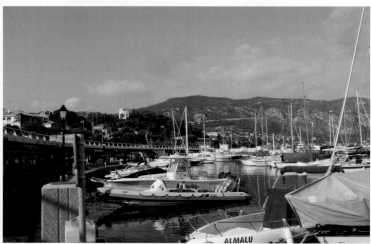

MARINA AT ST-JEAN-CAP-FERRAT

MIRO GARDEN AT THE MAEGHT FOUNDATION

SAINT PAUL-DE-VENCE (ALPES MARITIMES)

Vines were planted in the vicinity as early as the 6th century BC and the Romans cultivated vines until the 5th century AD, creating a strong tradition of viticulture in the area.

St-Paul-de-Vence is a medieval hilltop village, which was fortified in the 13th century. Ruled by the Lords of Grasse-Bar in the 16th century, it then became a Royal Village. François 1st built up the ramparts to enclose it in 1537, grateful for the village's stand against Charles V. In 1747, the town was invaded and many buildings were destroyed. Until 1868 it was a military outpost.

In the 1920s, restaurateur Paul Roux opened his first establishment in the village and later in 1934, he opened a small guest house called "La Colombe d'Or". The place became a magnet for artists, writers and actors and the village developed into the popular tourist spot it is for arts and culture today.

PLACES

The Maeght Foundation, 623 chemin des Gardettes, Miró, Chagall, Giacometti, Braque, Calder and Léger all helped create the museum and gardens located just outside the village.

Château de Villeneuve, Place du Frêne, houses the Émile Hugues Foundation, regular art exhibitions.

St-Paul Museum, Tourist Office, 2 rue Grande.

Porte Royale, fortified gateway.

Église de la Conversion de Saint Paul.

Folon Chapel, Place de L'Eglise, decorated by artist Folon.

Local History Museum, Place de L'Eglise, with wax figures.

Tour de la Fondule, 14th century tower.

La Colombe D'Or, hotel and restaurant.

Petite Cave de Saint-Paul, 7 Rue de L'Etoile, 14th century wine cellar. Offers wine-tasting.

VISIT

Rosaire Chapel (Matisse Chapel), designed and decorated by Matisse in 1949, Vence.

Notre-Dame Cathedral, 11th century historic monument, Vence.

The Celle-Roubaud Abbey and Chapel Sainte-Roseline home to a large mosaic by Marc Chagall, art by Giacometti, Louis Bréa and stained-glass windows.

MATISSE CHAPEL, VENCE

Many scenic walks in the countryside around Vence.

Raphael Vigneau & Louis Giraudo, vineyard, route des Serres.

Domaine Saint-Joseph vineyard, Tourrettes-sur-Loup .

FESTIVALS

Summer Arts Festival.

Feast of Sainte-Claire, August.

Wine Harvest Festival, beneath the ramparts, Sep-Oct.

Violet Festival, Tourrettes-sur-Loup, February.

www.saint-pauldevence.com

PEOPLE
JAMES BALDWIN
(1924 – 1987)

An American novelist, playwright, essayist and activist against racism and homophobia.

Born on August 2nd 1924, he grew up in Harlem, New York. His mother divorced his father, due to his drug abuse, and remarried a preacher called David Baldwin. James Baldwin became a preacher himself as a teenager, while editing the high school magazine. He met the black artist Beauford Delaney in Greenwich Village, and Delaney became his mentor.

Marlon Brando was another close friend for over twenty years and they shared a room in the 1940s. In 1948, he went to Paris where he was able to openly acknowledge his homosexuality.

In 1957, he returned to the USA to report on the Civil Rights Movement and interviewed Martin Luther King. He gave a series of lectures and became a spokesman for the movement, which he referred to as a 'slave rebellion'. His picture graced the cover of *Time* magazine in 1963. Along with other black writers such as Lorraine Hansberry, he met with Robert F. Kennedy to discuss the need for social change. Baldwin also attended the Civil Rights March on Washington, D.C. on August 28th, 1963, with Harry Belafonte, Sidney Poitier and Marlon Brando. When a bomb exploded in a Birmingham church not long afterwards, he called for a nationwide campaign of civil disobedience.

His novels include: *Go Tell it on the Mountain* (1953), *Giovanni's Room* (1956), and *Tell Me How Long the Train's Been Gone* (1968). His plays include: *The Amen Corner* (1954) and *Blues for Mister Charlie* (1964).

In 1970, Baldwin and his companion Bernard Hassell moved into an old Provençal house on Chemin du Pilon in St-Paul-de-Vence. Among his many visitors were Beauford Delaney, Miles Davis, Ray Charles, Harry Belafonte, Sidney Poitier, Nina Simone,

Josephine Baker and Bill Cosby.

He wrote *Just Above My Head, If Beale Street Could Talk* and *Harlem Quartet* while living there.

He died on December 1st, 1987 at his home in St-Paul but was buried in Ferncliff Cemetery, Westchester County, near New York. His influence on writers such as Maya Angelou and Toni Morrison has been well documented.

MARC CHAGALL (1887 – 1985)

A Belorussian-French artist best known for his vividly coloured figurative paintings. One of the pioneers of modernism and considered one of the greatest Jewish artists.

Born in Vitebsk, Belarus on July 7th, 1887, as Moishe Segal, to a poor family with nine children, he went to Jewish school and then studied painting in St Petersburg, where he began to develop his unique style.

He went to Paris in 1910 and was influenced by the avant-garde artists and writers he met there. He had his first successful solo show in Berlin in 1914 and exhibited his work in the Paris salons.

He spent the war years in Vitebsk, where he married Bella Rosenfeld and had a daughter, Ida. He embraced the Russian Revolution and set up an Art College in Vitebsk. He began illustrating books to bring in extra income and had exhibitions in Moscow and St. Petersburg.

During 1923, he returned to Paris with his family and in the 1930s he travelled in Europe and to Palestine where he made sketches for an illustrated Bible.

At the beginning of World War II, he was back in France, and was helped by Alfred Barr at MOMA in New York to flee the nazis in 1941. His wife Bella died in 1944 and this had a profound effect on his work. He had exhibitions in New York and Chicago, managed by Matisses's son Pierre, was involved in set and costume design for the ballet but left the US in 1947 to attend an exhibition of his works at the Musée National d'Art Moderne in Paris.

He met and married Valentina (Vava) Brodsky in 1952. They moved to Vence on the Côte d'Azur, to be near Matisse and Picasso, who regarded him as an artistic rival. In 1963,

REIMS CATHEDRAL WINDOWS
PHOTO: PETER LUCAS

he was commissioned to design the new ceiling for the Paris Opera, a 19th-century national monument. Despite objections to a Russian Jew being appointed, the ceiling was considered a success when it was unveiled in 1964.

Chagall also accepted a number of commissions to design stained glass windows for churches, cathedrals, a synagogue in Jerusalem and a memorial window for the UN.

In 1966, he and his wife moved to St-Paul-de-Vence, where they built a villa called "La Colline". He lived next door to Aimé and Marguerite Maeght, who have several of Chagall's works in their collection, including *Les Amoureux,* a mosaic at the entrance to the Foundation.

Chagall died on March 28th, 1985, in St-Paul-de-Vence where he is buried with his wife, Vava.

AIME MAEGHT (1906 – 1981)

An art collector and gallery owner known for co-creating the Maeght Foundation with his wife and for producing high quality lithographs of the major artists of the 20th century.

He was born on April 27th, 1906 in Hazebrouck, near Lille. His father was a railway engineer who was killed in World War I. His mother moved the family to Nîmes. Maeght was a good student and studied design and printing then found a job working in a print works in Cannes in 1927.

He met Marguerite Devaye and they were married in 1928 and had two sons, Adrien and Bernard.

In 1932, Maeght opened his own printing company ARTE in Cannes. Pierre Bonnard (see page 63) wanted one of his works printed on a program.

Maeght had the idea to sell a print of the painting in his shop and this developed into a sort of art gallery. Bonnard introduced him to Henri Matisse and Maeght joined the artistic circle around Nice and Cannes in the 30s.

During World War II, the Meaghts moved to nearby Vence, close to where Henri Matisse was staying, and after the war they opened an art gallery in Paris. The gallery became a place to hang out for artists, poets and writers and Maeght and his wife organised exhibitions of work by Matisse, Chagall, Miró, Braque, Kandinsky, Giacometti Fernand Léger among many others. The couple also opened a gallery in Barcelona.

Maeght also produced high quality art books to accompany the exhibitions as well as limited edition signed lithographs which have become collectors' items. He liked to combine the work of artists and poets in beautifully printed editions.

In 1954, following the death of their young son Bernard, the Maeghts travelled to the US to develop the idea of creating a Foundation as a memorial for him. The architect Josep Lluís Sert conceived of a space where modern art in all its forms could be harmoniously presented within the surrounding nature.

Ten years later the Foundation was launched with a show that featured singers Yves Montand and Ella Fitzgerald. The collection now features over 10,000 works by many important artists including: Bonnard, Braque, Calder, Chagall, Giacometti, Léger

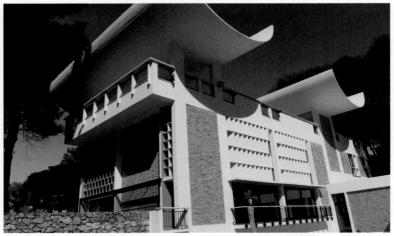

THE MAEGHT FOUNDATION

and a garden designed by Miró. The museum now attracts over 200,000 visitors each year.

YVES MONTAND (1921 – 1991)

A popular French singer and actor who came to fame due to Edith Piaf's promotion of his talents.

Born on October 13th, 1921, as Ivo Livi, in Monsummano Terme, Italy. His father was a militant communist and the family had to flee Italy's fascist regime in 1923, settling in Marseille. He left school at 11, worked as a hairdresser in his sister's barber shop and later as a docker. At 17, he began performing in a music hall act and worked his way up to the Moulin Rouge in Paris. At 23, he was discovered by Edith Piaf who helped to promote his music and acting career. The two became lovers for two years. Montand achieved considerable success as a singer with numerous hits.

In 1949, Montand met Simone Signoret at the "Colombe D'Or" in St-Paul-de-Vence, and the two held their wedding reception there in 1951. They co-starred in numerous films together. Montand had a number of affairs, including one with Marilyn Monroe, with whom he starred in *Let's Make Love.* He and Signoret also had a home in Autheuil-Authouillet, Normandy, where the main village street is named after him.

In the 50s, Montand became involved in left-wing politics and joined the Communist Party. He toured Russia in 1956 but by 1968 he was disillusioned and quit the Communists.

In the 60s, Montand's film career took off with *Compartiment Tueurs* and further collaborations with the director Costa-Gavras. This was followed by Alain Resnais' *La Guerre Est Finie* and René Clément's *Paris Brûle T'il?* A fallow period followed until 1986, when he played the scheming uncle in *Jean de Florette,* (co-starring Gérard Depardieu) and in *Manon des Sources,* (co-starring

Emmanuelle Béart). The films' global success raised his profile internationally.

Signoret died in 1985 and Montand remarried Carole Amiel in 1987. They had a son together, Valentin, in 1988 and lived in St-Paul-de-Vence.

On the last day of filming his final film, *IP5*, Montand suffered a heart attack, like the character he was playing in the film. He died on November 9th in Senlis, France in 1991. Due to a paternity suit court case, his body was exhumed so that a DNA sample could be taken. The results showed he was probably not the child's biological father.

Montand is interred next to his first wife, Simone Signoret, in Père Lachaise Cemetery in Paris.

JACQUES PREVERT (1900 – 1977)

PREVERT IN FRONT OF HIS HOUSE LA MIETTE:
OFFICE DE TOURISME DE ST-PAUL-DE-VENCE
PHOTO : JACQUES GOMOT

A French poet and screenwriter whose poems are popular in French schools due to their play on words.

Born February 4th, 1900, in Neuilly-sur-Seine, he grew up in Paris. He left school at 15 and went to work in Le Bon Marché, a large department store in Paris.

At 18, he was called up for military service and at the end of World War I, was sent to Istanbul to defend French interests. Discharged from the army, he met Marcel Duhamel and stayed with him in Paris where he met the Surrealists.

In April, 1925, he married the musician Simone Dienne who played accompaniments to silent movies. Prévert developed a form of song poems which were collected in *Words* (1945). So popular were they that Josef Kosma set many of them to music

and they became firm favourites with young people for their subversive humour. Prévert helped to hide Kosma, a Jew, during the German Occupation.

He divorced Simone in 1935 and began a relationship with Jacqueline (Janine) Tricotet, marrying her in 1947, after the birth of their daughter Michele. Prévert discovered St-Paul-de-Vence in 1941, due to his involvement with filmmaking at the Victorine Film Studios in Nice. He became one of the most successful French screenwriters in the 30s and 40s. His films include: *The Visitors of the Evening* (1942) and *The Children of Paradise* (1944).

He first stayed in La Résidence (now the Café de la Place), before moving across the square to the Colombe d'Or. Paul Roux, the proprietor, Prévert and Picasso became good friends and often spent time together. He also stayed at the hotel during the making of *The Devils' Envoys*. Prevert felt at home and rented "La Miette", a small house in the centre of the village.

Prévert had an accident in 1948 and spent time in St-Paul recovering, taking up collage. He decorated the walls of the Colombe D'Or with his collage, some of which still remains.

Later, the couple moved into "L'Ormeau", a property on the edge of the village, until the mid 1950s.

He died in Omonville-la-Petite, on April 11th, 1977.

PAUL ROUX

A French hotelier and restaurateur whose inn, "La Colombe D'Or" became a magnet for the jet-set after the war.

Paul Roux, the son of a village farmer, was probably born at the turn of the century. An aspiring artist, he opened a café-restaurant called "Chez Robinson" in the 1920s in St-Paul-de-Vence, where people could eat and dance to the sound of a pianola. It became so popular with the locals that it was forced to close by the Mairie.

In 1932, Roux and his

wife Baptistine (right) extended and transformed the 16th century inn and launched the "Colombe d'Or". It offered a warm welcome, with a sign over the door that read: *"Ici on loge a cheval, a pied ou en peinture."* (Welcome here on foot, on horseback or on canvas!)

During the German Occupation, many writers and artists left Paris and moved to the South of France. Those who came to paint the views in the pretty village often had dinner at the restaurant and stayed in the inn. Roux began accepting paintings and sketches in return for board and lodging, building up an extensive private collection. Chagall, Léger, Picasso, Calder and Braque all became regulars at the Colombe d'Or and Roux decorated the dining room and bedrooms with their paintings. Matisse often visited and sometimes he and Roux would have tea in his limousine as Matisse was not well enough to leave his car.

As the reputation of the inn spread, the clientele often included the rich and famous: The Prince of Wales, Roger Moore, Brigitte Bardot, François Truffaut, Orson Welles, Marlene Dietrich, Tyrone Power and Sophia Loren. Writers Jean-Paul Sartre, Simone de Beauvoir and James Baldwin were frequent visitors too.

In the 1950s Roux's son Francis got married and he commissioned a huge ceramic from his friend Fernand Léger, to decorate the garden and terrace. When Roux died, first his wife then his son took over the running of the establishment. Francis bought the 18th century house next door to create more bedrooms. He attracted a new generation of guests to the inn, including Yves Montand and Simone Signoret.

Some of the hotel's art collection was stolen on April 1st, 1960, but after an anonymous tip-off, the police recovered nineteen of the twenty stolen paintings in a left luggage locker at Marseille railway station. The ensuing publicity has helped put the village on the tourist trail with around seven thousand visitors a day in the summer.

SIMONE SIGNORET
(1921 – 1985)

A French film star who was the first French actress to win an Academy Award.

She was born on March 25th, 1921, in Wiesbaden, Germany, as Simone Kaminker. Her father was a French born Polish Jew, who worked as an interpreter at the League of Nations. Her mother was a French Catholic. Signoret grew up in Paris and was a good student who gained a teaching certificate and began work as an English tutor.

During the war, her father went to England to join de Gaulle's resistance force and she adopted her mother's maiden name to hide her Jewish origins. She became part of the artistic circle based at the Café de Flore in Paris and began acting.

In the 50s, her films included: *La Ronde* (1950), *Thérèse Raquin* (1953), *Les Diaboliques* (1954), and with Yves Montand in *Les Sorcières de Salem* (1957), based on Arthur Miller's *The Crucible*.

She married director Yves Allegret in 1944 and they had a daughter, Catherine. After meeting singer/actor Yves Montand at the "Colombe D'Or" in St-Paul-de-Vence, she divorced. Married to Montand in 1951, she put up with his numerous infidelities, but was criticised for losing her looks as she grew older.

In 1958, Signoret's performance in *Room at the Top* (1959) won her both the Best Female Performance Prize at Cannes and the Academy Award for Best Actress. She preferred to work in Europe rather than Hollywood, appearing opposite Laurence Olivier in *Term of Trial* (1962). She worked in America on *Ship of Fools* (1965), which earned her another Oscar nomination.

She translated and acted in Lillian Hellman's play *The Little Foxes,* a production which ran for six months at the Theatre Sarah-Bernhardt in Paris.

Signoret won two Cesar awards for Best Actress in her later years for *Madama Rosa* (1977) and *L'Etoile du Nord* (1982).Other awards include: several BAFTAs, an Emmy, the Silver Bear for Best Actress award and a Golden Globe nomination. She died on September 30th, 1985, in Autheuil-Authouillet, France.

PHOTO: ROLLAND FRANCK

SAINT-RAPHAEL (VAR)

Evidence of human occupation in prehistoric times remains in the standing stones, menhirs and dolmens found in the area. The red rock in the area is distinctive and very picturesque.

The Romans came to trade and even holiday in the area until the Barbarian invasions became too frequent.

In the 4th century, Saint Honorat stayed in a cave at St-Raphael and the town attracted many pilgrims so the hermit sought tranquility on the Iles des Lerins in the bay of Cannes.

Napoleon Bonaparte came to St-Raphael twice, on the way to his Egyptian campaign and then en route to exile on Elba island.

In the 19th century, tourism and the new train line brought many visitors and the town expanded. The Basilica and many Belle Epoque villas were constructed, attracting the fashionable set who came to the south for the mild climate in the winter.

In 1944, American troops landed at Le Dramont to launch their offensive to liberate Provence. 20,000 GIs from the 36th Infantry Division from Texas disembarked on August 15th, 1944.

PLACES
Archeological Museum, rue des Templiers.
Notre-Dame de la Victoire Basilica, Roman-Byzantine style.
Walk along the Promenade des Bains.
Jardin Bonaparte with play area for children.
Casino De Jeux De Saint-Raphael, Square De Gand.
Beaches – Agay and Veillat, Boulouris, Le Dramont.

VISIT
Roman Aqueduct, theatre and gates, Frejus.
Sudanese Mosque, route des Combattants d'Afrique du Nord, Frejus.
Cocteau Chapel, route de Cannes, Frejus.
Walk the coastal path from Santa Lucia to Agay.
Drive along the Corniche D'Or.
Go hiking in the Esterel mountains.
National Park of Port Cros.

FESTIVALS
The Mimosa Trail, Jan to Mar.
Carnival and Parade, mid- Feb.
La Bravade Parade, April-May, Frejus.
Les Nuits Aureliennes, theatre and music, Roman Theatre, July-August, Frejus.
La Messe du raisin, August, Frejus.
Les Nuits du Port, August, Frejus.
Le Roc D'Azur, cycle race, October, Frejus.
Kite Festival, November, Frejus.
Fete de la Lumiere, December-January.

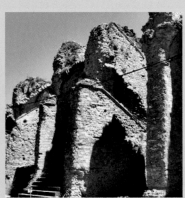

www.saint-raphael.com

HENRY CLEWS JR (1876 – 1937)

PHOTO: LNAF.ORG

An American sculptor who purchased the Chateau of La Napoule in Mandelieu-la-Napoule near St Raphael.

Born April 23rd, 1876 in New York City, the son of Henry Clews, a Wall Sreet banker. Clews grew up in New York and went to Westminster School and Groton. He attended Columbia University then studied at the Universities of Lausanne and Hanover.

From 1903, his work was exhibited in New York City. From 1914, when Clews married Marie, they spent most of their time abroad, firstly in Paris where they had a son, Mancha. In 1918, Clews and his wife bought the Chateau de la Napoule on the bay of Cannes and renovated it, creating a fairytale world, involving medieval costume parties. One of Clews' sculptures, God of Humormystica, a wedding gift to his wife, stands in the courtyard.

He died on July 28th, 1937 and is buried in a tower of the chateau. The Metropolitan Museum of Art organized a retrospective exhibition of sculptures by Clews in 1939.

Clews' wife, Marie, lived for a further twenty years and she founded the La Napoule Arts Foundation in 1951, an academy for the international exchange of writers and artists.

F. SCOTT FITZGERALD (1896 – 1940)

"It was an age of miracles, it was an age of art, it was an age of excess, and it was an age of satire."

An American author of novels and short stories, who epitomised the Jazz Age and the 'Lost Generation' of the 1920s. He is best known for his novel *The Great Gatsby.*

He was born in St. Paul Minnesota on 24th September, 1896. His father was a salesman but the family lived mainly off his Irish-Catholic mother's inheritance. At 15, he was sent to the Catholic Newman School, before entering Princeton University. He dropped out and joined the army but never saw active service

in World War I, being sent to a base in Alabama where he met his future wife, Zelda.

The success of his first novel *This Side of Paradise* (1920) gave him the financial security to marry Zelda and his second novel *The Beautiful and the Damned* (1922) added to his reputation.

They moved to Saint Raphael in France in 1924 and he wrote *The Great Gatsby* (1925) which is now considered one of the great

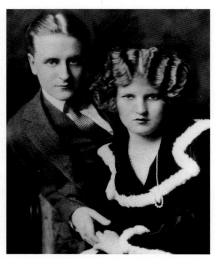

American novels. They stayed regularly with Gerald and Sara Murphy in Juan-les-Pins during the 1920s and 30s. At a restaurant in St-Paul-de-Vence, Zelda became so jealous of the attention that Scott was paying to Isadora Duncan, that she had an accident falling down a flight of stone steps. Zelda eventually suffered a mental breakdown and was hospitalised in a Swiss clinic, and Fitzgerald developed a drink problem.

Fitzgerald struggled to finish his fourth novel *Tender Is the Night* in 1934, as the drink and his depression took its toll. Later, he began to write *The Love of the Last Tycoon* in Hollywood. Due to a fatal heart attack on December 20th, 1940, the novel was only half finished. It was made into a film, directed by Elia Kazan and released as *The Last Tycoon* (1976), starring Robert De Niro.

Numerous adaptations of his works have been made, most recently the Baz Luhrmann film of *The Great Gatsby* (2013), starring Leonardo Di Caprio.

ALPHONSE KARR (1808 – 1890)

"The more things change, the more they stay the same,"
A French journalist, poet, and essayist of Bavarian descent.

Born November 24th, 1808, in Paris, he went to school at the Bourbon College and then became a teacher there.

He wrote his first novel *Sous les Tilleuls* in 1832 and it was an

immediate success.

In 1839, he became editor of *Le Figaro* as well as editing the magazine *Les Guepes (The Wasps)* in which he satirised the politics and society of the day. He was against the rise of Napoleon's nephew, Louis-Napoleon, and frequently opposed this in the press.

In 1855, after Louis-Napoleon became Emperor Napoleon III, Karr decided that it would be wise to leave France. With his wife and daughter, they moved to Nice, which at that time, was still part of Italy. There, he developed a successful business growing and selling flowers.

He enjoyed playing with words and liked to write his name in different ways: 'Karr nage' (Carnage), 'Karr n'avale' (Carnival), and 'Karr avance et raille' (Caravanserai).

Karr moved to St Raphael in 1865 with his family and spent his time writing and painting. His most successful novel was *Under the Linden Tree*. His short story *Les Willis* was the basis of Puccini's opera *Le Villi*.

There is a road in Nice named after him. He died on September 29th, 1890 at St Raphael.

ANTOINE DE ST-EXUPERY (1900 – 1944)

A French author and aviator best known for *The Little Prince*.

He was born on June 29th, 1900 in Marseille, France as Antoine-Marie-Roger de Saint-Exupéry, into an aristocratic family. His father died when he was 4 years old and he grew up with his extended family in a castle. He went to Jesuit schools and a Catholic boarding school in Switzerland before training as an architect in Paris. His grandparents owned the "Villa Marie-Madeleine" in Saint-Raphaël and he spent his summer holidays there.

He began flying in 1912 and joined the French Air Force in 1921 then took a job as a commercial pilot. His first novel *Southern Mail* (1929) explores the dangers of flying at the time.

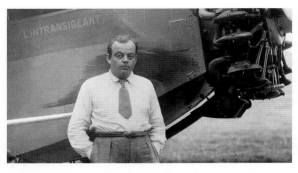

He spent a year based at a remote airfield in Morocco, delivering the post. In 1929, he took a job in Argentina, flying the postal service and wrote *Night Flight* (1931) which became an international success.

He married Consuelo Gómez Suncin in the Agay chapel at St-Raphael on May 12th, 1931 but as he was absent so much and often unfaithful, the marriage failed. His third novel, *Wind, Sand and Stars* (1939) won the French Academy's Grand Prix du Roman and the National Book Award in the United States.

During an attempt to break the speed record in 1935, Saint-Exupéry, and his navigator André Prévot, crashed in the Sahara desert. The pair struggled to find their way out of the desert but were picked up after four days by a Bedoin tribesman.

Saint-Exupéry flew for the French at the beginning of World War II. When France was occupied by the Germans, he moved to the U.S. and Canada, where he wrote his most famous work, *The Little Prince* (1943) which was published after his death in France.

He joined the Free French and Allied Air Forces at the end of World War II, undertaking reconaissance flights for them. He went on a mission to spy on German troop movements in the Rhone valley on July 31st, 1944 and disappeared.

His aircraft was thought to have crashed near Carquerainne. In 2000, fragments of his plane were discovered by a diver near Marseille, but there was no sign of his body. In June 2004, the fragments were given to the Air and Space Museum in Le Bourget, Paris, where Saint-Exupéry's life is honoured in a special exhibit. There is also a memorial to St-Exupéry at Pointe de la Baumette, Agay, near St-Raphael.

The Little Prince has been translated into over two hundred languages and has been adapted for film and TV.

SHADY SQUARE IN ST-REMY

SAINT-REMY (BOUCHES-DU-RHONE)

In the heart of Provence, at the foothills of Les Alpilles, the ancient Greco-Roman town of Glanum was established just south of the current town. Its ruins make up an enormous site of archeological interest, one of the most important in France.

Saint-Rémy was built under the protection of the Abbey St-Rémi of Rheims in the Middle Ages. Its centre is full of narrow alleyways, squares with tall trees and fountains surrounded by elegant buildings. The archways of its ancient walls still stand and provide entrance to the old town centre.

Van Gogh painted over 150 paintings of the countryside around St-Rémy, while staying at the asylum at Saint Paul de Mausole. (see page 45)

Favoured by Parisians as a weekend retreat, Princess Caroline of Monaco went to live there, following the death of her husband in a speedboat accident in 1990.

PLACES

Chapel of Notre Dame de Pitié, ave Durand Maillane, housing paintings by Mario Prassinos.

Saint-Roch Chapel, route de Maillane, quartier des Jardins.

Estrine Hotel and Museum and Van Gogh Interpretation Centre, 8 rue Estrine.

Musée des Alpilles, Place Favier.

Church of St. Martin, blvd Marceau.

Hôtel de Sade, de Sade family home, rue du Parage.

The Jewish cemetery, ave Antoine de la Salle.

Escobio Space, petite route du Grès.

Nostradamus House, rue Hoche.

VISIT

The archaeological site of Glanum, Roman mausoleum and Arc de Triomphe, route des Baux de Provence D5.

Les Antiques, route des Baux de Provence D5.

Saint Paul de Mausole, ave Vincent van Gogh.

The Regional Natural Park of the Alpilles.

Les Baux-de-Provence, fortified village on top of rocks.

Hotel Chateau de Roussan, route de Tarascon.

Calanquet Olive Oil Mill, vieux chemin d'Arles, Quartier du Gres.

Hiking paths, the Grande Randonee 6 goes through St-Rémy.

FESTIVALS

Winter Encierros, January.

Carnival, March.

Transhumance, sheep parade, May.

Festival Organa, concerts July-September.

Jazz Festival, September.

Bull racing, October.

Winter Encierro, November.

Christmas concert, December.

www.saintremy-de-provence.com

MICHEL DE NOSTRADAME (1503 – 1566)

A French Renaissance doctor, humanist and scholar, best known for his *Prophecies* first published in 1555.

Born in Saint-Remy de Provence on December 14th, 1503, he grew up in an environment of science and humanism. At 15, he went to Avignon to study but plague closed the university, then he spent eight years researching herbal remedies before going to the medical school of Montpellier in 1529, where he was nicknamed 'Nostradamus' and expelled for working as an apothecary.

In 1531 Nostredamus married and had two children but his family died, probably from plague. He set off on his travels again, around France and possibly Italy.

On his return in 1545, he helped treat victims of the plague in Marseille, and then in Salon-de-Provence and in Aix-en-Provence. In 1547, he settled in Salon-de-Provence where he married a rich widow named Anne Ponsarde and had six children.

He wrote an almanac for 1550 which was such a success that he continued to produce one each year. These contained calendars and led to him being consulted by the nobility. Then he wrote his books of prophecies.

Catherine de Medici, invited Nostradamus to Paris and in 1566 she made him Counsellor and Physician-in-Ordinary to her son, the young King Charles IX of France.

Nostradamus suffered from gout, which grew steadily worse. On the evening of July 1st, 1566 he is said to have foreseen his own death. The next day he was found dead and was buried in the local Franciscan chapel in Salon.

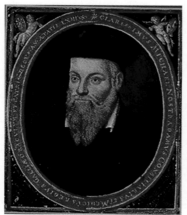

During the Revolution, he was re-interred in the Collegiale Saint-Laurent, where his tomb remains to this day. A bust of Nostradamus made in 1859 by sculptor Antoine Liotard Lambescorne decorates a fountain in Rue Carnot in the old centre of Saint-Remy.

CHATEAU DE ROUSSAN, NEAR ST-REMY

FREDERIC MISTRAL (1830 – 1914)

A French writer and poet who promoted the Occitan language of ancient Provence. Born on September 8th, 1830 in Maillane near St Remy, the son of wealthy landowners. He was a poor student so his parents sent him away to the Royal College in Avignon to be educated.

Mistral studied law in Aix-en-Provence from 1848 to 1851. He became a champion for the independence of Provence, and in particular for restoring the 'first literary language of civilised Europe' – Provençal. He had studied the history of Provence during his time in Aix-en-Provence.

He was wealthy enough not to have to work for a living so devoted himself to championing the Occitan language and traditions of his native Provence. Occitan had been the language of the troubadours, and was once common throughout the Midi, in southern France and parts of Italy and Spain.

For his literary output and philology, he was one of the recipients of the 1904 Nobel Prize for Literature. The other winner that year, Jose Echegaray, was honoured for his Spanish dramas. They each received one-half of the total prize money. Mistral

donated his half to the creation of the Museum at Arles, known locally as the Museon Arlaten. The museum contains a large collection of Provençal folk art, displaying furniture, costumes, ceramics, tools and farming implements.

In 1876, Mistral was married to Marie-Louise Riviere in Dijon Cathedral but they did not have any children.

In 1854, at a meeting in Châteauneuf-de-Gadagne in the Vaucluse, Mistral and Joseph Roumanille founded Felibrige with five other poets – Théodore Aubanel, Anselme Mathieu, Jean Brunet, Alphonse Tavan and Paul Giéra. The word 'félibrige' is derived from 'félibre', a Provençal word meaning pupil or follower and the number came from a Provençal tale in which Jesus is arguing in the temple with 'Seven Practitioners of the Law'.

Félibrige was a literary and cultural association aiming to promote the Occitan language as well as Provençal customs and literature. The group also welcomed Catalan poets from Spain and took the Cross of Toulouse (below) as their emblem. Mistral helped to revive the Occitan part of the Jeux Floraux, the oldest literary competition in the world, now held each year in Toulouse.

Mistral worked for twenty years to compile *Lou Tresor Dou Felibrige,* a bi-lingual dictionary of Occitan-French which remains a reference book today.

His most important work is *Mirèio* (Mireille), published in 1859, a long poem in Provençal made up of twelve songs. It tells the tragic love story of Vincent and Mireille, he a poor worker and she a rich farmer's daughter, divided by class. *Mireio* was translated into

 over a dozen languages. Mistral translated it into French himself. In 1863, Charles Gounod made it into an opera, *Mireille.*

He died on March 25th, 1914, in Maillane, where he was born.

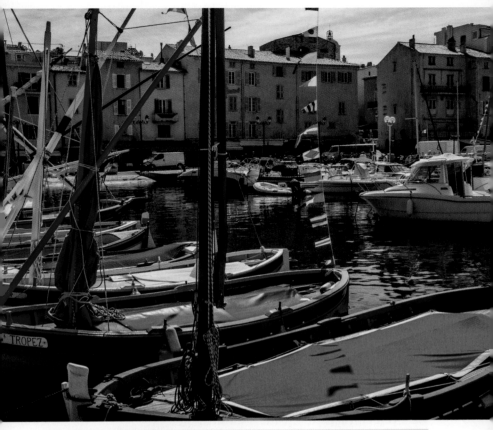

SAINT-TROPEZ (VAR)

The legend of Saint Topes whose body washed ashore in a boat in 68 AD gave St-Tropez its name. He was a Christian martyr from Pisa beheaded by Nero. The Romans came and built sumptuous villas around the bay until the Roman Empire fell apart.

In the 10th century the town came under the Saracens until William 1 Count of Provence reclaimed it and built the Suffren Tower. In the Middle Ages, St Tropez had its own militia to repel attacks. In 1615, an expedition led by the Japanese samurai Hasekura Tsunenaga was forced to stop in the port on their way to Rome. This may have been the first visit to France of the Japanese.

In 1637, the local nobility led a force which vanquished a fleet of Spanish galleons. Each year the locals celebrate this victory

with a parade called Les Bravades des Espagnols.

During the 1920s St-Tropez became a fashionable place to spend the winter. In the 1950s, it attracted the jet-set due to publicity from films such as *And God Created Woman* starring Brigitte Bardot. Today, it's still hugely popular with tourists. The small shops in the village sell luxury goods and the port is full of super-yachts owned by the likes of Jay Z, P Diddy and other celebrities. Princess Diana and Dodi al Fayed spent their last days on a yacht near St-Tropez, shortly before their fatal traffic accident in Paris.

PLACES

Quai Jean Jaures, see the super-yachts.
Place des Lices, central square, watch the boules.
Annonciade Museum, Place Grammont, Le Port.
Maritime Museum, Citadel of Saint-Tropez.
Le Lavoir Vasserot, art gallery on rue Joseph Quaranta.
Les Caves du Roy nightclub, Byblos Hotel.
VIP Room, nightclub and restaurant, Residence du Nouveau Port.
Papagayo nightclub, route Résidence du Port, St-Tropez.
La Glaye beach.

VISIT

Port Grimaud and its castle.
Cogolin, less touristy but pretty French village.
La Treille Muscate, Colette's former home.

FESTIVALS

Les Bravades des Espangnols, traditional military parade, May.
Giraglia Rolex Cup, Regatta, June.
Fisherman's Festival, July.
The Festival des Nuits de la Moutte takes place in the castle grounds, July-August.
Air Show, the French jet fighters give a display to celebrate the Liberation on August 15th, 1944.
St Tropez Sails Regatta with 300 yachts, September-October.
Braderie, street market and sale, October.
Big Anchoiade in the port, midday, New Year's Eve.

http://uk.ot-saint-tropez.com

PEOPLE
CHARLES AZNAVOUR
(1924 –)

A French-Armenian singer-songwriter and from 1995, Armenia's delegate to UNESCO. Voted Entertainer of the Century by CNN and *Time* online in a global poll.

He was born on May 22nd, 1924, in Paris, as Shahnour Varenagh Aznavourian, the son of Armenian immigrants. His father was a singer and restaurateur, while his mother was an actress. By 11 years old, he was attending stage school.

In 1941, he teamed up with songwriter and composer Pierre Roche and the pair began performing their songs on the cabaret circuit. He was spotted by Edith Piaf who signed him up to tour with her internationally.

In 1946 Aznavour married girlfriend Micheline and they had two children but it didn't last. In 1956 Aznavour married Evelyne Plessis and later that year they had a son named Patrick. By 1968 he was in another relationship with Ulla Thorsell, marrying her in Las Vegas. Later that year, they had a daughter, named Katia.

In 1974 Aznavour had a hit with 'She', which went platinum in the UK. In 1975, he wrote 'Ils sont tombés' to mark the 60th anniversary of the Armenian genocide. Since then he has written hundreds of songs and sold over 100 million records. He is regarded as one of the greatest entertainers in France, and in his 80s, was still touring his show, performing all over the world and singing in three or four languages.

He has also appeared in dozens of films, including François Truffaut's *Tirez sur le pianiste* which was a hit in the US. He has sung with the world's top performers, many of whom have also recorded his songs. He is the founder of the charitable organisation Aznavour for Armenia and in 2001, President Chirac made him a Commander of the National Order of Merit at a special ceremony at the Elysée Palace.

LAURA ASHLEY (1925 – 1985)

A Welsh fashion designer and entrepreneur who created a global brand with her husband Bernard.

Born on September 7th, 1925 as Laura Mountney in Dowlais, Merthyr Tydfil, she went to school there until 1932 when she moved to Elmwood School in Croydon. During World War II, she went back to Wales to escape the Blitz. At 16, she joined the WRNS and worked in British Intelligence in Paris during the German Occupation.

She met engineer Bernard Ashley at a youth club in Wallington. He was in the Royal Fusiliers then the Gurkha Rifles. They married in 1949 and had four children. Through the Women's Institute and the V & A Museum, Laura Ashley became interested in textiles, particularly quilt-making. In 1953, she and her husband began making printed headscarves from their flat in Pimlico.

In 1955 they set up a company in Kent but flooding closed the factory. Their products were so successful that Bernard gave up his job in the city to take charge of manufacturing.

In the 1960s, they moved to Wales and Laura developed furnishings and clothing designed in her distinctive chintzy, feminine style. She and her husband opened their first shop in Powys; many more shops followed in Britain. In the 70s, the business expanded internationally and the turnover grew to £25 million. The couple had homes in London and Brussels and bought a chateau in Picardy, France. Bernard Ashley had a pilot's licence which helped them travel easily between Britain and Europe. In 1975, Laura Ashley turned down an OBE as her husband had not been offered one too. He was finally given a knighthood in 1987

after her death.

In 1983, they bought Le Preverger, a house in La Garde-Freinet near St-Tropez. It had belonged to actress Jeanne Moreau.

They welcomed many famous guests there including Diana, Princess of Wales and Margaret

Thatcher. In 1985, Laura was visiting family in the UK on her birthday. She fell down the stairs and was taken to hospital where she later died. She is buried in Carno, Powys, Wales at St John the Baptist Church. A memorial plaque was erected on their former home at 83 Cambridge Street, Pimlico in 1994.

Sir Bernard Ashley died on February 14th, 2009.

BRIGITTE BARDOT (1934 –)

A French movie star and animal rights activist, nicknamed BB.

She was born Brigitte Anne-Marie Bardot on September 28th, 1934 in Paris, France. Her father was an engineer. She had dance lessons as a child and at 13 was accepted at the Conservatory of Paris for ballet lessons. By 15, she was modelling and appeared on the cover of *Elle* (France) which led her to meet Roger Vadim, an aspiring film director, and to switch to acting.

In 1952, she married Vadim and he cast her as the lead in *And God Created Woman* (1956) set in St-Tropez, which launched her international career and helped her to become a sex symbol. By 1957 the marriage was over, partly due to an affair with her co-star Jean-Louis Trintignant. Constant attention from the paparazzi took its toll and she became suicidal in 1958, buying a house called La Madrague in St-Tropez to escape to. She was photographed in a bikini on the Côte D'Azur, popularising the swimwear and bringing glamour to the small fishing village, nicknamed 'St-Trop'.

In 1959, she married actor Jacques Charrier and they had a son, Nicolas-Jacques, but the couple divorced in 1962 and the child was brought up by Charrier's family.

She won a David di Donatello Award for Best Foreign Actress for her role in *A Very Private Affair* (1962), directed by Louis Malle and was nominated for a BAFTA in Malle's *Viva Maria!* (1965). She also starred in Jean-Luc Godard's film *Contempt* (1963). She developed her recording career, singing with, among others, Bob Zagury, Sacha Distel and working with Serge Gainsbourg.

She recorded over sixty songs and had many hits.

In 1970, a sculpture of her face called 'Marianne' became an emblem of the liberty of France. She was married to German millionaire Gunter Sachs briefly, then lived with sculptor Miroslav Brozek. In 1973, she gave up her acting career after making forty-seven movies. In 1974, Bardot appeared nude in *Playboy* magazine, to mark her 40th birthday.

She became an animal rights activist after her film and recording career and is responsible for raising millions of euros for numerous animal welfare projects. Her influence in raising the profile of animal rights issues helped bring about the banning of the importation of seal fur by the Council of Europe and the French government's ban on ivory imports.

Currently married to Bernard d'Ormale, an adviser to Jean-Marie LePen, France's former leader of the Front National, she has been convicted of inciting racial hatred against Muslims for her comments on immigration and the ritual slaughter of animals.

COLETTE (1873 – 1954)

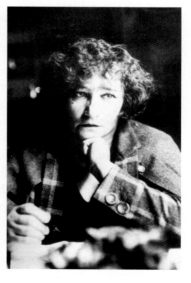

One of France's greatest female novelists best known for *Gigi,* which was adapted for stage and screen.

She was born as Sidonie Gabrielle Colette on January 28th, 1873, in Saint-Sauveur-en-Puisaye, France. Her father was a naval captain from Toulon. Her childhood in the village was happy and at 20, she married bisexual critic and writer Henri Gauthier-Villars ('Willy'), fifteen years her senior and the couple moved to Paris. Realising that his wife had a talent for writing, he encouraged her to pen four novels about her childhood, with teenage 'Claudine' as the central character. He published them under his own name

'Willy', and when the books were successful, he spent the royalties on gambling.

In 1906, recognising her attraction to women, she moved in with American writer Natalie Clifford Barney. Later, she had a relationship with Mathilde de Morny (Missy), the Marquise de Belbeuf, and the pair performed, scantily clad, at the Moulin Rouge, causing a scandal by kissing on stage. They were banned from performing together and had to conceal their relationship; at the same time she was involved with Italian writer Gabriele D'Annunzio.

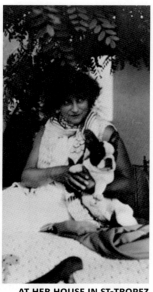

AT HER HOUSE IN ST-TROPEZ

In 1912, Colette married the news editor of *Le Matin,* Henri de Jouvenel and they had a daughter, also named Colette, but nicknamed Bel-Gazou. During World War I, the family's St. Malo estate was converted into a military hospital for which she was made a Knight of the Legion of Honour in 1920.

In the 1920s she also collaborated with the composer Maurice Ravel, writing the libretto for his opera *The Child and the Spells: A Lyric Fantasy in Two Parts.*

She had success with *Chéri* in 1923 but divorced de Jouvenel in 1924 when a five year affair with her stepson, Bertrand, came to light. The plot of *Cheri* centres on an aging courtesan who seduces a much younger man. She followed this up with *The End of Cheri* in 1926. The books were adapted to film in 2009, starring Michelle Pfeiffer.

In 1925, she spent the summer on the Riviera with her new boyfriend, Jewish pearl dealer, Maurice Goudeket. She bought a small house in St-Tropez, called "La Treille Muscate" and went there to write *Pure and the Impure* and *Break of Day.* They married in 1935 but sold the house in 1939. During World War II, she had to use her influence to get Goudeket released, following his arrest by the Germans. He looked after her as the onset of arthritis made

her increasingly immobile and she had to rely on a wheelchair.

In 1945, she was elected to the Académie Goncourt and by 1949, she had become the President of the academy. She moved to an apartment in Palais-Royal where Jean Cocteau was her neighbour.

After the war, she helped to restore the village of St-Tropez, which had become badly damaged during the fighting. She often spent the winters in Nice or Monte-Carlo and it was there she spotted a young actress for the role of Gigi – Audrey Hepburn.

Colette died in Paris on August 3rd, 1954 at the age of 81 and was given a State Funeral. She was buried in the Père Lachaise cemetery.

JOHNNY DEPP (1963 –)

An American movie star, producer and musician, best known for his role as Captain Jack Sparrow in the *Pirates of the Caribbean* series of films.

He was born John Christopher II, on June 9th, 1963 in Owensboro, Kentucky. His father was a civil engineer and his mother is said to be of Cherokee descent. The family moved constantly in his youth and his parents divorced in 1978. The stress of his early life led to a period of drug-taking and self-harming as a teenager.

His mother gave him a guitar which he taught himself to play and he dropped out of school to be in a band called The Kids. At 20, he married make-up artist Lori Allison. They moved to Los Angeles with his band and after a period of playing as support acts to bigger bands, he switched to acting with some help from the actor Nicholas Cage.

His first film role was in *Nightmare on Elm Street* (1984) and breakthrough came in the Fox TV series *21 Jump Street* in 1987. His subsequent choice of film roles often showed him as a loner – *Edward Scissorhands* (1990), *What's Eating Gilbert Grape* (1993), *Ed Wood* (1994) *Fear and Loathing in Las Vegas* (1998), *Charlie and the Chocolate Factory* (2005), *Rango* (2011).

His marriage broke down as his fame increased and he dated a number of actresses and models including Winona Ryder and

Kate Moss. In 1998, Depp was filming the sci-fi drama *The Ninth Gate* in France, where he met French actress and singer Vanessa Paradis. They had a daughter together in 1999, Lily-Rose, followed by a son, Jack. They bought a house together in Plan-de-la-Tour near St-Tropez where they have a vineyard that produces wine. In 2007, Lily-Rose fell ill with an E. coli infection that led to her being hospitalised at Great Ormond Street Hospital. Depp later donated £1 million to the hospital and read stories to the children there. Depp and Paradis split up in 2012 and Depp is now engaged to actress, Amber Heard.

With his friend, off-beat, gothic film director Tim Burton, Depp has collaborated on several films, most recently, *Dark Shadows* (2012). His ability to infuse comedy into his characters was beautifully displayed in the *Pirates of the Caribbean* film series which have become a huge hit for the Disney Studios.

In 2008, he won the Best Actor Award at the Golden Globes for *Sweeney Todd: The Demon Barber of Fleet Street* and his work has been nominated many times for the Golden Globe Awards, Academy Awards, Baftas and many others.

JEANNE MOREAU (1928 –)

A French movie star, with a career spanning fifty years, best known for her role in the French classic *Jules and Jim*.

She was born on January 23rd, 1928 in Paris. Her father was a restaurateur and her mother an English dancer with the Tiller Girls performing at the Folies-Bergère. The marriage was unhappy and Moreau's mother took her and her sister home to England for a

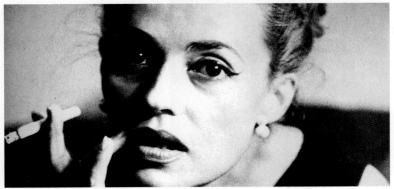

while. They returned when World War II was declared but Jeanne's mother had to remain in Paris, as an alien, while her father lived in the South.

Moreau was a good student until she fell in love with the theatre. She had a few drama lessons and won a place at the Conservatory of Drama. Her stage debut soon followed in 1947, in the Comédie Française production of Turgenev's *A Month in the Country* at the Avignon Festival. She became a leading light of the company and played a wide variety of roles until 1952.

Pregnant, she married Jean-Louis Richard in 1949 and they had a son, Jérome, who was brought up by Richard's family. The marriage fell apart while her career was taking off, working with Jean Cocteau and then Peter Brook in *Cat on a Hot Tin Roof*.

Although she'd already made several films it was Louis Malle's *Elevator to the Gallows* which allowed Moreau to shine. Their collaboration led to a love affair and the sexually explicit film *The Lovers* (1959) winning a prize at the Venice Film Festival. Next, she worked with directors Vadim and Truffaut, before starring opposite Jean-Paul Belmondo in Peter Brook's *Seven Days, Seven Nights* (1960).

ILLUSTRATOR: CHRISTIAN BROUTIN

Her son Jerome was involved in a car accident and almost died so Moreau bought a country house, "Le Preverger," near St-Tropez to get away from Paris and reassess her life.

She had an affair with Truffaut while in production for his masterly film *Jules and Jim,* which won many prizes and became a classic on the art-house circuit. Then she fell in love with fashion designer, Pierre Cardin, who styled her clothes. They were much followed

by the paparazzi as a celebrity couple. She starred with Bardot in Louis Malle's *Viva Maria!*, a film that became a big success, partly due to the publicity generated by tales of rivalry between the two women.

In 1975, Moreau switched to directing. *Light* (1976) was followed by *The Adolescent* in 1979 and in between these, she married the director William Friedkin. With conflicting schedules in different countries, the relationship soon fell apart.

During her long career, she worked with many of the great directors including Jean-Luc Godard, Antonioni, Orson Welles, Elia Kazan, Luis Bunuel, Fassbinder, Luc Besson and Wim Wenders.

In her sixties, she returned to the stage in a challenging role in *The Story of the Servant Zerline*. The play was a huge success and the production went on an international tour.

Moreau has made over 130 films. She has received many awards including a Cesar Best Actress for *The Old Woman Who Walked in the Sea* (1992), a Golden Lion for career achievement at the Venice Film Festival (1991) and a European Film Academy Lifetime Achievement Award (1997). Sharon Stone presented her with an Academy Award Lifetime Achievement Award in 1998.

VANESSA PARADIS (1972 –)

A French singer, model and actress, once married to Johnny Depp.

Born on December 22nd, 1972 in Saint-Maur-des-Fossés, France, her parents were interior designers. Her uncle, a record producer, encouraged her to appear on the local TV talent show in 1981. She recorded her first single in 1983. At 14, she had an international hit with *Joe le taxi* and recorded her first album.

At 16, she left school to pursue a career in music and film. In 1990 she won a Cesar Award for Most Promising Actress for her film debut in *Noce Blanche*. Her second album, *Variations on the Same Theme* (1990) was produced with the help of singer-songwriter/producer, Serge Gainsbourg. She won awards for Best Female Artist and Best Music Video in 1991.

In 1991, she was picked to be the face of Chanel's perfume Coco and she has since featured on many magazine covers, combining modelling with her singing and acting careers.

At 20, she moved to the USA to work with musician and producer Lenny Kravitz with whom she had a relationship. She released a new album, titled *Vanessa Paradis*, with songs in English for the first time. It was well received by the music press and reached Number 1 in the French music charts, while the single 'Be My Baby' reached Number 6 in the charts in the U.K. In 1993, Paradis started her first international tour, playing over seventy dates and releasing a live album from the tour. She met American actor Johnny Depp while he was filming *The*

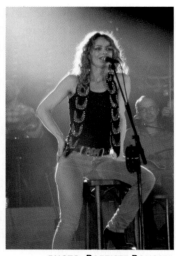

PHOTO: BAPTISTE ROUSSEL

Ninth Gate (1999) and they began a relationship, which led to the news that the couple were expecting their first child. While pregnant, Paradis took on a challenging role in *Girl on the Bridge*, which was an art-house success. In May, 1999, she and Depp had a baby daughter, Lily-Rose. Her next album was titled *Bliss* (2000) with Depp playing guitar on some of the tracks. It reached Number 1 in the French charts. The next year, she released her second live album, *To the Zenith*. In 2002, she gave birth to son, John Christopher 'Jack' Depp III.

In 2007, she was made a Knight in the French Order of Arts and Letters. Her album, *Divinidylle* (2008), garnered two Victoires Awards for Best Pop Album and Best Female Artist. She went on tour to promote the album and the DVD of the tour also won an award.

She appeared in *Heartbreaker* alongside Romain Duris and Andrew Lincoln, a box office success in France (2010).

In 2012, she won two Best Actress Awards for the film *Café de Flore.* Later that year she and Depp parted.

She launched a new album in 2013 titled *Love Songs* and won Best Music Video for the single 'La Seine'.

She has been linked with a number of new boyfriends, including Guy-David Gharbi, the entrepreneur behind UsineDeco in France.

PAUL SIGNAC (1863 – 1935)

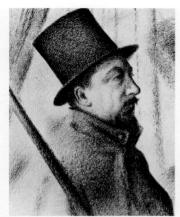

PORTRAIT OF SIGNAC BY GEORGES SEURAT

A French painter and print-maker who co-created the pointillist style with Georges Seurat, which influenced abstract art in the 20th century.

Born on 11th November, 1863 in Paris, his family were shopkeepers. He was intending to become an architect, when a visit to an Impressionist exhibition at 18, made him switch to art.

In 1884, Signac met Georges Seurat, whose ideas on the division of colours impressed him. By 1886, the two painters were creating paintings using tiny dots, termed 'pointillism'. Their ideas influenced both Pissarro and Van Gogh.

Seurat died in 1891, and Signac led the neo-impressionist movement, helped by the critic Félix Fénéon. He consciously painted with scientist Charles Henry's theory about the emotional impact of colour in mind and began to label his paintings musically.

In 1892, he married Berthe Robles and bought Villa La Hune in St Tropez, where he loved to go sailing and sketch landscapes, returning to his studio to apply paint in a mosaic type effect. He sailed around the coast of France and up to Holland, sketching and painting watercolours.

From 1904, he worked with Matisse, whose work he promoted, and inspired Andre Derain and the Fauvist painters to explore colour for its own sake, as well as abstraction.

In 1913, Signac moved to Antibes, with Jeanne Selmersheim-Desgrange, and they had a daughter Ginette in October of that year. In 1927, Signac adopted Ginette.

Paul Signac died of septicemia in Paris on 15th August, 1935.

PAUL SIGNAC'S PORT OF ST-TROPEZ
NATIONAL MUSEUM OF WESTERN ART, TOKYO

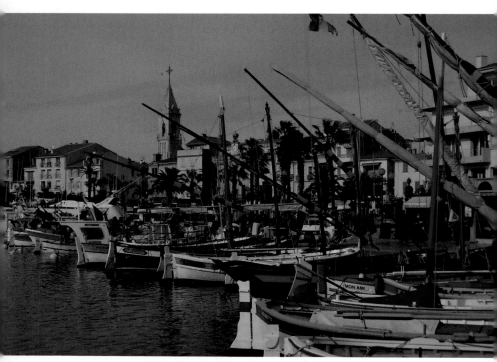

SANARY-SUR-MER (VAR)

Originally called Saint-Nazari, after the Christian martyr killed by Nero in 66AD, much evidence of the town's Roman past has been found by divers in the numerous remains of ancient shipwrecks around the port, with artifacts now housed in the Historical Diving Museum. In the 16th century, the port of the small fishing village was developed for the export of local wine from Bandol. The Queen of Spain and her entourage visited in 1701.

Sanary became a 'station de tourisme' in 1921 and a 'station de climat' in 1929, when it added the 'Sur-Mer' to its name to promote tourism. In 1930, writer Aldous Huxley moved to the town, while writer Klaus Mann visited the area also.

With the rise of nazism in the early 1930s, many German and Austrian dissidents went into exile. Some chose the South of France because of the climate and cheaper cost of living. A lively community of German émigrés developed around Sanary-Sur-Mer where much fine German literature was produced until 1939,

SANARY

Lieu de Mémoire Vivante
Gedenkort
Memorial site

CAPITALE DE L'EXIL ARTISTIQUE ET LITTERAIRE
HAUPTSTADT DES KÜNSTLERISCHEN UND LITERARISCHEN EXILS
CITY OF THE ARTISTIC AND LITERARY EXILE
1933 - 1940

ERNST BLOCH	GOLO MANN
WALTER BONDY	VALERIU MARCU
BERTOLT BRECHT	LUDWIG MARCUSE
JOSEPH BREITBACH	FRITZI MASSARY
FERDINAND BRÜCKNER	ANNEMARIE MEIER-GRAEFE
FRITZ BRÜGEL	JULIUS MEIER-GRAEFE
FRANZ THEODOR CSOKOR	ALFRED NEUMANN
ALBERT DRACH	ROBERT NEUMANN
WILLI EISENSCHITZ	ERNST ERICH NOTH
LION FEUCHTWANGER	BALDER OLDEN
MARTA FEUCHTWANGER	ERWIN PISCATOR
BRUNO FRANK	ANTON RADERSCHEIDT
EMIL JULIUS GUMBEL	ERICH MARIA REMARQUE
WALTER HASENCLEVER	EMIL ALPHONS RHEINHARDT
WILHELM HERZOG	JOSEPH ROTH
FRANZ HESSEL	ILSE SALBERG
HELEN HESSEL	RENÉ SCHICKELE
LOLA HUMM-SERNAU	FRANZ SCHOENBERNER
HANS ARNO-JOACHIM	LEOPOLD SCHWARZSCHILD
ALFRED KANTOROWICZ	DAVID SEIFERT
ALFRED KERR	HANS SEMSEN
HERMANN KESTEN	HILDE STIELER
EGON ERWIN KISCH	WILHELM THONY
ERICH KLOSSOWSKI	CHRISTIANE GRAUTOFF-TOLLER
ARTHUR KOESTLER	ERNST TOLLER
ANNETTE KOLB	ALMA MAHLER-WERFEL
FRITZ HELMUT LANDSHOFF	FRANZ WERFEL
RUDOLF LEONHARD	FRIEDRICH WOLF
EMIL LUDWIG	CHARLOTTE WOLFF
HEINRICH MANN	KURT WOLFF
THOMAS MANN	THEODOR WOLFF-
KATIA MANN	OTTO ZOFF
ERIKA MANN	ARNOLD ZWEIG
KLAUS MANN	STEFAN ZWEIG

when the émigrés were detained in camps – the men at Les Milles, near Aix and the women at Gurs, in the Basses-Pyrénées. Some managed to escape to America, others were sent to the death camps in the East.

A memorial plaque has been erected at the Tourist Office in remembrance of the town's anti-fascist émigrés. (see left)

PLACES

Historic Diving Museum, archeological finds and history of diving including Jacques Cousteau's possessions.
Chapelle Notre-Dame-de-Pitié, west of the town.
Église Saint-Nazaire.
'Roman' Tower, circa 1300.
Port and marina, fishermen sell their catch every morning.

VISIT

Jardin Exotique and Zoo of Sanary-Bandol.
Ile de Bendor.
The Maison des Vins, 22 allée Vivien, wine-tasting, Bandol.
Aqualand, St-Cyr-Sur-Mer.

FESTIVALS

Mediterranean Festival of Photography, PhotoMed, May-June.
Festival Under The Stars, musical concerts, July-August.
Festival Les Voix Du Gaou, Six-Fours-les-Plages, July.
Cuban Festival Bayamo, June.
Jazz Festival Jazz, Fort Napoléon, La Seyne-sur-Mer, July.
Couleurs du Monde, world music and dance festival, various towns around the area, July.
Bandol Wine Festival, November.
Christmas Festival and Parade, Bandol.

www.sanary.com

SYBILLE BEDFORD, OBE (1911 – 2006)

A German-born English writer, known for her travel writing.

She was born on March 16th, 1911 as Sybille von Schoenebeck in Berlin. Her father was a German aristocrat and her mother was from a wealthy Jewish family. She grew up in a castle in the Black Forest but her parents divorced in 1921. Bedford lived with her father until his death in 1926. Bedford caught up with her mother in Italy but the rise of fascism forced them to go to France where they settled in Sanary-sur-Mer. Bedford became friends with Aldous and Maria Huxley, who gave her some moral guidance and encouraged her to write.

Among the community of émigré artists and writers who were living there, she became friends with Thomas Mann and his children, Klaus and Erica. A brief marriage of convenience to ensure a British passport gave her the name Sybille Bedford. She had a lesbian affair with Evelyn W. Gendel and was a close friend of journalist Martha Gellhorn, Hemingway's third wife.

In 1940, she went to the USA, and spent a year in Mexico. After World War II, she took an apartment in Rome and published her first travel book, *The Sudden View/A Visit to Don Otavio* (1953). Her first novel, *A Legacy* (1956) received a rave review from Evelyn Waugh in *The Spectator*, helping its success.

As a legal reporter she covered many trials including the Lady Chatterley obscenity case and Jack Ruby's trial for the murder of Lee Oswald.

A Favourite of the gods (1963) and *A Compass Error* (1968) were written whilst also writing a well-researched biography of Aldous Huxley (1973).

Her novel *Jigsaw* (1989) was short-listed for the Booker Prize, and her memoir, *Quicksands* (2005) explored her early life in Europe.

She was awarded an O.B.E. in 1981 and elected Companion of Literature in 1994.

She died on February 17th, 2006 in London.

PHOTO: JORG KOLBE

BERTHOLD BRECHT (1898 – 1956)

A German playwright, poet and theatre director famous for his Epic Theatre concept and Alienation Technique.

He was born on February 10th, 1898 in Augsburg, Bavaria. His father was a Catholic who managed a paper mill and his mother a Protestant. He met Caspar Neher at school and the pair collaborated on set design for many years. He studied medicine at the University of Munich and served briefly as a medical orderly in the war. He began writing plays influenced by cabaret and comedy acts. He won the Kleist Prize for *Baal, Drums in the Night,* and *In the Jungle.* He married an opera singer, Marianne Zoff, in 1922 and they had a daughter but the relationship didn't last.

By 1924, he was working at Max Reinhardt's Deutsches Theater in Berlin and had begun a relationship with Helene Weigel. They had a son, Stefan, and married in 1930, before the birth of a daughter, Barbara. In 1927, he collaborated with Erwin Piscator and Kurt Weil and began to develop his ensemble theatre. His musical *The Threepenny Opera* proved a great success. He left Germany in 1933, living in Denmark, Sweden and the USSR. He stayed with his friend Lion Feuchtwanger in the "Villa Valmer" in Sanary-sur-Mer. In 1941, he moved to Hollywood, where he met Chaplin and contributed to the filmscript for *Hangman Also Die.*

In 1947, Brecht was interviewed by the House of Un-American Activities Committee, where he denied being a member of the American Communist Party. He then moved to East Germany.

In 1949, Brecht founded the Berliner Ensemble with Helene Weigel. The company reputation grew and it was soon performing internationally. His works include: *The Threepenny Opera, The Caucasian Chalk Circle, The Good Person of Szechwan, Mother Courage* and her children, all written during his years in exile.

He died on 14th August, 1956 and is buried in Berlin.

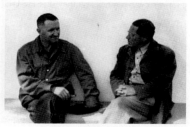

BRECHT AND FEUCHTWANGER

JACQUES COUSTEAU (1910 – 1997)

"Mankind has probably done more damage to the Earth in the 20th century than in all of previous human history."

A French filmmaker, explorer and author who pioneered environmental conservation. He also co-invented the Aqualung for scuba diving in 1943 with Emile Gagnan.

Born on June 11th, 1910, in Saint-André-de-Cubzac, France, he was a sickly child. He was not a good student either and was sent to boarding school at 13. He then had a brief spell at college before the French Naval academy at 20 years old. He had a serious car accident in 1933, and while recovering, he began swimming in the sea in the South of France.

In 1937, he married Simone Melchior and they had two sons. During the German Occupation of France, he joined the Resistance, spying on the Italians. In 1945, Cousteau started doing underwater research for the French Navy, often working to help clear mines.

In 1948, Cousteau led the first underwater archaeology expedition to find the Roman shipwreck of The Mahdia. In 1951, he began filming his explorations on The Calypso to finance his work. This became the TV series *The Undersea World of Jacques Cousteau*. His first book *The Silent World* was later made into a film. From 1957–88 he was Director of the Oceanographic Museum in Monaco while making further TV series such as *The Undersea World of Jacques Cousteau,* which gained an audience of several million.

In 1973, he founded the Cousteau Society to stop man from destroying the oceans. His son Philippe was killed in a plane crash in 1979. That same year, *The Calypso* sank in Singapore.

He was widowed in 1990 and then married his long-time mistress, Francine Triplet.

He died on June 25th, 1997, at the age of 87.

THE AQUARIUM AT THE MONACO OCEANOGRAPHIC MUSEUM

LION FEUCHTWANGER
(1884 – 1958)

A German Jewish writer, editor and critic best known for creating *Der Spiegel* literary journal in 1908.

He was born on July 7th, 1884, in Munich, the son of a factory owner. He studied Philology and History at Munich University then worked as a theatre critic.

He created *Der Spiegel* and also published his first plays and novellas. Later came novels including *The Ugly Duchess* (1923), *Power* (1921) and *Success* (1930).

In 1912, he married Marta Löffler and in 1925 they moved to Berlin. In 1919, he met Bertolt Brecht in Munich, and promoted his work. They remained close friends for many years.

In 1933, Feuchtwanger was in the USA when he learned about the Nazis burning his books. He decided to go to live in Sanary-sur-Mer, France, and wrote the satirical novel *Exile* (1940). Feuchtwanger's villa became the centre of left-wing dissent among the German émigrés. There were numerous visitors including Arthur Koestler, Heinrich Mann, Ernst Toller, Ellen Wilkinson, Arnold Zweig, Robert Neumann and Ernst Kantorowicz.

In 1940, he was interned near Aix-en-Provence, but managed to escape with Marta's help, disguised in women's clothing. Walking across the Pyrenees to Portugal they boarded a ship for the USA. He wrote *The Devil in France* (1941) about this experience.

The couple moved to Los Angeles and bought "Villa Aurora", which became a gathering place for German émigrés, and later an arts centre. Feuchtwanger co-founded Aurora-Verlag Publishers in 1944. His novels sold well in the USA, notably *Goya; This is the Hour* (1951). In 1953, he was awarded the National Award for Arts and Literature, by the GDR.

Feuchtwanger was investigated by the House of Un-American Activities Committee and his application for American citizenship was damaged by his former communist beliefs.

He died of cancer on December 24th, 1958 and is buried at Wood Lawn Cemetery in Santa Monica together with his wife.

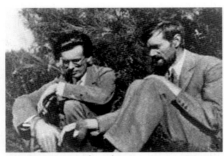

ALDOUS HUXLEY (LEFT) WITH D. H. LAWRENCE IN BANDOL, 1929.

ALDOUS HUXLEY (1894 – 1963)

An English writer best known for his novel *Brave New World* (1932).

He was born on July 26th, 1894, in Godalming, Surrey. His father was a poet, editor and biographer and his grandfather was a renowned scientist nicknamed 'Darwin's Bulldog'.

He went to Eton and suffered an illness at 16, which led him to become blind for over a year, during which he learned Braille. He studied English at Oxford where he met D.H. Lawrence and began writing poetry and novels including: *Crome Yellow* (1921), *Point Counter Point* (1928) and *Do What You Will* (1929). He married Maria Nys in 1919. They had a son Matthew, the following year.

He travelled in Italy and France with Lawrence and they visited Bandol in 1929. He bought his house, "Villa Huxley" in March 1930 after the death in Vence of his friend. He completed *Brave New World* there and also wrote *Music at night* (1931) *Beyond the Mexique Bay* (1934), and *Eyeless in Gaza* (1936) which is set in Sanary. Visitors to the house included: Paul Valery, Edith Wharton, Victoria Ocampo and the Noailles.

In 1937, Huxley moved to California and began writing screenplays for Hollywood. In 1950, he was the recipient of an Award of Merit from the American Academy of Arts and Letters.

In 1938, Huxley became interested in spiritual matters and met Krishnamurti. In the 1950s, Huxley experimented with LSD and mescaline, and wrote *The Doors of Perception* (1954), which inspired the hippy generation. Jim Morrison, the singer, called his band 'The Doors' in homage. In 1958, Aldous Huxley published *Brave New World Revisited*, a collection of essays.

Huxley died On November 22nd, 1963, at the age of 69 in Los Angeles. His ashes were buried in Compton, Surrey, in the the UK.

MOISE KISLING (1891 – 1953)

A Jewish painter and graphic artist who was part of the avant-garde in Paris in the 1920s.

Born Mojżesz Kisling in Craków (now Poland) formerly part of Austria-Hungary, on January 22nd, 1891, he began drawing as a child and at 15 enrolled at the Craków School of Fine Arts before heading for Paris' Montmartre in 1910. He lived in the Bateau-Lavoir artists' commune and met Picasso, Matisse and Cocteau. He was invited by Picasso to an artist's colony at Ceret in the Pyrenees where he spent a year developing his work.

Back in Montparnasse, he became friends with Bulgarian artist Jules Pascin and Italian artist Amedeo Modigliani who both lived nearby. He began exhibiting his work in the Paris Salons in 1913 and sold some works to American collector Albert Barnes. That year he also visited Sanary-sur-Mer for the first time, returning annually with his family and eventually buying a sea-view villa "La Baie" in 1932.

In June 1914, Kisling fought a duel with the Polish artist Leopold Gottlieb, over a matter of honour. During World War I, he served in the French Foreign Legion and was seriously wounded in the Battle of the Somme, his military bravery enabling him to become a French citizen.

In 1917, he married Renée Gros and their wedding celebrations were said to have lasted for three days. They had two sons, Guy and Jean.

Kisling joined up again in 1940, but when France surrendered to the Germans, Kisling and his family left for the USA. He had successful exhibitions in New York and Washington and moved to California until the end of the war.

In 1946, Kisling returned to Sanary-sur-Mer where he died on April 29th, 1953. A street in the town has been named after him.

Many of Kisling's paintings are on show at the Musée du Petit Palais in Geneva.

KISLING, ACTRESS PAQUERETTE AND PICASSO AT THE CAFE ROTONDE, PARIS IN 1916

D. H. LAWRENCE (1885 – 1930)

"If there weren't so many lies in the world... I wouldn't write at all."
An English novelist, poet and playwright best known for his sexually explicit novel *Lady Chatterley's Lover.*

He was born on September 11th, 1885, in Eastwood, Nottinghamshire. His father was a coal miner, his mother a trainee teacher who had to work in a factory. His childhood was marred by family stress and grinding poverty but he won a scholarship to high school and went to Nottingham University.

He worked as a teacher and had his first novel *The White Peacock* published in 1911. In 1912, he met Frieda von Richthofen, who was already married to Professor Ernest Weekley. They ran away together to Bavaria, finally marrying in 1914. On returning to the UK, they were not allowed passports, due to Frieda's German origins and Lawrence's anti-war views. They were even accused of spying and signalling to German submarines in Cornwall. He wrote both *Sons and Lovers* (1913) and *The Rainbow* (1915) during this time.

They left England in 1919 and went first to Italy where Lawrence completed *The Lost Girl* (1920) and *Women In Love* (1920), a sequel to *The Rainbow.* They travelled around Europe until 1922 when they went to the USA and stayed in New Mexico. Lawrence was visited there by Aldous Huxley, who remained a lifelong friend. Ill-health forced a return to Italy where *Lady Chatterley's Lover* was published privately in Florence in 1928. Banned in both the UK and the US, pirated versions were soon printed.

In 1928 they stayed for a year in a seaside hotel in Bandol where Lawrence wrote poetry and articles, suffering from TB. He

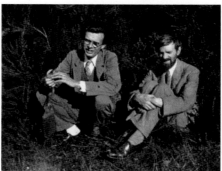

tried a sanatorium in Vence, but with his condition worsening, he moved to the "Villa Robermond" where he died on March 2nd, 1930.

His ashes are now in a small chapel in Taos, New Mexico.

ALDOUS HUXLEY (LEFT) WITH D. H. LAWRENCE IN BANDOL, 1929.

THOMAS MANN
(1875 – 1955)

"Has the world ever been changed by anything save the thought and its magic vehicle the Word?"

A German novelist and winner of the Nobel Prize for Literature, best known for his novel *Death in Venice* which was adapted for film.

Born on June 6th, 1875 as Paul Thomas Mann in Lübeck, Germany, was a senator and grain dealer who died in 1891. His mother was of Portuguese Brazilian descent. He went to the local gymnasium then Munich University with a view to becoming a journalist.

In 1905, in spite of his homosexual desires, he married Katia Pringsheim, from a wealthy, Jewish family and they had six children. He wrote the novel *Death In Venice* in 1912, later made into a film starring Dirk Bogarde (see page 96), directed by Visconti. It was also adapted as a ballet and an opera.

In 1929, he was awarded the Nobel Prize for Literature for his novels *Buddenbrooks* (1901) and *The Magic Mountain* (1924).

In 1933, Mann spent the summer with his family in Bandol and in a villa called "La Tranquille" at Sanary-sur-Mer. Following advice from his family in Munich, he decided it would be wiser to go to Switzerland than return to Germany as the nazis were putting authors whose work they didn't like onto a blacklist. He obtained a Czechoslovak passport in 1936 and went to the USA in 1939, where he taught at Princeton University. While in exile he wrote many novels, stories and essays including: *Josephe and his Brothers* (1933–43) and *Doctor Faustus* (1947).

He returned to live in Switzerland in 1952 and died on August 12th, 1955, in Zurich.

THOMAS MANN WITH HIS WIFE KATIA.

ARNOLD ZWEIG (1887 – 1968)

"Keep the war going until the last drop of – other – people's blood."

A German writer and anti-war activist best known for his series of novels including *The Case of Sergeant Grischa* (1928) which tells the true story of a Russian prisoner of war who is executed as a deserter from the German Army in spite of his real identity becoming known.

Born November 10th, 1887, in Glogau, Silesia, Germany, which is now part of Poland, he joined the German army and served at Verdun in World War I. What he witnessed made him a lifelong opponent to militarism.

A critic of Adolf Hitler and the nazi party, Zweig co-edited the anti-fascist magazine, *World Stage* until he realised he must leave Germany in 1933 and fled to Czechoslovakia. He also went to visit his friends and colleagues Ludwig Marcuse, René Schickele and Lion Feuchtwanger in Sanary-sur-Mer .

He continued to publish his work including *Education Before Verdun* (1935), *The Crowning of a King* (1937) and *The Axe of Wandsbek* (1947). He travelled to Haifa in Palestine in 1948 and published a German-language newspaper, *The Orient*. During his years in Palestine, Zweig underwent psychoanalysis but became disillusioned with Zionism.

Zweig was formally invited to return to the Soviet zone, later East Germany, in 1948 which he did. He served as president of the German Academy of the Arts (1950–53). He was also a member of

parliament, delegate to the World Peace Council Congresses and on the cultural advisory board of the communist party.

He was awarded the Lenin Peace Prize in 1959.

He died in East Berlin on November 26th, 1968.

LE ROCHER DE LA BAUME, SISTERON

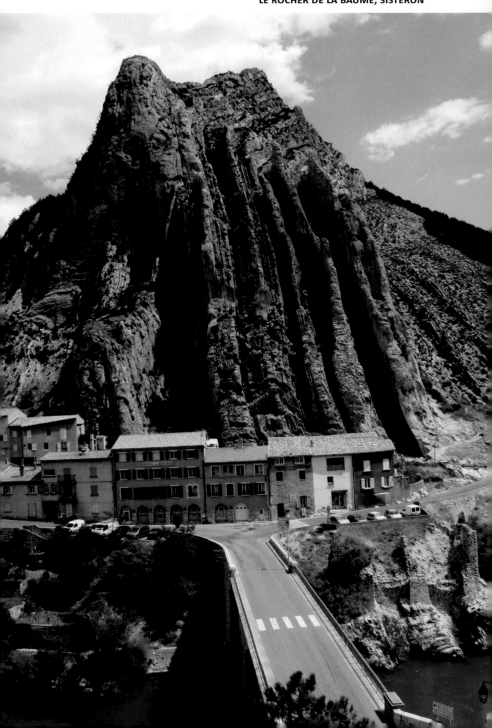

SISTERON (ALPES-DE-HAUTE-PROVENCE)

Known as 'the Gateway to Provence' due to its position at the confluence of two rivers, there is evidence of habitation since prehistoric times, 4000 years or more. The town was originally established by the Celtic Gauls.

The Roman's Via Domitia (120 BC), the oldest road in France linking Italy to Spain, runs through Sisteron and vestiges of the road can be found in a number of places along the route.

Attacked frequently by the Saracens, Sisteron was a stronghold for the Counts of Forcalquier in the 11th century. Later, it became part of the northern territory ruled by the Counts of Provence who ceded it to the French King Louis XI in 1483. In the 15th century, a large part of the population was wiped out by plague.

Loyal to the Crown in the Wars of Religion (1562-94), it withstood two seiges. The residents remained Royalist during the French revolution and therefore did nothing to stop Napoleon Bonaparte on his route north in 1815, while escaping from Elba.

The Resistance were active in the town during World War II, freeing political prisoners held in the citadel. The allies bombed the town in 1944 and destroyed the bridges over the Durance river.

PLACES

The Citadelle and its museum, on top of the hill.
Museum of Earth and Time, behind the Cathedral.
Museum of Old Sisteron, Place de la Mairie.
Eco Museum. at the roundabout Melchior Donnet.
Scouting Museum Baden-Powell, behind the Cathedral.
The Cathedral Notre-Dame and Saint-Thyrse.
The Towers, 14th century, well preserved, on the ramparts.
St-Dominique, former Dominican monastery built in 1248 by Beatrice of Savoy.

VISIT

Le Rocher de la Baume, go rock climbing there.
Walk the Imperial Way, the Route Napoleon.
Hiking along the Grande Randonée GR6.
Digne, the centre of the Lavender trade, nearby.
Alexandra David-Neel Museum in Digne, nearby.
Botanical Gardens, Digne, Place des Cordeliers.

Digne Cathedral, started in 15th century but expanded in 1860s.
Gassendi Museum, Digne, blvd Gassendi.
Notre Dame du Bourg, rue du Souvenir Français, Digne.
Geopark of Haute Provence, fossils and butterfly garden.
Hot springs, ave des Thermes.
Les Penitents des Mées, rock formation in Les Mées, near Digne.

FESTIVALS
Nuits de la Citadelle, July-August.
Fair-Expo, October.
Lavender Festival and parades, Digne, August.
Film Festival, Digne, April.
Inventerre Festival, Digne, July – nature, science, hiking.

http://www.sisteron.fr/

PAUL ARENE (1843 – 1896)
A French Provençal poet and writer.

He was born in Sisteron, on June 26th, 1843. His father was a watchmaker and his mother a milliner.

Educated in Sisteron, he went to Marseille University and studied philosophy then went on to teach in high school until his play *Pierrot Heir* had a little success at the Odeon in Paris. He began writing for *Le Figaro* and joined literary circles where he met with Alphonse Daudet, Francois Coppe and Catullus Mendes. He began to write poetry in Provençal , publishing it in the *Almanach Avignonnais* by Joseph Roumanille.

In 1868, he wrote *Jean of the Figs* then fought in the Franco-Prussian war in 1870, reaching the rank of captain. He was inducted into the Legion of Honour in 1884.

He had several stories, plays and poems published, including *Provençal stories* (1876) and his best known work *La Chèvre d'Or* (1889). With Daudet, some of his tales were collected under the title *Letters from my Windmill*.

He died on December 17th, 1896 in Antibes.

ALEXANDRA DAVID-NEEL (1868 – 1969)

Alexandra David-Neel

"Suffering raises up those souls that are truly great; it is only small souls that are made mean-spirited by it."

A French explorer, writer and teacher famous for being the first white woman to enter Lhassa, the 'forbidden city' of Tibet in 1924, detailed in *My Journey to Lhasa* (1927) which became a classic of travel literature.

She was born on 24th October, 1868, east of Paris and her father was a left-wing publisher. She moved to Brussels when she was 6. She became an opera singer then an anarcho-feminist writer. She also joined the Theosophist Society.

In 1904, she married Philip Neel but left him to travel to India. In 1911, she was invited to the royal monastery of Sikkim, where she met and formed a close relationship with Maharaj Kumar, the Crown Prince, who was mysteriously poisoned in 1914.

In 1912, she twice met the 13th Dalai Lama to discuss Buddhism. She then became a hermit and lived in a cave near a small monastery in Sikkim, 12,000 feet high, near the Tibetan border. She studied Tantric Buddhism for two years with Gomchen Lachan, a spiritual master. Aphur Yongden, a 15-year-old monk became her companion and adopted son. Her book *Magic and Mystery in Tibet* was based on this experience.

The pair also travelled to Vietnam, Japan and eastern Tibet via China. In 1946 they settled at Villa "Samten Dzong" (fortress of meditation) in Digne when David-Neel was 78 years old.

In 1955 Yongden died, at 56 years old. In 1969, David-Neel died at the age of 101 and in 1973 her ashes were scattered in the Ganges at Varanasi by her friend Marie-Madeleine Peyronnet.

She wrote over thirty books and her teachings inspired writers Jack Kerouac and Allen Ginsberg as well as countless others to travel to Tibet or explore eastern mysticism.

There is a road named after her in Massy, Essonne, near Paris and her villa in Digne-les-Bains is now a museum.

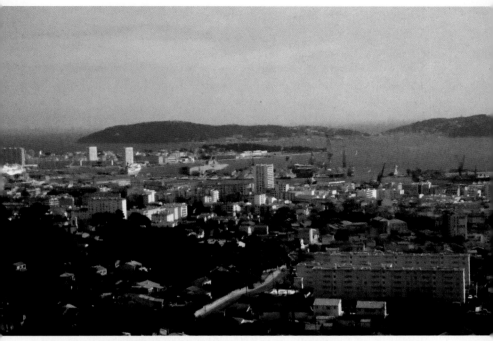

TOULON (VAR)

Toulon's name originates from Telonus, the Celto-Ligurian goddess of springs and fountains and Toulon celebrates this with over fifty fountains sprinkled around the city.

Its strategic location and deep harbour have made Toulon important since Roman times. Its port has enabled foreign trade and fishing as well as providing a key naval base for centuries.

In 1744, a great naval battle was fought off the coast in which Britain's fleet was forced by the French and Spanish to withdraw to Minorca in disgrace. In 1793, Napoleon led the successful campaign to recapture Toulon from the anti-revolutionary factions, which led to his ascendancy in the French army.

The city was badly bombed in World War II and while some of its monuments have been restored, much of the city has been redeveloped with high rise blocks that add little to its charm.

It is the capital of the Var department and one of the main Mediterranean ports for passengers embarking on cruise ships.

PLACES

The beaches at Mourillon and Fort Balaguier.

The port, take a trip around the bay or a ferry to Saint-Mandrier.

The Naval Museum, Place Monsenergue.

Toulon Cathedral (see right).

Old Toulon Museum, 69, cours Lafayette.

Photography Museum, place du Globe.

Art Museum, 113, blvd Maréchal Leclerc.

Asian Arts Museum, 169, littoral Frédéric Mistral.

Hôtel des Arts, Modern Art Museum, 236, bd Maréchal Leclerc.

Allied Landings Museum, Tour Beaumont, top of Mount Faron.

Natural History Museum, Jardin du Las, 737 chemin du Jonquet.

Toulon Opera House, 1862, designed by Charles Garnier.

VISIT

Guided walks around the city, contact Tourist Office.

Mount Faron Zoo, take the cable car up.

Jean Aicard-Pauline Bertrand Museum, avenue du 8 mai, La Garde.

Museum of the Mine, near Le Pradet.

Chateauvallon Amphitheatre.

The cable car ride to the top of Mount Faron. (see below).

FESTIVALS

Festival of Female Presences, female performers, music, March.
Festival Mang'Azur, Japanese culture, April.
Country Music and Dance Festival, May.
International Festival of Street Painting, May.
Multi-cultural Festival Couleurs Urbaines, May.
Rockorama, music festival in the Tour Royale gardens, June.
Summer Festival of Musique, open air concerts, June-July.
Jazz Festival Jazz of Toulon, July-August.
World Folk Festival, open air concerts, July.
Sails of Legend Tall Ships Regatta, September.
International Festival of Ocean, Exploration and Environmental Film, September.
Classical Music Festival, October to April.
Organ recitals and concerts in the churches of the Var, October.
Festival des Musiques Insolentes, multi-media, October.
Festival of Film Music, live performances, November.
Contemporary Design Festival, November.

http://toulontourisme.com

NAPOLEON BONAPARTE (1769 – 1821)

A French military leader who became Emperor of France and conquered much of Europe.

He was born on August 15th, 1769 in Corsica into a family of minor nobility. His father was Corsica's representative to the French court. Educated at military school, he gained rapid promotion in the army.

In 1793, Toulon was the site of a rebellion against the Revolutionaries and the rebels sought protection from British ships and their commanders. General Carteaux began a siege of the port to try and regain control of it. Bonaparte played a key role in the defeat of the rebels and was given command of the army in Italy. Toulon commemorated his triumph by building a gate called the Porte d'Italie.

By 1796, he had forced Austria and its allies to make peace. In 1798, he invaded Egypt to block British trade with India but his fleet was destroyed by the British on the Nile. When Austria and Russia formed an alliance with Britain against the French, Napoleon came to power in a coup d'etat. In 1799, he became first consul but within a few years he'd been crowned emperor. He centralised the government, promoted Catholicism, reformed the law with the Napoleonic Code and created the Bank of France.

In 1805, the Battle of Trafalgar was a major defeat, so Napoleon took on Britain's allies at Austerlitz and won. He had the Arc de Triomphe in Paris built to commemorate this. He also annexed part of Prussia and created Holland and Westphalia.

In 1810, he married the daughter of the Austrian emperor and they had a son, Napoleon. His marriage to Josephine was annulled.

The Peninsular War was a disaster, followed by a foolhardy invasion of Russia in 1812. By 1814, the government in Paris fell. Napoleon went into exile on the island of Elba but escaped in 1815 and resumed control in Paris. He surrendered to the British after the Battle of Waterloo, and was imprisoned on the remote Atlantic island of St Helena, where he died on May 5th, 1821.

EMPEROR NAPOLEON BY JACQUES-LOUIS DAVID
PHOTO: NATIONAL GALLERY OF ART

RAIMU (1883 – 1946)

A French actor whose comic ability on stage and screen led to his huge popularity in France.

Born December 18th, 1883 as Jules Auguste Muraire in Toulon, into a poor family, he made his stage debut in 1899, performing in local cafés. He came to the attention of music hall director, Félix Mayol, also from Toulon, and went to Paris to perform in a comedy act. In 1914, he was mobilised and went to fight at the front in World War I but was discharged in 1915.

In 1916, director Sacha Guitry cast him in *Let's Make a Dream* and he performed in numerous revues and small comic sketches in shows during the 1920s at the Folies Bergère, La Cigale and the Casino de Paris. He also tried acting in films without much success.

In 1929, Raimu was cast as the Marseilles inn-keeper Cesar in Marcel Pagnol's *Marius*. He worked with Guitry on the film *The White and the Black* (1931), then signed on for the role of Cesar for the film verison of *Marius*, which was directed by Alexander Korda and adapted from Pagnol's book. He did two more films in the trilogy: *Fanny* (1932) and *Cesar* (1935). These became known as the 'Marseille trilogy'. He went on to perform in other film adaptations of Pagnol's works, notably as the baker in *The Baker's Wife* (1938) then as the well-digger in *The Well-Digger's Daughter* (1940), filmed at the start of the German Occupation.

He was much in demand by the German company Continental Films and he appeared in *The Strangers in the House of Henry Decoin* (1942) but he then avoided any further projects.

Raimu became one of France's leading actors, performing for three

years at the Comedy Française. He was much admired as an actor by Orson Welles and Marlene Dietrich. *The Eternal Husband* (1946) was his last film.

He had a heart attack following a minor operaion and died on September 20th, 1946, in Neuilly-sur-Seine. He was buried in Toulon where there are two statues of him. The Cinéma Raimu in Toulon was also named in his honour and the French government honoured him with his image on a postage stamp in 1961.

There is a small museum in Cogolin, devoted to his memory.

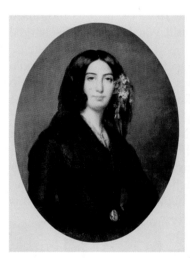

GEORGE SAND (1804 – 1876)

A French novelist and playwright best known for her novels and for being the lover of Chopin.

Born Amantine Aurore Lucile Dupin on July 1st, 1804, in Paris, she was known as 'Aurore' and was descended from Polish royalty on her father's side. Her mother was a former prostitute. She grew up in a large country estate in Nohant, Berry, and was raised by her grandmother. In 1817, she was sent to a convent in Paris to be educated. Sand wrote plays and these were performed in the small private theatre at the Nohant estate.

At 19, she married Baron Casimir Dudevant and they had two children, Maurice and Solange. In 1831 articles she had written with her lover, Jules Sandeau, were published in *Le Figaro* where she became the only female writer. In 1832, she adopted the pseudonym, George Sand, and published her first novel, *Indiana.*

In 1833, she met an actress, Marie Dorval, and had a lesbian relationship with her. She began cross-dressing, smoked cigars and a hookah. In 1835, she formally separated from Dudevant and took her children away with her.

Sand then had many affairs with writers and artists including

Prosper Merimee and Alfred de Musset, about whom she wrote *She and Him* (1859). Her relationship with Frederic Chopin lasted almost ten years from 1838-1847. She wrote about the visit she made to Majorca with him in *A Winter in Majorca* (1838).

She wrote a prodigious number of essays, articles, plays and novels including: *La Petite Fadette* (1849), and *Les Beaux Messieurs Bois-Dore* (1857) as well as autobiography.

After the Revolution of 1848 she acted as Minister for Propaganda then had to withdraw to Nohant when there was a coup d'état in 1851 in fear of reprisals.

She rented a villa in 1861, at La-Seyne-sur-Mer near Toulon where she stayed with Chopin. Later, she wrote her novel *Tamaris*. "Les Tamarins" where she stayed was demolished in 1975.

She died on June 8th, 1876, at her home in Nohant.

Of several museums, the most important housing a permanent display about her life and work is at the Musée de la Vie Romantique at the Hôtel Scheffer-Renan, in Paris.

Several of her books have been adapted for film and TV. Charles Vidor made a film called *A Song to Remember* about her relationship with Chopin in 1945. The BBC also made a series called *Notorious Woman* (1974) about the couple. Numerous documentaries and plays have also been inspired by her life.

12797. TAMARIS-sur-MER — VILLA GEORGE SAND où l'illustre auteur composa son roman "TAMARIS".

POSTCARD WITH PHOTO OF VILLA WHERE SAND STAYED NEAR TOULON

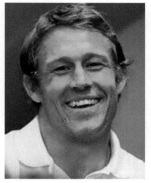

JONNY WILKINSON OBE (1979 –)

An English Rugby Union player who became a national hero when he scored the winning drop goal in the last minute of extra time ensuring England's victory against Australia in the 2003 Rugby World Cup. He was nicknamed 'Wilko' by the fans.

Born on May 25th, 1979, as Jonathan Peter Wilkinson, in Frimley, Surrey, as a child he enjoyed watching his father play rugby. He went to Pierrepont School and Lord Wandsworth College. The England rugby selectors took notice when he scored impressively on the English Under 18s Schools Tour of Australia in 1997. He turned down a university place that year to play rugby union professionally for the Newcastle Falcons.

In his first game for the England squad in 1999, he was the youngest player for England for many years. Wearing the Number 10 shirt, he has broken many records including becoming the first English player to score 1000 Test points and the highest drop goal scorer in international rugby with a total of 36. He also holds the record for Rugby World Cup points with 277 and is the only player to have scored points in two Rugby World Cup Finals.

He toured twice with the British and Irish Lions – in 2001 to Australia and 2005 to New Zealand – and scored 67 Test points in six matches.

In 2003, he won BBC Sports Personality of the Year and was named the IRB International Player of the Year. He received an MBE in 2003 and an OBE in 2004.

He has suffered several injuries which disrupted his playing. For the opening game of the 2007 Six Nations Championship against Scotland he scored a record 27 points and was proclaimed 'Man of the Match'. Playing Italy, he scored more points than anyone in the history of the Six Nations Championship.

Following twelve seasons in the English Premiership with the Newcastle Falcons, Wilkinson signed a deal to play for the French team, Toulon. In 2013, he was integral to Toulon's victory in the

2013 Heineken Cup Final against Clermont Auvergne. He has recently celebrated playing one hundred games with Toulon.

In 2009, he was awarded an honorary doctorate by the University of Surrey, for services to the sports industry, at Guildford Cathedral.

In 2011, he retired from the English national squad.

Wilkinson was named ERC European Player of the Year in 2013.

He also married his long-term girlfriend Shelley Jenkins, in a small ceremony at the town hall in Bandol.

In 2014, he helped to launch the volunteer programme for the Rugby World Cup in the UK, called 'The Pack'.

He has also set up a casual clothing company with his brother called Fineside.

VIEW FROM THE PORQUEROLLES, ISLANDS OFF THE COAST OF TOULON

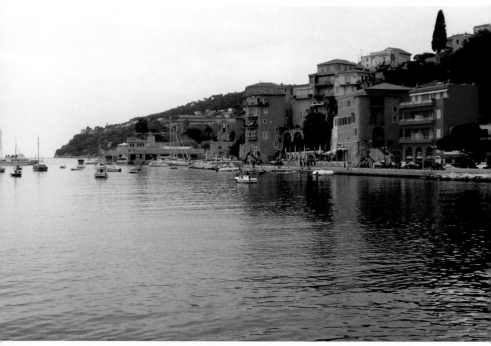

VILLEFRANCHE-SUR-MER (ALPES-MARITIMES)

Said to be one of the most beautiful bays in the world, the history of Villefranche dates back to Roman times when the Romans frequently stopped at the pretty fishing village en route to Gaul from Italy. It was then called Olivula.

The port was created in 1295 by Charles II d'Anjou, Count of Provence, who gave the village its current name, Villefranche.

After centuries of conflict, due to its proximity to the Italian border, Villefranche was brought into the French Republic in 1860. The Rade de Villefranche, which is a protected deep water bay, was an important port until the port of Nice was developed and eclipsed it.

Villefranche is now a popular port of call for many cruise ships in the Mediterranean and many tourists visit in summer. Even so, the village still retains its old world charm.

Built on terraces on steep inclines, hovering above the azure blue sea below, the village's tall brightly coloured houses,

enjoy spectacular views of the coast.

PLACES

The Citadel of St-Elme.

The Volti Museum, sculptures by Antoniucci Volti.

The Goetz-Boumeester Museum works by Henri Goetz and Christina Boumeester as well as Picasso, Picabia, Miro, Hartung and others.

Port de la Darse.

Chapel St-Pierre, 14th century, decorated by Jean Cocteau.

The Old Town.

The Rue Obscura, a 14th century road, covered by vaulted archways.

Maison de Charles Quint, house in which Charles V stayed. Built by Philibert, the Duke of Savoy in 1557.

VISIT

Villa Kerylos, at Beaulieu, a 1902 mansion built in the classical Greek style.

Musee du Patrimoine Berlugan, ave des Hellènes, Beaulieu.

Promenade Maurice Rouvier, walk the coastal path.

Drive along the Basse Corniche road to Monaco.

Take the bus to Nice.

FESTIVALS

Spring Carnival and Battle of the Flowers in boats, February.

Brocante, junk stalls, on Sundays.

Petit Salon de l'Octroi, Jardins Binon de l'Octroi , April-May.

Music Festival, June.

Fishermen's Festival, end of June.

Illuminations de la Rade, fireworks in the bay on August 15th.

Fête Patronale, end of September.

www.villefranche-sur-mer.com

GORDON BENNETT (1841 – 1918)

An American media mogul and entrepreneur, nicknamed 'the Commodore', who became known for his extravagant parties and outlandish behaviour. His name was adopted by the English as an expression for something considered unbelievable or over the top.

He was born on May 10th, 1841 in New York as James Gordon Bennett Jr. His father was a Scot and the publisher of the *New York Herald*, who built the newspaper up to have the highest circulation in America.

Due to the *New York Herald's* political influence Bennett was sent to school in France. Bennett was a keen sailor and at 16, became the youngest member of the New York Yacht Club. He served in the Civil War in America by patrolling the coast in his yacht, then took part in a naval attack on Florida. In 1866, he won a transatlantic boat race on his yacht from New Jersey to the Isle of Wight in England. He later set up the Gordon Bennett Cup as a prize for international yacht racing.

His father handed him the editorial helm of the *New York Herald* in 1867 and he lauched the *Evening Telegram*. He signed an exclusive with Henry Morton Stanley to print the story of his expedition in 1869 to find David Livingstone in Africa, garnering much publicity for the newspaper. He also scooped Custer's last stand in 1876.

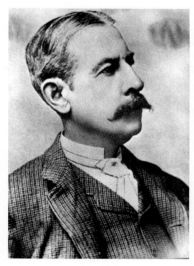

In 1877, a drunken incident that involved urinating in a fireplace caused a scandal and put an end to his engagement to debutante Caroline May. He returned to France and sailed into Villefranche on his 246 foot yacht, the steamship, *Namouna,* in 1883.

He created the *Paris Herald,* which later became the *International Herald Tribune.* When George W. DeLong planned an expedition to the North Pole via the Bering Strait,

Bennett helped finance it. The tragic deaths of DeLong and his team led to a rise in sales of the newspaper.

Bennett ran his business from his villa Namouna in Beaulieu-sur-Mer or from his yacht, which had many guests including Lady Randolph Churchill and her son Winston. Bennett set up a mail service from the *Herald's*

PHOTO: WWW.NAMOUNA.COM

office in Nice to his favourite restaurant, La Réserve, in Beaulieu, where he also had a telephone installed. At another favourite haunt in Montecarlo, he was prevented from dining on the terrace, one day, to which he replied: *"I'll buy the restaurant!"* He not only bought the restaurant, he put his waiter in charge.

His *Villa Namouna* was festooned with statues of animals and his dogs wore diamond collars. His parties were the kind of lavish affairs where near-naked dancing girls popped out of large cakes or were served for dessert on silver platters. He was said to light his cigars with flaming dollar bills.

Jay Gould had a monopoly over transatlantic communications, so Bennett set up a rival cable company with mine owner John W. Mackay, and reduced the cost of telegraphs and cables.

In 1900, Bennett launched the 314 ft *Lysistrata*. Lights in the shape of owl's eyes graced the prow. Bennett was obsessed with owls and even had a 200 foot tomb designed in the shape of one but when the architect died in 1906, the project was dropped.

In 1914, when he was 73, he married a Baroness, Maud Potter, the widow of George de Reuter, whose father had created Reuters news agency. Bennett had a feeling he would die when he was 77. He went into a coma on his 77th birthday, eventually dying on May 14th, 1918 at his home in Beaulieu, where there is now a street named after him.

He is buried at the Cimetière de Passy in Paris.

The *New York Herald's* circulation dropped under Bennett and was later merged with its rival paper, the *New York Tribune.*

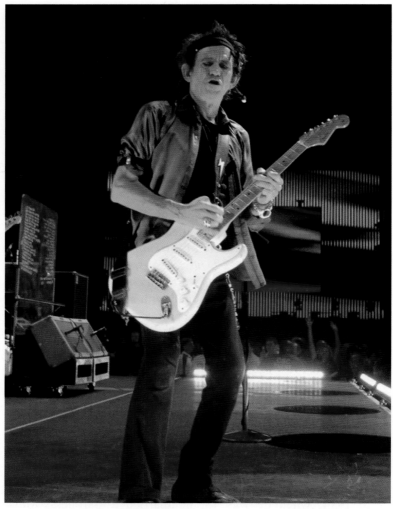

KEITH RICHARDS (1943 –)

PHOTO: KELSEY TRACEY

"I've never had a problem with drugs… I had problems with the police."

An English musician, singer-song-writer and guitarist, best known as a founding member of the Rolling Stones.

Born on December 18th, 1943 in Dartford, Kent, into a musical family, his grandfather was a band leader and Richards sang in a choir at the coronation of Elizabeth II in 1953.

His mother gave him a guitar when he was 15, and he taught himself to play it, emulating Chuck Berry's style. Although he had a place at Sidcup Art School, he was more interested in being in a band than attending lessons. He met Dick Taylor and Mick Jagger and soon joined their band, Little Boy Blue and the Blue Boys. One evening, Jagger and Richards went to the Ealing Club where Alexis Korner's Blues Incorporated was playing, and encountered a young Brian Jones, playing with the band, as a guest guitarist. Jones was trying to form a band and they joined forces.

Starting out performing covers, the Rolling Stones charted in the UK in 1964 with *It's All Over Now*. A US tour followed and they had hits with *Satisfaction* and *Paint It Black*. Richards and Jagger developed into a successful song-writing duo and the legendary rock band emerged.

Richards and girlfriend Anita Pallenberg had a son, Marlon, in 1969 and a daughter Dandelion (Angela) in 1972. But Richards developed a serious heroin addiction and had to go into rehab in 1977 following his arrest in Toronto, Canada for illegal drug possession.

In 1969, following the death of Brian Jones, who drowned in his pool, the Rolling Stones played a free concert in Hyde Park, dedicating the concert to his memory. In a Byronesque white shirt, Jagger read from a poem by Shelley and a large number of white butterflies were released.

At another free concert in the Altamont Speedway Stadium in California to promote *Let It Bleed* (1969) there was a fatal stabbing in the audience. The Hell's Angel responsible

MICK JAGGER AND KEITH RICHARDS IN 1972
PHOTO: LARRY KING

was caught on film by a documentary team making what became *Gimme Shelter.*

Becoming tax exiles due to financial problems in the UK, they formed their own Rolling Stones Records label. Over the summer of 1971, the band worked in the basement of Richards' home, the Villa Nellcôte, in Avenue Louise Bordes in Villefranche-sur-Mer. They wrote and recorded their 10th album *Exile On Main Street* using a mobile studio parked outside. They often took a break from recording by going out on Richards' speedboat to Monaco nearby. Thieves wandered in to the villa and stole their guitars and other equipment but the double album which was later mixed and re-mastered in Los Angeles, proved a huge success.

The villa had served as Gestapo headquarters during the German Occupation in the 1940s. The police raided the villa in 1973 and Richards and his girlfriend Anita Pallenberg were subsequently charged with possession of heroin and intent to supply. Richards was banned from France for two years. They never went back to the villa. It is now owned by a Russian billionaire.

Richards next married model Patti Hansen and the couple went on to have two daughters together, Theodora and Alexandra. Richards released his first solo album, *Talk Is Cheap* (1988) and then with the Rolling Stones, he released albums including: *Steel Wheels* (1989) and *Voodoo Lounge* (1994) for which the band won a Grammy Award for Best Rock Album.

On tour with *A Bigger Bang* (2005), Richards fell out of a tree in Fiji and had to undergo brain surgery. He soon recovered and rejoined the tour a few months later.

In 2007, he had a cameo role as the father of Jack Sparrow, the character played by Johnny Depp in *Pirates of The Caribbean: At World's End*. Johnny Depp (see page 212) is said to have been partly inspired by Richards in his creation of the role.

In 2010, *Life,* Richards' autobiography was published.

In 2013, the Rolling Stones played at both Glastonbury Festival and in Hyde Park, London, celebrating their 50th anniversary, before embarking on a world tour.

TINA TURNER (1939 –)

An American singer and actress nicknamed the 'Queen of Rock'.

Born in Nutbush, Tennessee on November 26th, 1939, as Anna Mae Bullock, to a poor mixed race family, she sang in the church choir and when her parents separated, she was raised by her religious grandmother. She died when Turner was an adolescent, so she moved to St. Louis, Missouri, to live with her mother.

As a teenager, Turner dreamed of becoming a nurse but when she started going to nightclubs with her sister, she was drawn to Rhythm and Blues at Club Manhattan. In 1956, she began a relationship with saxophonist, Raymond Hill, from The Kings of Rhythm band and they had a son, Raymond Craig, in 1958. Soon, she was singing with the group and duetting with Ike Turner.

In 1960, Turner and the band recorded *A Fool in Love.* When the song became a hit, the band changed its name to the Ike and Tina Turner Revue and undertook a gruelling touring schedule. Ike and Tina were married in 1962 in Tijuana, Mexico. Tina already had a son, and Ike had two, from previous relationships. Together they had another son, Ronald, in 1964.

In 1966, their album *River Deep, Mountain High* produced by Phil Spector, was highly successful and in 1969 they toured as the support act for the Rolling Stones in the UK and the USA. Notable hits included: *Nutbush City Limits* (1973) and *Proud Mary* (1971).

Turner branched out into acting, appearing in the Who's rock musical *Tommy* and a decade later, opposite

Mel Gibson in the blockbuster *Mad Max Beyond Thunderdome* (1985). She also appeared in *The Last Action Hero* (1993).

Her marriage to Ike had long become untenable due to Ike's drinking and drugtaking, his physical abuse and womanising. In 1969, she had attempted suicide and by 1976, she finally left him after a violent row. They were later divorced in 1978. Turner had taken up Nichiren Buddhism in 1974, and credited the spiritual practice of chanting *Nam Myoho Renge Kyo* for her survival.

Turner found it hard to kick-start her solo career until 1982 when she signed a deal with Capitol, who released her fifth solo album, *Private Dancer* (1984), which won four Grammy Awards and sold more than 20 million records worldwide. It included *What's Love Got To Do With It?* as well as two other top ten hits.

In 1986, Turner was given a star on the Hollywood walk of fame and she began a relationship with record executive Erwin Bach and they have been based in Switzerland since 1995. They were married in 2013 in Zurich.

Her autobiography, *I, Tina* published in 1986, was adapted as the film *What's Love Got to Do with It?* (1993). In 1991, Ike and Tina Turner were inducted into the Rock 'n' Roll Hall of Fame. Ike didn't attend the ceremony, as he was in prison for drug offences.

Turner had a villa built in the 1990s called "Anna Fleur" in the gated community Le Castellet at the peak of the Colline du Vinaigrier in Villefranche-sur-Mer which she described as 'heaven'. She and partner Erwin split their time between the Château Algonquin in Zurich and Villefranche-sur-Mer until recently when she sold the villa. She is now a Swiss citizen.

In 1999, she received the Lifetime Achievement Award at the MOBO (Music of Black Origin) Awards held at the Royal Albert Hall, in London and in 2002, she was ranked number two on VH1's poll of Greatest Women of Rock 'n' Roll.

In 2008, Turner began her 'Tina! 50th Anniversary Tour' which was highly successful, earning over $130 million in ticket sales. She has sold over 100 million records worldwide.

PROVENCAL CULTURE

PROVENCAL CULTURE

The Romans referred to the southern region of Gaul as Provincia Nostra, from which the name Provence is derived.

There are many Roman buildings from classical antiquity still in existence in the region, notably the arena at Arles, the theatre at Orange and the Pont du Gard aqueduct. The Romans introduced Christianity to the area in the 3rd century and the oldest surviving Christian religious site is the Cathedral in Fréjus, built in the 5th century. Two monasteries from that time also survive, one on the Isle de Lérins, near Cannes and the other at Abbey Saint-Victor in Marseille. Numerous religious traditions have evolved celebrating particular saints all over the region.

When the Roman Empire finally collapsed, Provence was attacked and invaded repeatedly by many factions including the Moors (or Saracens) from the south and the Normans from the North, requiring villages and towns to build heavy fortifications.

The power and influence of the Popes in Avignon made Provence into an important centre of culture and learning in the Middle Ages. The Counts of Provence ruled over Provence from 879 from their base in Aix, until the death of Good King René in 1480, when the title passed to his nephew Charles du Maine and then to King Louis XI of France. Provence officially became part of France in 1486 and Paris developed into the powerful centre that it is today.

OCCITAN – THE LANGUAGE OF LOVE

Another legacy of the Romans is Occitan, a Romance language which evolved from spoken Latin, once the Romans had left. Similar to Catalan, it was spoken in some parts of Italy, Monaco, in the Val D'Aran in Catalonia and across southern France.

In the 11th and 12th centuries, the language of Oc, (*langue d'Oc*) was popularised by strolling minstrels and troubadours, often itinerant knights, who travelled around the feudal courts, setting poetry and stories to music and

performing them for the nobility.

By writing down their poems and songs in the vernacular, the minstrels and troubadours created the basis for a literary culture distinct from classical literature in Latin and Greek.

Occitan was the language that was used at the court of the Popes of Avignon too and Petrarch, who was exiled in Avignon, wrote many accounts of local life in the language.

As Paris gained more power and influence in the north of France, it was decreed in 1539 that the Parisian dialect would be used for all French administration therafter.

Consequently, the Occitan language was spoken far less by the nobility after that time, and the minstrels and troubadours departed for the courts of Italy and Spain.

At the end of the 19th century, Frédéric Mistral led a revival of all things Provençal including the Occitan language and compiled a bi-lingual dictionary in Occitan-French (see page 203).

To experience some of the romance of the age of the troubadours, there are many medieval festivals held in the villages of Provence, usually in the summer. These often involve dressing up in medieval costumes, displays of sword fighting, pony rides, traditional crafts, street theatre and lyric poetry recitals.

One of the most popular medieval festivals is held each year in Brignoles at the end of August, over three days.

TRADITIONAL FOLK DANCING AT LES OURSINIERES, NEAR TOULON FOR THE FETE DE LA SAINT-PIERRE AND BLESSING OF THE PORT, IN JULY.

TEMPLIER TOWER, HYERES.

THE KNIGHTS TEMPLAR

The Order of the Knights Templar was founded in the early 12th century, after the First Crusade. Hugues de Payens, a knight from the Champagne area, created the Order, along with a group of fellow knights, with the aim of protecting pilgrims who were often attacked and robbed while travelling on their pilgrimages.

Sanctioned by the church around a decade later, they attracted large donations from the devout, in horses, land, money and even businesses. New recruits had to donate their property to the Order

upon joining. The Order became a fearsome private militia, well-trained in the art of battle and willing to die, rather than retreat.

Ten years later, in 1139, they gained a powerful protector in Pope Innocent II, who issued a papal bull, relieving them of payment of any taxes, and permitting them to travel freely throughout Europe.

The Knights Templar soon had a network not just in France, but also in England, Scotland, Spain and Portugal as well as a base at Temple Mount in the Holy Land. This network provided excellent communications and they gained economic, political and financial power as a result. Their introduction of 'letters of credit' to help pilgrims finance their travels without the need to carry their valuables, both reduced the attacks on pilgrims and enabled the Knights Templar to receive a great deal of funds which they 'held' safe until the pilgrim's return. This formed the basis of a banking system which saw the Order offering loans to many of the nobles and even the royal families in Europe. Within fifty years of their creation, they were also financing their hugely expensive Crusades in the Holy Lands from their business dealings. They even owned the island of Cyprus where they had a base.

In 1187, Saladin dealt the Knights Templar a crushing blow and subsequently managed to recapture Jerusalem. After that defeat, morale suffered, and eventually they lost their last stronghold, Arwad, in 1300.

Philip IV, King of France was furious that the Order had refused to loan him the money to go to war with England. He instructed his ministers to secretly build a case against them. On October 13th, 1307, the King ordered the arrest of the Knights Templars in France and they were rounded up and tortured by the Inquisition into confessing acts of heresy.

In 1312, King Philip IV exerted pressure on Pope Clement V (see page 53), to dissolve the Order and transfer its assets to the Knights Hospitaller of St. John, which in 1530 became the Knights of Malta.

Outside of France, the network collapsed and the various chapters of the Knights Templar were disbanded.

LOOK OUT FOR

CHEESE

The Moors who settled along the coast from the 8th century introduced goats and the art of making goats' cheese.

Pur chèvre on the label means that the cheese is made only from goat's milk. It comes in a variety of shapes and is often covered with herbs, ash or leaves.

You can visit a chèvrerie (goats' cheese maker):

Chèvrerie of Rocbaron – **www.chevrerie-rocbaron.jimdo.com**

Chèvrerie of Garagaïes – **www.leluec.perso.neuf.fr**

Banon cheese has been made for thousands of years in the Alpes de Haute-Provence. The round cheese, which is a blend of both goats' and cows' milk, is often wrapped in chestnut leaves and tied with raffia to keep it fresh.

PERFUME

You can buy lavender products, colognes, aromatic oils and perfume in the shops and on market stalls throughout Provence. Grasse has been producing perfume since the end of the 18th century. It is the centre of the French perfume industry and said to be the world's perfume capital (see page 90). Visit the Museum of Perfume at the Fragonard factory. **www.fragonard.com**

PETANQUE (BOULES)

Petanque (meaning feet together from the Occitan words *pes tancats* is a form of boules (or bowls) which can be seen in action throughout Provence. It seems to have been played for thousands of years in the region.

Anyone can play for free on the hundreds of boules courts which exist in the region. You will need to buy a set of metal balls, or children can use plastic ones.

A player aims to get his boule as close as possible to the cochonnet (a tiny ball), or to knock his opponent's boule away from the cochonnet, thereby scoring the point.

You can play in pairs or one-on-one with the aim of scoring thirteen points.

POTTERY

Biot has been a centre for Pottery for 400 years, producing hundreds of thousands of jars, and employing hundreds of potters. Its expansion was linked to the export of olive oil, as well as other food products. **www.musee-de-biot.fr**

Moustiers-Sainte-Marie also produced glazed ceramics in the

faience style. An italian monk from the monastery on the Isle de Lérins passed on the craft of making the white enamel glaze in 1668. Numerous workshops still exist in the village. **www.moustiers.eu**

SANTONS

As you travel around Provence, you will often see shops or market stalls selling small clay figurines, or Santons (little saints), depicting people dressed in the traditional costumes of Provence.

Originally made from wood, they formed part of the Nativity Scenes or Crèches created in churches at Christmas time. When the churches were closed as a result of the Revolution of 1789, an enterprising manufacturer from Marseille, Jean-Louis Lagnel, saw an opportunity to make and sell the figures for the general public.

Santon Fairs soon sprang up around Marseille, and continue to be held around Christmas time in many towns and villages each year. The Salon International des Santonniers is held in Arles from November to March each year and there is a Museum with 1800 Santons on display in Chateau de l'Aumerade in Pierrefeu-du-Var.

www.aumerade.com

SOAP

Savon de Marseille, made from natural vegetable oils, has been produced since the Middle Ages in Marseille. In 1688, Louis XIV introduced regulations that only soaps made by traditional methods, in and around Marseille, could bear the famous stamp 'Savon de Marseille'. Marseille was producing half the national output by 1938. Today, only a few *savonneries* (soap factories) still

exist in the city, but traditional soap is still made elsewhere in Provence.

You can visit a soap factory to see how the vegetable oil-based soap is made:

www.savon-leserail.com

www.savon-demarseille.com

TEXTILES

The history of fabric production in Provence goes back to the 16th century when colourful printed cottons, known as '*les indiennes*' were imported from India to Marseille.

They became so fashionable, following the lead of the ladies at court, that they were banned in 1686 when French textile manufacturers in Lyon complained they were being put out of business by the competition. Manufacturers in France got round the import ban, by bringing in Armenian creaftsmen to make the dyes and designing fabric with similar patterns to the Indian prints, adding little Provençal touches.

Today, the designs appear on tablecloths, clothing, ceramics, napkins and linens and are exported worldwide.

In Avignon, visit the Rue des Teinturiers or in Tarascon there is a museum at 39, rue Charles Demery, devoted to the craft.

www.souleiado-lemusee.com

TRUFFLES

Nicknamed the 'black diamond', truffles are a kind of mushroom that usually grows around the roots of oak trees. Due to the large demand from restaurants and gourmets for the delicacy, truffles now fetch a very high price.

Provence has many cultivated truffle farms or *'truffières'* mainly in the Var and Alpes-Maritimes, producing tonnes of the black diamonds each year. Many more are collected from wild truffle hunting where truffles are found growing naturally, usually in oak forests, but occasionally at the roots of lavender bushes.

A truffle hunter or *'rabassier'* will often use a trained pig, which has an acute sense of smell and a taste for truffles, or sometimes a trained dog which can also smell the pungent odour of the truffles growing underground.

With the high prices, poachers are common, and truffle farmers have been prepared to use shotguns to deter them, particularly around Christmas time.

The truffle season runs from November to March and truffle fairs take place throughout Provence. Carpentras has a truffle market every Friday during the winter.

www.avignon-et-provence.com/provence/black_truffles/

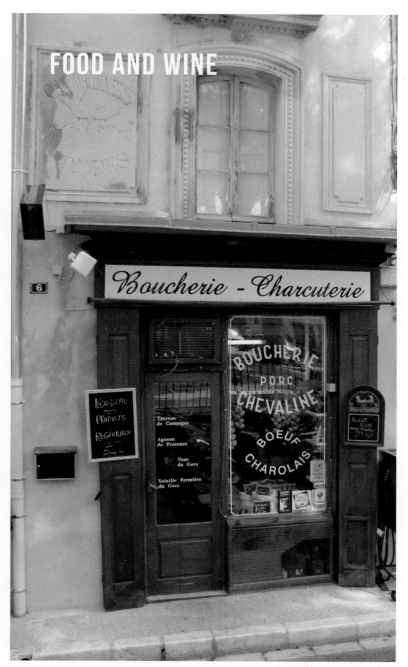

FOOD AND WINE

BUTCHER'S SHOP IN ST-REMY

FOOD AND WINE

Provençal cooking is celebrated worldwide. The kitchen is at the heart of the home in Provence and long family meals involving three generations eating together *al fresco* is still a common event.

It relies on locally grown fruit and vegetables and the plentiful supply of seafood on the coast, all combined with copious amounts of olive oil and North African influenced spices.

HERBES DE PROVENCE

Herbes de Provence are sold in packets or bags comprising a blend of dried herbs, usually: basil, fennel, rosemary, thyme, savory and lavender.

Other common herbs and spices are:

Ail – **Garlic.**
Basilic – **Basil.**
Bouquet Garni – **usually bay leaves, parsley and thyme.**
Cerfuil – **Chervil.**
Ciboulette – **Chives.**
Estragon – **Tarragon.**
Fenouil – **Fennel.**
Laurier – **Bay Leaf.**
Lavande – **Lavender.**
Marjolaine – **Marjoram.**
Menthe – **Mint.**
Persil – **Parsley.**
Romarin – **Rosemary.**
Sarriette – **Savory.**
Sauge – **Sage.**
Serpolet – **Wild Thyme.**

POPULAR PROVENCAL DISHES

AIOLI – SERVES 4
A kind of garlic mayonnaise. Often served with a bourride – a fish soup that is made from cod and potatoes.

Ingredients:
3 egg yolks
4 cloves garlic
½ lemon, juice only
Salt and freshly ground black pepper
5fl oz (150ml) extra virgin olive oil
Mustard powder (optional)
Saffron (optional)

Method:
1. Blend all the ingredients together then add the olive oil slowly while stirring or blending.
2. The mixture should become a bright yellow sauce which you can make thinner by adding a tablespoon or two of hot water. To make it sharper, add mustard.
3. Serve with carrot sticks, celery or other raw vegetables.

Bouillabaisse – Serves 4

A fish stew from Marseille. Traditionally made with sea robin, scorpion fish and conger eel. Often made from a variety of fish and shellfish, such as monkfish, seabass, John Dory, shrimp, crab or lobster. The stew can also be served over thick slices of bread with a touch of sauce called *Rouille.*

Ingredients:

3 lbs (1.36 kg) of at least 3 kinds of fish fillets
½ cup olive oil
1-2 lbs (0.5 - 0.9kg) of mussels, prawns or oysters
1 cup cooked crab or lobster flesh
⅔ cup white wine
2 cloves crushed garlic
2 whole cloves
1 cup diced onions
1 large chopped tomato
1 thinly sliced red pepper
2 thinly sliced leeks
3 thinly sliced celery stalks
2 tablespoons of lemon juice
2 teaspoons salt
1 teaspoon of fennel seeds
1 teaspoon dried thyme
1 bay leaf
½ teaspoon powdered saffron
¼ teaspoon freshly ground black pepper
1 cup clam juice or fish broth
Half a loaf of sliced bread

Method:

1. Heat half the olive oil in a large saucepan. When it's hot, add the onions and leeks. Sauté for a minute, then add the crushed garlic, fennel, red pepper, tomato and celery. Stir well then add the remainder of the olive oil, cloves, bay leaf and thyme. Cook until the onion and pepper turns soft.
2. Cut the fish fillets into small pieces and add them to the vegetables. Add 2 cups of water and heat almost to boiling point

then leave the pan to simmer for about 10 minutes. Add the seafood, sliced or whole.

3. Add the lemon juice, clam juice and white wine together with salt, pepper and saffron. Let the pan simmer again for another 5 minutes.

4. At serving time taste and correct the seasoning of the broth, adding a little more salt or pepper if need be, and maybe a touch of lemon juice.

5. Place a few thick chunks of bread in each bowl and spoon the bouillabaisse on top. Add Rouille Sauce for more flavour.

Rouille Sauce:

1 tablespoon of fish stock or clam broth
2 cloves crushed garlic
1 small thinly sliced red pepper
½ teaspoon salt
¼ cup diced soft white bread
½ cup olive oil

1. Put the fish stock or clam broth into a pan or blender.

2. Add the garlic and sliced red pepper, salt and bread. Stir or blend until a smooth consistency.

3. Drizzle the olive oil into the mixture and stop stirring as soon as the oil disappears.

4. Serve alongside the bouillabaisse, adding about half a teaspoon to your stew for added flavour.

BRANDADE DE MORUE – SERVES 8

An appetiser made from puréed cod, popular around Marseille. Potatoes can be added for a thicker dip. Cheese can be added for extra taste.

Ingredients:

8 oz (220g) salted cod
1 cup of milk
6 cloves thinly sliced garlic
¼ teaspoon ground thyme
⅛ teaspoon ground cloves
1 cup of double cream
½ cup extra virgin olive oil
1 teaspoon of lemon juice
3 large potatoes, mashed
1-2 oz (28-56g) grated cheese
Salt and pepper to taste

Method:

1. Remove the skin and soak the cod in a bowl with one inch of water for 24 hours. Refrigerate bowl, changing water twice daily.
2. If using potatoes, cut them into small pieces and place in a pan of water. Boil the water for 20 minutes until potatoes are tender. Mash the soft potatoes.
3. Drain the cod and transfer to a large pan. Add two inches of water and simmer for 10 minutes but do not boil or cod will be too hard to purée.
3. In a small saucepan, gently heat the garlic, cream, lemon juice, cloves and thyme until garlic is tender. Blend the mixture until all is reduced to a creamy paste.
4. Drain the cod then and add the milk, garlic cream (and mashed potatoes) to a food processor. Mix slowly for a few minutes, until combined then add the olive oil in a steady stream while still mixing.
5. If adding cheese, place the mixture in a baking dish and sprinkle cheese on top. Cook in oven at 375°F/190°C (Gas Mark 5) for 20 minutes until top is golden brown.
6. Season with salt and pepper and serve with sliced baguettes.

CALISSONS – 12 TO 15 PIECES

Made from a base of almond paste, flavoured with candied orange peel and melon, topped with icing.

Said to have been created for the wedding of King René in 1454, the almond-shaped delicacy has been produced in and around Aix-en-Provence for centuries. Priests used to give the treats in place of the Communion host on special feast days.

Nowadays, Calissons are often part of the Christmas tradition in Provence in which thirteen different desserts are served after Midnight Mass. It is customary to sample a little of each dessert and to drink mulled wine to ensure a prosperous New Year.

The desserts often comprise nougat, dried figs, dates, nuts, oranges, apples, pears, fougasse – and calissons.

Ingredients:

8 ozs (220g) almond paste
1 oz (28g) crystallised melon or apricot jam
1 oz (28g) diced candied orange peel
3 tablespoons orange flower water

Royal icing:

3 ozs (85g) icing sugar (colour optional)
1 egg white

1. Put the almond paste, candied fruit, (jam) and orange flower water in a food processor and mix until you have a smooth paste, or blend it by hand.
2. Place a piece of grease-proof baking paper on a tray and roll out the almond paste mixture until it's about ¼ inch (1cm) thick.
3. Cut out the almond shapes and leave to dry overnight in a cool place, uncovered.
4. Beat the egg white until stiff then slowly add the icing sugar to make a light, fluffy glaze.
5. Spread the glaze over the top of each biscuit.
6. Let them dry for one hour.
7. Serve after dessert.

DAUBE PROVENCALE – SERVES 6 TO 8

A traditional beef stew braised in wine, garlic and Herbes de Provence. For the best flavour, the meat is marinated in the mixture over a day or two and cooked in a daubiere.

Ingredients:

3 lbs (1.36kg) cubed beef
1 bottle red wine
3 thinly sliced onions
3 cloves crushed garlic
3 diced carrots
1 diced celery stalk
1 bouquet garni
¼ cup cognac
⅓ cup flour
¼ cup olive oil
¾ cup beef stock
1 tablespoon tomato paste
1 cup of olives
½ teaspoon salt
1-2 cups rice

Method:

1. Place the bouquet garni in a dish with the celery, onions, garlic, carrots and beef and pour the cognac and red wine over the mixture.
2. Refrigerate it for at least 24 hours.
3. Preheat the oven to 375°F/190°C (Gas Mark 5). Separate the beef from the vegetables.
4. Heat the oil in a large pan. Coat the beef with the flour and brown the mixture. Remove the beef from the pan then add the beef stock and tomato paste.
5. Combine the beef, stock, salt, vegetables and wine mixture in a large casserole dish or daubiere.
6. Braise the beef for 2 to 3 hours, until tender. Remove the bouquet garni.
7. Cook the rice according to the packet instructions and serve with the beef stew.

Escabeche – Serves 4

A popular Mediterranean fish dish, served cold.
The fish (preferably oily fish) is marinated overnight in vinegar or lemon juice then poached or fried in spices.

Ingredients:

1 lb (450g) fish fillets, cut into pieces
1 tablespoon salt
¼ cup of water
2 crushed garlic cloves
1 large diced onion
1 thinly sliced red pepper
2 tablespoons olive oil
1 tablespoon soya sauce
1 teaspoon of ground black pepper
½ teaspoon of cumin seeds
1 tablespoon ginger
1 teaspoon coriander
1 teaspoon thyme
1 cup fish stock
1 cup white wine vinegar

1. Add the salt to the water and soak the fish for one hour.
2. Heat the oil gently in a pan and fry the onion, garlic, red pepper and ginger until garlic goes tender. Add the soya sauce, cumin, coriander and thyme.
3. Add the fish pieces and cook each side lightly.
4. Add the fish stock and vinegar to the mixture and increase the heat slightly so the fish cooks through for about 5 minutes.
5. Leave to cool.
6. Transfer the fish and marinade to a dish and place in the refrigerator overnight.
7. Serve cold the next day.

FOUGASSE – SERVES 4

It is not the crusty baguette but the oval-shaped flat-bread sometimes filled with anchovies, olives, cheese or nuts which is the traditional bread of Provence. Originally cooked in a wood fired oven, this bread has been made since Roman times.

In Nice, they have their own version, called *La Pissaladière* which is usually topped with caramelized onions, small black olives and a fish paste called *Pissalat* (made from sardines and anchovies).

Ingredients:

1 lb 2 oz (500g) strong bread flour
1 heaped teaspoon (10g) fresh yeast/or half as much dry yeast
2 teaspoons salt
2 tbsp extra virgin olive oil
2 cups (400ml) lukewarm water
chopped rosemary, sage, or thyme leaves
10 black olives
1 teaspoon (10g) sea salt

Method:

1. Pre-heat oven to 425°F/220°C (Gas Mark 7)
2. In a bowl, rub the yeast into the flour then add oil and salt. Add 1 cup of water and stir with a wooden spoon, until dough forms. Add more water as required.
3. Transfer dough to a floured worktop then knead it until it will lift off the surface without sticking. Form the dough into a ball.
4. Place in a large oiled bowl, cover with a tea towel and leave it to rise in a warm place for one hour until it has doubled in size.
5. Place on a well-floured baking tray and flatten it out with your fingers and leave to rest and rise for 10 more minutes.
6. Cut the surface of the dough, dimpling it, then sprinkle with the herbs and optionally place the black olives, peppers, nuts, anchovies or grated cheese in the holes.
7. Sprinkle with sea salt and place in the centre of the oven. Bake for 12-15 minutes, or until golden.
8. Cut into pieces and serve while warm.

RATATOUILLE – SERVES 6

A vegetarian dish made from seasonal Mediterranean vegetables. It originated from Nice and can be served either hot as a stew or cold as a side accompaniment.

Ingredients:
2 sliced aubergines
2 sliced courgettes
2 sliced red peppers
2 sliced yellow peppers
4 large sliced tomatoes (or 400g canned tomatoes)
2 thinly sliced onions
4 tablespoons olive oil
4 cloves crushed garlic
2-3 sprigs thyme
1 tablespoon chopped basil
1 teaspoon sugar
1 tablespoon red wine vinegar or juice of half a lemon

Method:
1. Heat the onions and garlic in a pan with the olive oil until they are soft.
2. Transfer to a baking dish with a lid.
3. Lightly brown each of the vegetables separately with olive oil in another pan and set each aside. Don't overcook them.
4. Season with salt, pepper and thyme.
5. Arrange the vegetables in layers over the garlic and onion in the baking dish.
6. Add the vinegar and sugar.
7. Bake at 350°F/ 180°C (Gas Mark 4) for 20-30 minutes until the vegetables are soft.
8. Remove from oven and ladle into dishes. Or serve as a side dish.
9. Sprinkle the basil over the vegetables and serve it hot as a stew or use as an accompaniment to hot or cold dishes.

Soupe au Pistou – Serves 6
A vegetable soup made with ground basil.

Ingredients for the soup:
8oz (220g) canned beans
1lb (450g) frozen mixed vegetables: peas, carrots, cauliflower
1lb (450g) diced courgettes
8oz (220g) sliced green beans
4oz (100g) pasta
2 bay leaves
3 tablespoons olive oil
2 diced onions, or 4 sliced leeks
2 teaspoons thyme
4 cloves of thinly sliced garlic
1 tablespoon sea salt
1 teaspoon black pepper

Ingredients for the pistou:
2oz (50g) chopped basil
3 tablespoons olive oil
1 clove crushed garlic
pinch of salt
1 diced tomato
2oz (50g) grated Parmesan cheese

Method:
1. In a large pot, gently heat the olive oil, add the garlic and onions and cook until soft.
2. Add 4 pints (2 litres) water then the canned and frozen vegetables, courgettes, green beans. Season with salt, pepper and thyme.
3. Simmer until the vegetables are completely cooked.
4. Add the pasta and bring to the boil, then simmer until the pasta is cooked.

For the pistou:

1. Mix the chopped basil and crushed garlic together. Drizzle in the olive oil slowly, while mixing, and then add in the tomato, salt and pepper.
2. Finally, mix in the grated cheese.

To serve:

Pour hot soup into bowls and add the pistou for extra flavour, stirring gently. In summer, when cold soup is preferred, allow to cool before serving.

TOMATES A LA PROVENCALE – SERVES 4 TO 6

Stuffed large red tomatoes baked in the oven.

Ingredients:

6 tomatoes
¼ cup of olive oil
½ cup of fresh breadcrumbs
3 tablespoons of diced onions
4 tablespoons of mixed herbs
1 clove of crushed garlic
salt and pepper

Method:

1. Pre-heat oven to 375°F/190°C (Gas Mark 5)
2. Cut tomatoes in half and scoop out seeds. Place on a lightly oiled baking sheet.
3. Mix the onions, garlic, breadcrumbs, herbs and oil in a bowl.
4. Add salt and pepper. Spoon the mixture into the tomato shells.
5. Bake the tomatoes for 25-30 minutes until the breadcrumbs are lightly browned.
6. Serve as a starter or side dish.

WINES OF PROVENCE

Wine has been cultivated in Provence for over two thousand years with the ancient Greeks bringing the first vines in 600 BC. The Romans continued the tradition and Provence is the world's leading producer of rosé wines with excellent red and white wines exported worldwide too.

THE MAIN WINE-MAKING AREAS

Bandol, Cassis, Côteaux d'Aix-en-Provence, Côteaux Varois and Côtes de Provence. Provence makes hundreds of types of

wine, including blends of different grape varieties. Some of the red varieties are: Carigan, Cinsault, Mourvèdre and some of the white varieties are Clairette, Ugni Blanc and Rolle.

In 1955, fourteen Provençal wine estates were designated Crus Classés based on an evaluation of the history of the estates, their winemaking and cellar reputations and the overall quality of their vineyards.

Many vineyards are open to the public and have outlets selling wine by the bottle or the case. You can usually try before you buy. However, when visiting the domaines please note that the shops tend to close between 12-2pm for lunch and always check if they are open on Sundays before visiting. You can try:

www.chateau-de-bregancon.fr
www.clos-cibonne.com/fr
www.mauvanne.com
www.chateauminuty.com
www.domaines-ott.com
www.chateausaintmaur.com

Bandol

West of Toulon on the coast, Bandol covers eight communes, producing mostly red wine which is often aged in oak casks for at least a year. The well-drained stony soil and the mild climate makes Bandol perfect for producing a strong red wine. It contains

at least 50% of the Mourvèdre 'King Grape' variety, and is often blended with Grenache and Cinsault. This wine improves with age.

Cassis

Further west from Toulon towards Marseille, Cassis produces mainly white wine. The soil is primarily limestone which is particularly suited to the cultivation of Clairette, Marsanne, Ugni blanc and Sauvignon blanc which are the major varieties in the area. Production is limited to the few vineyards in and around Cassis.

Côteaux d' Aix-en-Provence

Located in and around the city of Aix-en-Provence, producing mostly red wine, with a third of production given over to rosé and a little to white wine. Grapes used: Cinsaut, Grenache and Mourvèdre.

Côteaux Varois

Located around Mont Sainte-Baume in the Var. Rosé wine dominates output with only a third given over to red wine and a little to white wine. Grape varieties: Cabernet Sauvignon, Cinsaut, Grenache and Mourvèdre.

Côtes de Provence

An area that extends from the Alpilles down to Saint-Tropez on the coast. Rosé is the dominant wine in this area with a little red wine and scarcely any white wine produced. Grape varieties: Cinsaut, Grenache, Syrah and Tibouren.

WINE LABELLING

AOC – Appellation d'Origine Contrôlée

The Institut National des Appellations d'Origine controls the size of vines and their yield, the variety of grapes, the level of alcohol, the type of cultivation and the vinification. Provence has eight main wine-making areas with AOC designations: Côtes de Provence and Côteaux d'Aix-en-Provence are the most important of these.

Cru Classé

This prestigious classification was created in 1855 in the Bordeaux region as a way of ranking the superior wines. Only a few wine producers were allowed to call their wine Grand Cru Classé, such as Château La Tour and Château Margaux. Grand Cru is the highest ranking with Premier Cru following shortly behind. There are

fourteen vineyards with Cru Classé designations in the region, which are: Château de Brégançon in Bormes-les-Mimosas, Clos Cibonne in Le Pradet, Château du Galoupet in La Londe-les-Maures, Domaine du Jas d'Esclans in La Motte, Château de Mauvanne in Hyères, Château Minuty in Gassin, Clos Mireille in La Londe-les-Maures, Domaine de Rimauresq in Pignans, Château de Roubine in Lorgues, Château Ste-Marguerite in La Londe-les-Maures, Château St. Maur in Cogolin, Château Ste. Roseline in Les Arcs, and Château de Selle in Taradeau.

VDQS – Vin Délimité de Qualité Supérieure

Superior Quality Wine is classified with strict controls on production and cultivation, with the VDQS logo on the label.

Vin de Pays

A good table wine produced in a particular area of France and in a given year. The type of grapes used and the volume produced is regulated. Provence has several vin de pays designations, with Bouches-du-Rhône, being one of the most popular.

Vin de Table

This kind of table wine is widely available and is often a blend of wines from a number of sources. Sold in supermarkets, restaurants, co-ops and local shops.

PASTIS

A liqueur and apéritif, flavoured with star anise and liquorice root and popular in Provence where anise liquors are an old tradition. Other similar drinks are: sambuca, ouzo, arak, rakı and mastika.

Dilute the pastis with water before drinking: five volumes of water for each volume of pastis. Best served cold, with or without ice. Or mix with cola or grenadine for a pastis cocktail.

INDEX
PEOPLE

PLACES

CULTURE

FOOD

WINE